Four Decades

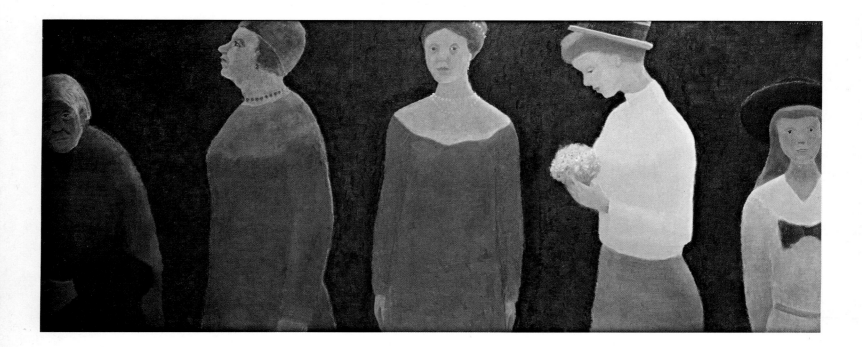

Four Decades

The Canadian Group of Painters and their contemporaries – 1930-1970

Paul Duval

Clarke, Irwin & Company Limited Toronto Vancouver 1972

ISBN 0-7720-0553-2

12345 SM 76 75 74 73 72

Printed in Canada

Contents

Acknowledgements

No book is born without the direct or indirect assistance of many persons. Among those whose co-operation helped to make this book possible I wish to acknowledge the following:

Mr. T. R. MacDonald, Director, The Art Gallery of Hamilton; Miss Joan Murray, Curator of Canadian Art, The Art Gallery of Ontario; Mr. Dennis Reid, Curator of Post-Confederation Art, National Gallery of Canada; Mrs. Barry Woods, Curator, The Robert McLaughlin Art Gallery, Oshawa; Mr. Kenneth Saltmarche, Director, The Art Gallery of Windsor; Mr. Clare Bice, Director, The London Public Library and Art Museum; Mr. Robert McMichael, The McMichael Canadian Collection, Kleinburg; Mr. R. F. Wodehouse, Curator of War Collections, The Public Archives of Canada; Mr. Michael Greenwood, Curator of Art, York University; Alan Toft, Curator, Hart House, University of Toronto; Mrs. Doris Shadbolt, Curator, Vancouver Art Gallery; Mrs. Frances K. Smith, Queen's University; Mr. David Carter, Director, The Montreal Museum Of Fine Arts; Miss Patricia E. Glover, Curator, The Winnipeg Art Gallery; Museo de Arte Moderno, Mexico City.

Private Galleries and Dealers: Mr. Walter Moos, Gallery Moos, Toronto; Mr. Jack Wildridge, Roberts Gallery, Toronto; Mr. Jerrold Morris, The Morris Gallery, Toronto; Mr. Avrom Isaacs, The Isaacs Gallery, Toronto; Mrs. Mira Godard, Marlborough-Godard Gallery, Toronto; Mrs. B. Dunkleman, The Dunkleman Gallery, Toronto; Mr. Carmen Lamanna, The Carmen Lamanna Gallery, Toronto; Dr. Max Stern, The Dominion Gallery, Montreal; Mr. Simon Dresdnere, The Gallery Dresdnere, Toronto; Mrs. Helen Mazelow, The Mazelow Gallery, Toronto; Mr. Theo Waddington, Waddington Galleries, Montreal; Mr. David Mirvish, The Mirvish Gallery, Toronto; Fischer Fine Arts Ltd., London.

Private Collectors: Mrs. C. S. Band, Mr. and Mrs. Pierre Berton, Mr. Victor Brooker, Dr. and Mrs. W. H. Clarke, Mr. R. G. P. Colgrove, Mr. M. F. Feheley, Mrs. Eugene Hawke, Mr. and Mrs. Henri Kolin, Mr. Al Latner, Mr. and Mrs. Jules Leger, Mr. and Mrs. Max Merkur, Mr. Gerry Moses, Mr. and Mrs. J. A. McCuaig, Mr. and Mrs. James McKague, Mr. and Mrs. E. R. S. McLaughlin, Mr. and Mrs. T. E. Nichols, Mr. and Mrs. A. N. Steiner, Mr. and Mrs. R. N. Steiner, Mrs. Ayala Zacks, The Toronto-Dominion Bank, Imperial Oil Limited, Pitney-Bowes Limited, Canadian Imperial Bank of Commerce, Montreal.

A warm acknowledgement goes to all of the artists whose works are reproduced in this book and to the special committee of the Canadian Group of Painters – Mrs. Yvonne Housser, Mrs. B. Cogill Haworth, Miss Isabel McLaughlin, Mr. Carl Schaefer, Mr. Sydney Watson, Mr. York Wilson, Mr. Gus Weisman, and their indefatigable secretary, Mr. George Hulme. Mr. MacKay Houstoun carefully supervised the photographing of most of the reproductions contained in this volume.

Preface

It is a current fashion to play down the role that societies or groups may exert in helping establish the art of an individual or nation. It has been suggested that such organizations are mainly social outlets and their exhibitions ego trips for the participants. Such assertions are usually based on ignorance or spite.

Until the very recent past in Canada, artists depended upon societies to establish both their reputations and their markets. They banded together for mutual encouragement in an environment which was at best indifferent and at worst hostile. The rise of private dealers in contemporary art is a relatively new phenomenon in this country and the few that existed previously mainly traded in European pot-boilers or the safest of Canadian artists of the past.

Before the emergence of venturesome private galleries, the painter with a fresh talent could only hope to reach an audience through one of the established national or local art societies. Among these societies, the Canadian Group of Painters unquestionably provided the most creative base for the display of original talent. During its almost forty years of existence, the Canadian Group, as it was familiarly known, invited virtually every significant painter of its period to become an exhibitor and a part of its membership.

The artists who showed with the Canadian Group of Painters included almost every major figure in this country's modern art. Among them were artists as diverse as Paul-Emile Borduas and Alex Colville, Emily Carr and Oscar Cahen, Goodridge Roberts and Jack Bush, Jock Macdonald and Jacques de Tonnancour, Graham Coughtry and Guido Molinari, LeMoine Fitz-Gerald and York Wilson. Significantly, the Canadian Group did not wait until such artists were established to invite them, but showed their work when they were young and virtually unknown.

Strangely, the story of the Canadian Group of Painters is almost a total blank to all but the artists who exhibited with it. It has even been dismissed as unimportant by commentators whose experience in Canadian art is almost non-existent and whose knowledge is limited to cullings from past commentators. It is to correct these circumstances that the present volume has been written. In it, the history of the Canadian Group is incorporated within a broad survey of the main developments of the past forty years of Canadian painting.

I have personally known most of the painters about whom I write. Among them, I have counted many friends. I have reviewed their art for more than a quarter of a century. I have sat on exhibition and award juries with them, written forewords for many of their exhibitions, and helped oversee the estates of a number. I have not hesitated to quote from my own writings of the period covered where I believe it is relevant. After all, there is no better evidence than that of an informed eye-witness. Nor have I hesitated to reproduce occasional paintings for which the date briefly precedes the period covered by this book, when those paintings illuminate some aspect of the text.

Regrettably, because of restrictions placed upon reproduction, the works of certain artists are not included in this book.

Paul Duval
The Studio Building
Toronto
June 8, 1972

1 / *The Beginnings*

For a decade following 1920, Canadian painting was dominated by the landscape art of the famed Group of Seven. The impact of its members' powerful masculine style was such that even today many people still think of the Group of Seven as the only truly Canadian art movement. In doing so, they are forty years behind the times.

By the early 1930's, there were many original and vital artists at work in all parts of Canada, most of them not at all concerned with the Group of Seven's basic preoccupation with pure landscape. Significant work was being done in the fields of figure, genre, portraiture, still life, and even abstract painting. On all sides new social and aesthetic attitudes were appearing.

After only ten years of existence, the Group of Seven came under the gun of these younger artists, some of whom were jealous of the publicity gained by that band of senior painters.

Despite its encouragement of many younger artists, the Group of Seven was running into complaints that it "dictated" the policies of the National Gallery under Director Eric Brown, and crowded the achievements of other artists from the columns of the press.

It was true that the Group of Seven, by its very title and personal character, left little room for the inclusion of fresh blood within its structure, although the will to do so was certainly there. There were thirteen guest contributors invited to the 1930 Group of Seven show at the Art Gallery of Toronto. (Not everyone agreed that inviting younger artists to exhibit was a good idea. Thoreau MacDonald, a founding member of The Canadian Group of Painters, later wrote in his essay, "The Group of Seven" – Ryerson Press, 1944: "In their later exhibition the Group invited a number of younger artists to show pictures,

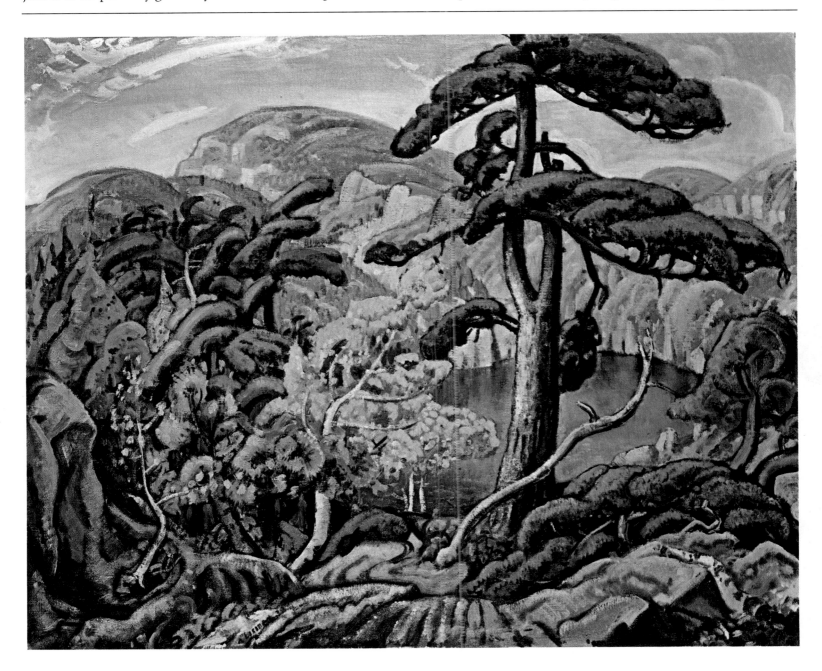

ARTHUR LISMER *Bright Land* 1938 32x40 McMichael Canadian Collection

with the good intention of encouraging them and bringing on new growth. To the present writer this seems to have been a mistake, diluting the old quality, lowering the general standard of Canadian art, and taking out a lot of power that earlier Group shows never lacked.") The feeling still persisted, however, that these invited associates were virtually invisible in the backwash of the "magnificent Seven."

The changing form of the Group of Seven membership itself added to its instability. Edwin Holgate and LeMoine FitzGerald, for example, were not admitted to full membership in it until 1930 and 1932, respectively, and the substance of their work related only slightly to the bravura extroverted style of the original members. The addition of FitzGerald was an empty gesture, since the final Group of Seven exhibit had been held the year before his election and it had already announced its demise.

In a prophetic letter to LeMoine FitzGerald, dated November 27th, 1931, painter Bertram Brooker foretold the end of the Group of Seven: "I think I told you that my feeling at the last show was that it marked the death-knell of the group of Seven as an organization. Subsequent events and the lack of material for the proposed show seemed to bear out this pessimistic view. This does not mean, of course, painting is going to stop in Canada, but I do think it will definitely turn away from the rigid stamp imposed upon it by the Group."

In December 1931 this prophecy came true. After the Group of Seven show of that year, A.Y. Jackson told the press that the Group was disbanding: "The interest in a freer form of art expression in Canada has become so general that we believe the time has arrived when the Group of Seven should expand, and the original members become the members of a larger group of

J.E.H. MACDONALD *Snow in the Mountains* 1932 21x26 C.S. Band Collection

artists, with no officials or constitution, but held together by the common intention of doing original and sincere work."

The Group of Seven's decision to disband and be absorbed into a society of artists more truly representative of Canadian painting, as it then existed, was a wisely timed one. If its members had persisted in exhibiting under their original banner, they could soon have become bound to a commonplace and tiresome institution. As it was, their unerring sense of public relations was to prove as effective in establishing their future position in history as it did in the jugular, day-to-day campaigns of their years of active existence.

The needs and complaints of the many fine artists who were outside the Group of Seven were finally answered in the late winter of 1933, during an historic March meeting at the home of Lawren Harris, at 2 Ava Crescent in Toronto. There, the original members of the Group met with a number of upcoming younger painters, to found an art society which might fit the needs of all creative Canadian painters. The meeting was not all peace and harmony. There were heated discussions and differences as to the philosophy, aims and title of the body.

On March 20th, following this meeting, Bertram Brooker wrote a fellow founding member, LeMoine FitzGerald, who had been unable to leave his Winnipeg home for the gathering: "You know all about the new Group, of course. We had an evening at Lawren's house to get things started, and I have really not seen any of them, except Lismer and Comfort since that evening, and neither of us have discussed the thing very much. Between ourselves, however, I am a little afraid that a strong nationalistic bias which always gets into the utterances of the old Group, either public or private, is going to continue very strongly in the

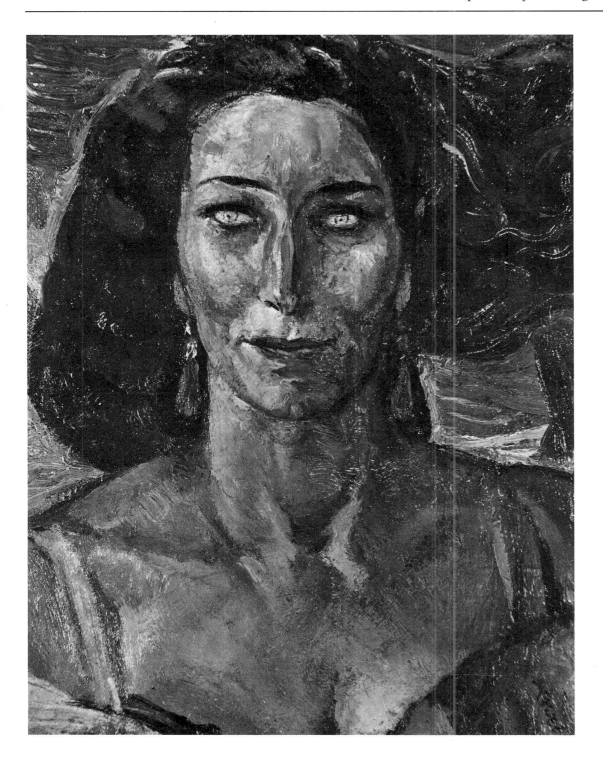

F.H. VARLEY *Natasha* 1942 14x12 Private Collection

new Group. Comfort and I were the only ones at the meeting who raised our voices in protest against this rather insular attitude. We both felt, for example, that the very name of the new Group—Canadian Group of Painters—puts undue emphasis on the word 'Canadian.' We did not press the point, but we did stress the feeling we both have, that painting, even by Canadians in Canada, need not necessarily be confined to any sort of nationalistic tradition."

In spite of such hesitations over nationalism and other matters, "The Canadian Group of Painters" was adopted as the name for the new body of twenty-eight members, and it served well for more than thirty-six years, until the disbanding of the organization in 1969.

The twenty-eight painters who formed the original membership of The Canadian Group of Painters were: Bertram Brooker, Franklin Carmichael, Emily Carr, A.J. Casson, Charles Comfort, LeMoine FitzGerald, Lawren Harris, Prudence Heward, Randolph Hewton, Edwin Holgate, Bess Housser, A.Y. Jackson, Arthur Lismer, J.W.G. Macdonald, Thoreau MacDonald, Mabel May, Yvonne McKague, Isabel McLaughlin, Lilias Newton, Will Ogilvie, George Pepper, Sarah Robertson, Albert Robinson, Anne Savage, Charles Scott, Frederick Varley, William Weston and W.J. Wood.

All of these artists were represented in the maiden exhibition of the new Canadian Group, as was the recently-deceased J.E.H. MacDonald. Ironically, that first show was held not in Canada, but in Atlantic City. So much for the earlier fears of being too nationalistic. Even more ironic, the expenses for this landmark Canadian venture were paid by the H.J. Heinz Company, of "57 Varieties" fame. All 57 were listed in sedate

ALBERT H. ROBINSON *St. Joseph* c. 1930 26x32 McMichael Canadian Collection

type at the back of the exhibition catalogue along with an ad for Atlantic City's Heinz Ocean Pier Exhibition Hall, which boasted "Writing Rooms and Sun Parlors" and "Motion Pictures Showing the Making of the World Famous 57."

Commercial and American though its sponsorship may have been, that inaugural exhibition in the summer of 1933 was a superb display, representing the finest talent of the era, and foretelling the vital role The Canadian Group of Painters exhibitions were to play as a continuing showplace for new and established painters. Most artists at the Atlantic City show were represented by three or four canvases. Among these were such now-acknowledged Canadian masterpieces as Emily Carr's Indian Church, Lawren Harris' Pic Island and Lake Superior, F.H.Varley's Dharana, Arthur Lismer's Happy Isles, J.E.H. MacDonald's Gleam on the Hills and J.W.G. Macdonald's Black Tusk.

The foreword to the illustrated catalogue told Atlantic City visitors: "This exhibition represents the modern movement in Canadian painting and consists of canvases by the twenty-nine [sic] members of the newly formed Canadian Group of Painters and a few [sic] additional contributors."

The first Canadian Group of Painters' exhibition to be held in Canada was hung at the Art Gallery of Toronto in November of 1933. Again, most of the artists showed three or four works and these were, in the main, different from the Atlantic City selections. Among the later-famous compositions displayed this time were Arthur Lismer's Pine Wrack, Lawren Harris' Grey Day In Town, Sarah Robertson's In The Nuns' Garden, Frederick Varley's The Open Window, Edwin Holgate's Interior and A.Y. Jackson's Winter Morning, Charlevoix County.

The twenty-eight original Canadian Group members in the

A.Y. JACKSON *Hills at Great Bear Lake* c. 1953 38x50 Art Gallery of Hamilton

1933 Toronto show were almost equalled in number by invited contributors, of whom there were twenty-five. Among these were many who were later to enjoy full membership and to contribute importantly to twentieth-century Canadian art (for example, Carl Schaefer, Marc-Aurèle Fortin, Jack Humphrey, Paraskeva Clark, John Alfsen, Adrien Hébert, Gordon Webber, André Biéler, Peter Haworth and B. Cogill Haworth).

The local critical response to this first Canadian Group exhibition at home could hardly have been encouraging. In a long review in the *Bridle and Golfer*, William Colgate blistered the show as "futile" and "immature": "The new group as a whole," he wrote, "will obviously have to achieve a growth in skill, intelligence and understanding as well as in numbers, before it can hope to affect profoundly the course of Canadian art. Very few of the group can paint; very few can draw; very few, indeed, display a scintilla of that imagination and acute power of observation which are among the first requirements of an artist. Not to put too fine a point on it, this aspiring society of stencil-like decorators have strayed from the main current of life into a backwater of their own.

"The Canadian Society [*sic*] of Painters is clearly of that radical wing whose basic belief seems to be that the uglier you make a thing the more truly authentic it is. The truth is that the new society confuses simplicity with loose, distorted drawing, fat pigment and map or stencil-like contours of elementary colors. It is all very quaint, very primitive, very naive—but unfortunately it is not art, nor ever will be. There is a kaleidoscopic impression of plasticine hills, dirty backyards, green doors, cast-iron waves, tumble-down houses in which nobody lives A jazz medley of confused, geometrical designs on canvas."

A.Y. JACKSON *Alberta Foothills* 1937 25x32 McMichael Canadian Collection

Colgate concluded with a gloomy prophecy as to the Canadian Group's future: "It may, in the meanwhile, struggle for an unhealthy sort of existence, but in the end it will die. It will die because the truth is not in it."

Fortunately, there was more truth in the Canadian Group than in Colgate's prediction. It was to survive until 1969, when it came to a dignified end through the voluntary agreement of its members. During the thirty-six years of its existence it played host to virtually every major contemporary artist. All of the pivotal figures of those decades were to exhibit with The Canadian Group of Painters, many of them coming to national attention for the first time through it.

In 1933 Emily Carr, Charles Comfort, Bertram Brooker, Carl Schaefer, Jack Humphrey and J.W.G. Macdonald exhibited with the Group. In 1937 David Milne, John Lyman and Fritz Brandtner showed. In 1939 there were Goodridge Roberts and York Wilson; in 1942 Paul-Emile Borduas and Alfred Pellan; in 1947 Alex Colville and Jack Bush; in 1950 Jean-Paul Lemieux, Jacques de Tonnancour, Jack Shadbolt and B.C. Binning; in 1952 Oscar Cahen, Leon Bellefleur, Gordon Smith, Harold Town and William Ronald; in 1956 Tom Hodgson, Dennis Burton and John Meredith; in 1957 Roy Kiyooka; in 1959 Graham Coughtry; in 1966 Jack Reppen and Iain Baxter. And in 1967 there was Guido Molinari. Many artists remained members until their deaths, or until the Group was disbanded in 1969.

The anonymous foreword for the 1933 catalogue of the first Canadian Group of Painters exhibition remained a fair statement of its aims and achievements throughout the thirty-six-year span of the organization: "Its policy is to encourage and foster

FRANKLIN CARMICHAEL *Northern Tundra* 1931 30x36 McMichael Canadian Collection

the growth of Art in Canada which has a national character, not necessarily of time and place, but also expressive of its philosophy, and wide appreciation of the right of Canadian artists to find beauty and character in all things. To extend the creative faculty beyond the professional meaning of art and to make it a more common language of expression is also a part of its aim. Hitherto, it has been a landscape art, typical of all new movements, but . . .figures and portraits have been slowly added to the subject matter, strengthening and occupying the background of landscape. Here also more modern ideas of technique and subject have been brought into the scope of Canadian painting, keeping the art in the van of our forward stride as a nation."

This was hardly an eloquent or breathtaking declaration of freedom, but in its dogged way it did bring forth a fresh tolerance, and offered a totally open-ended structure upon which exhibitions of The Canadian Group of Painters could build in the future.

Painter Pegi Nicol summed up the spirit of the new Group in a more lively fashion in an article published by the *Canadian Forum* in April 1936:"Where is the burning snow, the passionate hill of the earlier day of Canadian art? This, the second exhibition of The Canadian Group of Painters, is a remarkably summery green. Through the latter day group of artists budding from the Group of Seven comes maturity to our national art movement. The life of a school of art fades from a vigorous primitive to refinement and subtlety. Our art has become both subtle and intimate."

As the Canadian Group continued, the more alert reviewers increasingly recognized its importance. Reviewing The Canadian Group of Painters exhibition held in Toronto in November

ARTHUR LISMER *Glacier above Moraine Lake* 1928 40x50 Art Gallery of Hamilton

1937, Graham McInness wrote in *Saturday Night*: "The dominant note of the third exhibition of the Canadian Group of Painters, at the Art Gallery of Toronto, is one of indecision. Yet this very indecision tells us so much about the present state of creative Canadian painting, hints so clearly at trends within the next few years, that it is in some respects more satisfying than complete certainty, and makes the exhibition, despite its very uneven quality, extremely important.... For all this, you will find among the works of these fifty-nine painters, most of the significant art which is being produced in the Dominion today. While there are sufficient canvases of real greatness to make one sanguine as to the future."

Thirteen years later, Pearl McCarthy stated in *The Globe and Mail* (November 11, 1950): "No matter how many less sensational exhibitions arrive on gallery walls, you cannot size up the health of Canadian art without a good look at the Canadian Group of Painters whose exhibition opened last night at the Art Gallery of Toronto...this Canadian Group show ranks as vastly important and gives unequivocal proof that liberalism in Canadian art has proud, sound bases. The best of the Canadian Group have gone ahead of the man in the street, but have not tried to cultivate a ground which the average man could not possibly share. That is leadership and what makes a classic."

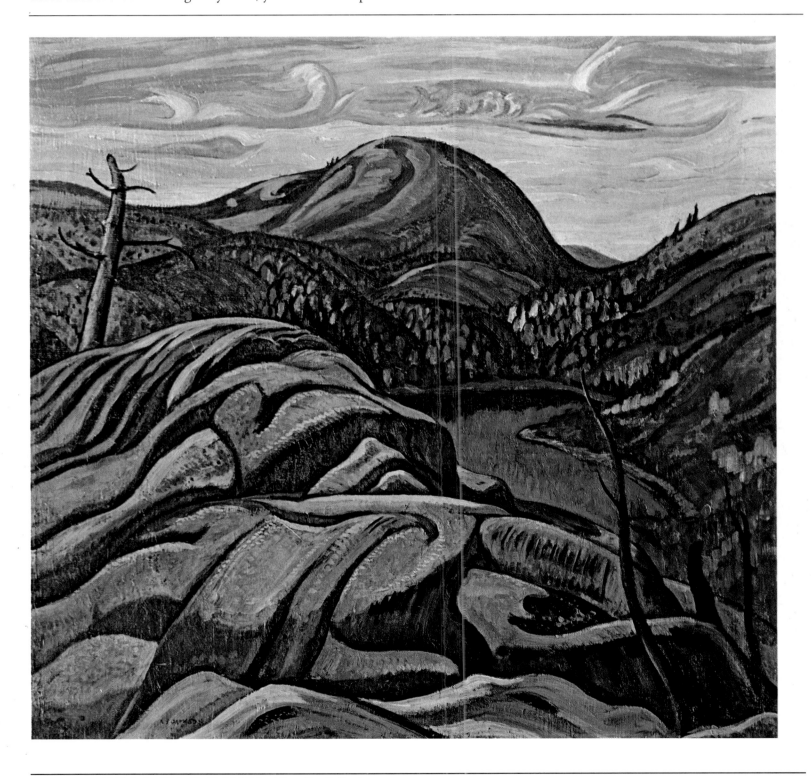

A.Y. JACKSON *Nellie Lake* 1933 32x30 McMichael Canadian Collection

2 / The Forerunners

By 1933, most of the members of the original Group of Seven had reached their zenith. J.E.H. MacDonald, whose painting was at its peak in 1919 and 1920, had died in November of 1932. Franklin Carmichael, A.Y. Jackson and Arthur Lismer had produced what were to be their most significant works, and continued later to create in what was already a fairly set style. Jackson visited new places but added little to his creative vocabulary. Lismer loosened his brushwork in some of his later canvases of Georgian Bay, the Maritimes and British Columbia, but his essential approach to colour and composition remained the same. If any change could be noted it would be in his point of view. In his later works, Lismer frequently closed in on his subject matter, so that we get highly textured and detailed studies of shells, boulders, vines and branches, typified by such canvases as Canadian Jungle of 1946, (McMichael Collection).

Of the original Group, only Fred Varley and Lawren Harris continued to enrich and extend their aesthetic range significantly.

Fred Varley's art was regularly undergoing change. His colour grew in intensity and freshness through the thirties and forties. The magnificent canvas The Open Window (Hart House Collection), which was his first exhibit in 1933 as a member of The Canadian Group of Painters, revealed a new subtlety and resolution of design and chroma. It is utterly without the crusty surface manner which sometimes marred his earlier pictures, and caused them to appear forced and mannered. The Open Window is a perfect meeting of technique and mood, the quietness of the scene and the reticence of the brushwork composing a triumphant and inevitable unity.

The mystical quality of The Open Window was to be maintained in pictures which Varley was to exhibit with The

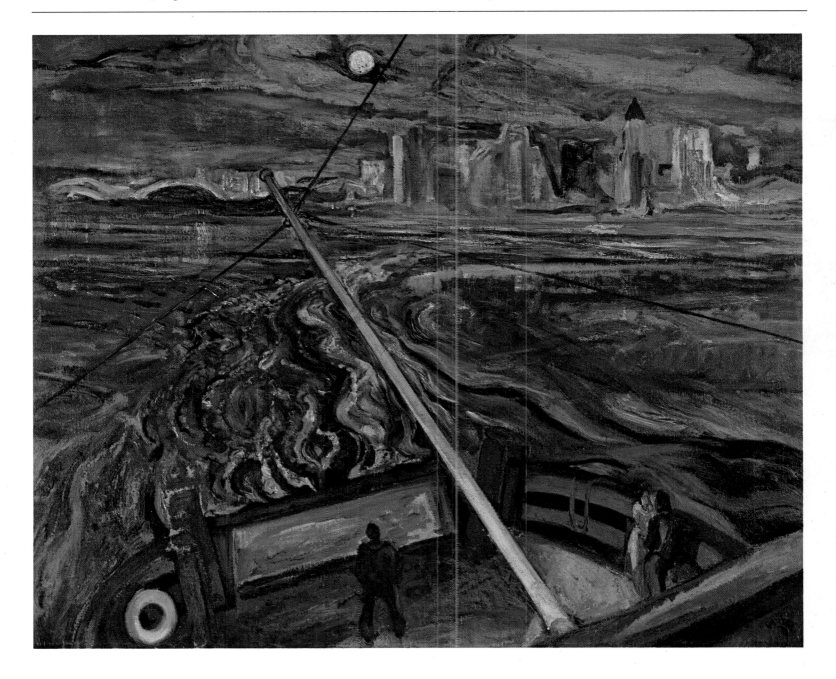

F.H. VARLEY *Night Ferry Vancouver* 1937 32x40 C.S. Band Collection

Canadian Group of Painters. His abstract use of colour continued to be heightened from painting to painting. Varley often spoke of the colours on his palette as "spiritual equivalents," and would hold forth for long periods about the "mystery and majesty" of cobalt violet, the "purity" of emerald green and the "romance" of aureolin yellow. This preoccupation with the subjective nature of colour shines out of his most successful landscapes and portraits, particularly those of women. In such works as Night Ferry, Vancouver (C.S. Band Collection), Sea Music (Alan Manford Collection) and Woman in Green (C.S. Band Collection) abstract colour is provocatively contrasted against a vigorous but almost academic precision of drawing.

Varley easily made the move from the landscape-preoccupied Group of Seven to The Canadian Group of Painters' wider thematic interests. Although creatively very much of a loner, his concern for new talent and his ever-youthful outlook on life assisted many of the younger members of the Canadian Group to find their confidence (as Jock Macdonald, Jack Nichols and other artists were always ready to testify).

Lawren Harris was the true architect of the new Group. In characteristic fashion he planned and promoted its success. His home was not only the site of the meeting which brought the Canadian Group into being, but was also a place where a variety of his painter contemporaries came to discuss problems of painting and creative philosophy. Harris' interests ranged over a wide spectrum of aesthetic and intellectual matters, embracing music, literature, theology and science, as well as art. His breadth of mind and generosity of spirit were to sustain other Canadian artists, physically and morally, over many years. Emily Carr

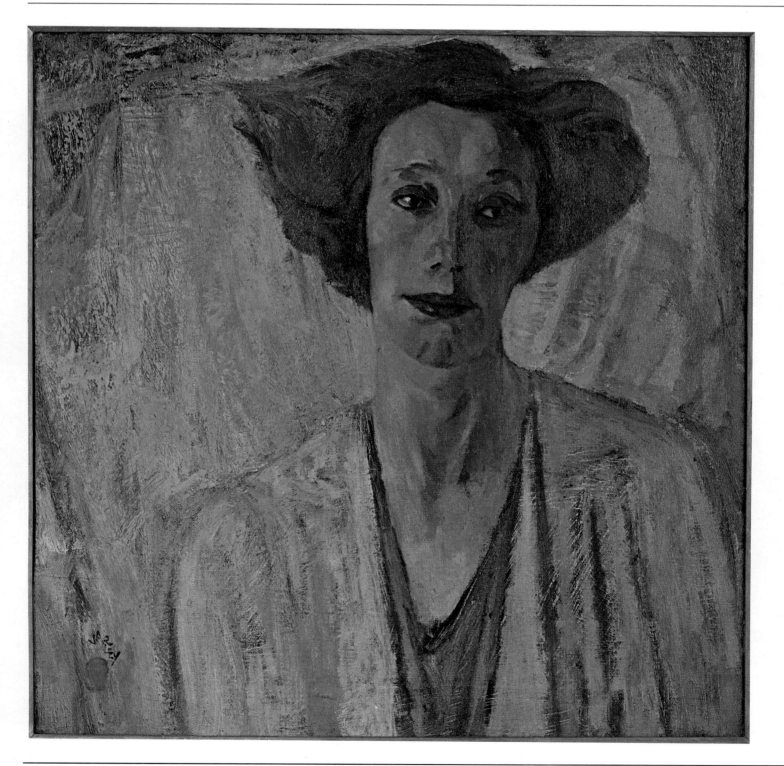

F.H. VARLEY *Woman in Green* 1949 20x20 C.S. Band Collection

was among those whose careers were made easier by Lawren Harris' eye for talent and constant concern for the welfare of those who possessed it.

As an artist, Harris had already shifted away from the muskeg and spruces of his Group of Seven days by the time The Canadian Group of Painters came into being. By then, he had moved into the almost monochrome, semi-abstract blue studies of Arctic solitude which were to lead him eventually into abstraction. Such canvases as Greenland Shore, shown by Harris in The Canadian Group of Painters exhibition of 1936, were the forerunners of his eventual expeditions into pure design. The simple planes of sky and water, the isolation of ice-formed shapes and lack of material texture that marks the extremes of the Arctic confirmed a direction and instinct for pure design that had long intrigued him.

Harris' interest in the Arctic as subject matter had unquestionably been stimulated by his association with the American artist, Rockwell Kent, who had been painting in Alaska and Greenland since before 1917. (Some of Kent's canvases of the 1917-1920 era can easily be mistaken for Harris paintings of the post-1930 period.) The American was a frequent guest of Lawren Harris during the 1920's and often visited the Studio Building, where many of the Group of Seven had their quarters. During this period, Kent delivered a number of lectures in Toronto at the local Eaton Auditorium, under the auspices of the Art Gallery of Toronto. One of these lectures, "Cold Feet and Warm Hearts in Greenland," was advertised by the Art Gallery as "one of the outstanding events of this season."

Harris' inclination toward abstraction was also fed by a close friendship with Bertram Brooker, who had been experimenting

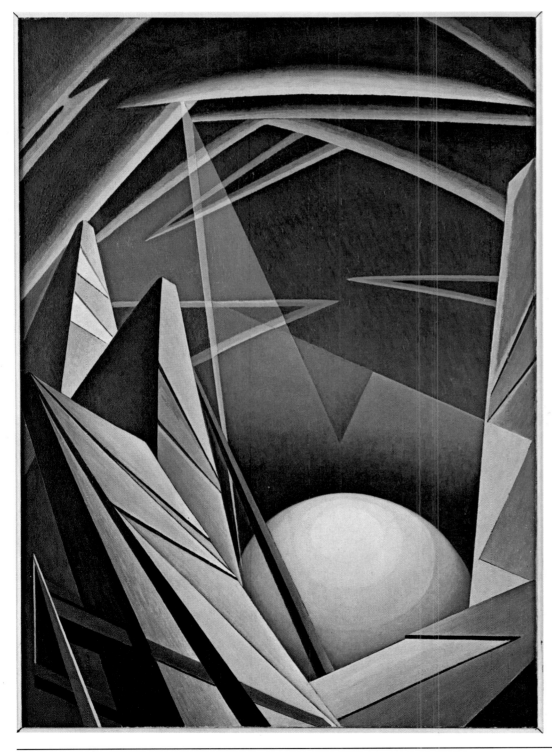

LAWREN HARRIS *Abstract* 1942 42x30 Hart House, University of Toronto

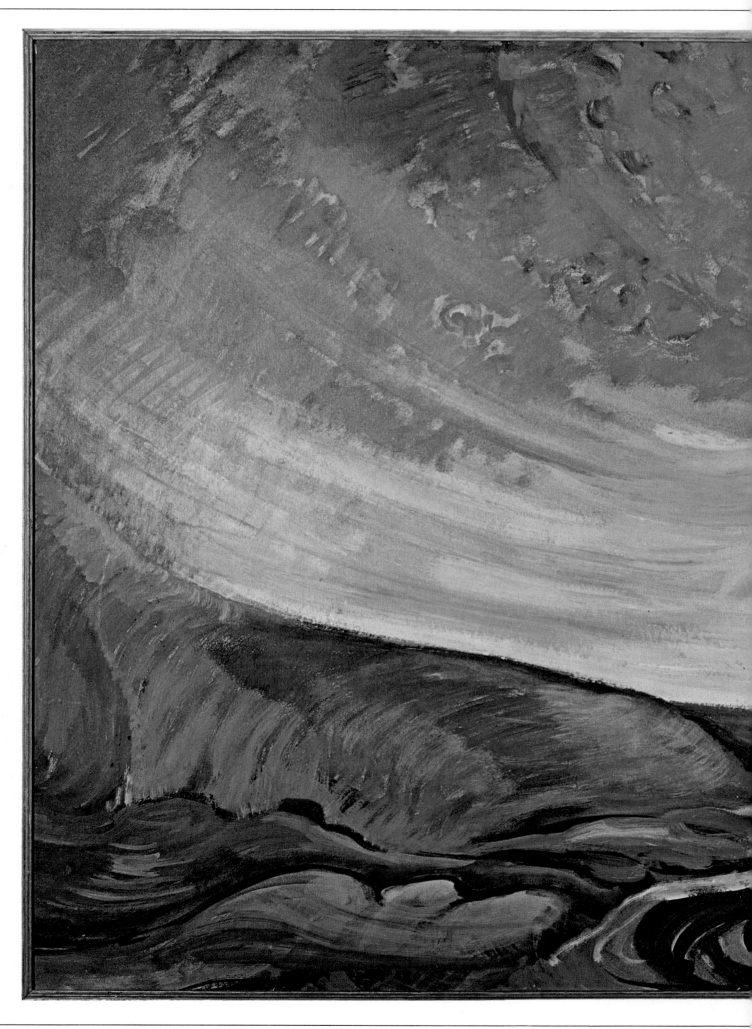

EMILY CARR *Sea and Sky* c.1935 23x35 Collection: Dr. and Mrs. W.H. Clarke

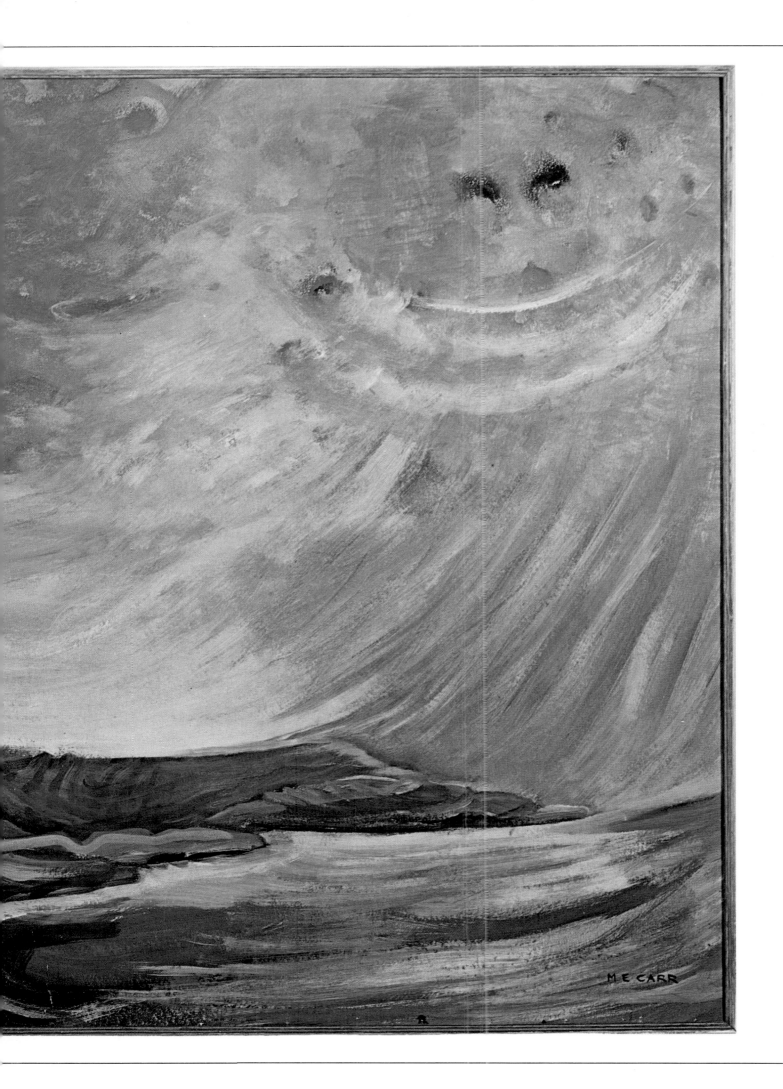

with pure abstraction since the mid-1920's. The two men shared a common intellectual approach to design, combined with a deeply metaphysical preoccupation with the expression of subconscious and spiritual concepts. (Harris had already reached out into the international mainstream of painting as a member of the Société Anonyme in the late 1920's. Founded by famed collector-patron Katherine Drier, the Société's membership included such notable figures of modern art as Marcel Duchamp, Francis Picabia, Alexander Archipenko and Max Weber.)

Harris' commitment to abstraction was finally sealed when, for personal reasons, he left Canada in 1934 to live in the United States. He first settled in Hanover, New Hampshire, where he did his earliest experimental abstracts, and then, in 1938, moved to Santa Fe, New Mexico. Santa Fe was the head-quarters of the Transcendental Painting Group, and Harris

readily joined that somewhat esoteric band of abstract and semi-abstract artists. From that time on, his painting remained almost solely abstract.

He first exhibited an abstract canvas in 1937 in a Canadian Group of Painters show. In that work—Composition No. 8—there remained only the barest bones of identifiable landscape. From then on, his offerings to Canadian Group exhibitions, from War Painting in 1944, to Migratory Flight in 1956 and The Way in 1966, were almost consistently non-figurative.

Response on the part of museums, collectors and the general public to these paintings was indifferent but the reaction of some of his artist colleagues was much more positive. Yvonne Housser, a fellow founding member of The Canadian Group of Painters, praised the Harris abstracts in her review of the Canadian Group show of 1944 (*Canadian Art*, April/May,

LAWREN HARRIS *The Bridge* 1937 15x12 R.G.P. Colgrove Collection

LAWREN HARRIS *Abstract Vertical* c. 1940 43x22 Art Gallery of Hamilton

1944): "They need contemplation to let their quality seep into the consciousness. Looking at these paintings is akin to listening to fine music."

A good deal of careless dating has been done, and much nonsense written about Harris' approach to his own abstracts and his adoption of the colour theories of the Russian pioneer, Wassily Kandinsky. Harris himself denied this, as "reading into my pictures after the fact." He was, indeed, a highly intuitive colourist and his main concern was simply to bring about a "right relation," as he phrased it, between the hues in a given composition. Nor did Harris usually have a preconceived idea behind his abstractions. At times, as in In Memoriam to a Canadian Artist (1950), this occurred, but generally the artist claimed that his abstract compositions, certainly the later ones, were the result of intuition and executive control—and nothing more.

Harris' transition to abstraction seemed inevitable throughout his career. As I wrote of his Arctic canvases in an essay for the catalogue of the National Gallery's 1963 Harris Retrospective Exhibition: "He had moved from the tender intimacy of tiny, peopled dwellings to an empty world where he was almost the sole witness. He had withdrawn away from the world of habitations and more and more into his own spiritual resources. His entry into the field of abstraction now seemed a foregone conclusion."

Harris' capacity for change is almost humorously revealed in a series of statements he made about abstract art between 1948 and 1954. In a note for the 1948 catalogue of his retrospective exhibition, organized by the Art Gallery of Toronto, he wrote: "Abstract paintings are of two kinds." In a later article for the *Royal Canadian Architectural Institute of Canada Journal*,

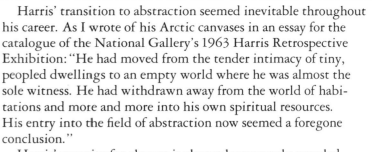

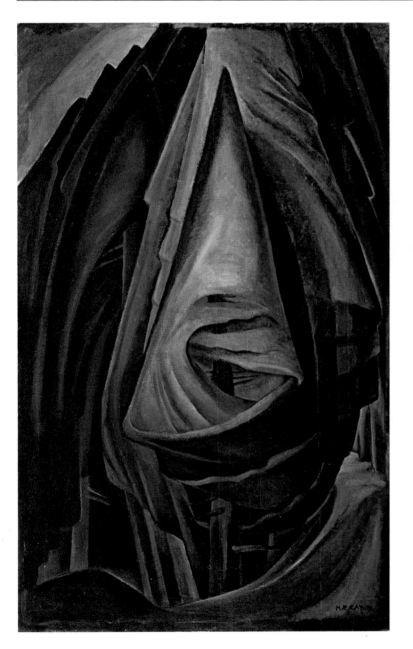

EMILY CARR *Grey* c. 1931 44x27 C.S. Band Collection

EMILY CARR *Kispiax Village* 1929 36x49 Art Gallery of Ontario

in 1949, he stated: "There are *three* main kinds of abstract painting." By 1954, in a further revision of the same article, he proposed: "There are *four* main kinds of abstract painting." It was just this capacity for change and growth that marked Lawren Harris as this country's most complete artist of his generation. It was also this flexibility that makes it possible to call him the father of The Canadian Group of Painters. He inspired its birth and remained loyal to it as a member and exhibitor until the end of his career.

No Canadian painter has been more literate about his own painting and art generally than Lawren Harris. He possessed an unrivalled perspective on the changes that have taken place in twentieth-century Canadian painting. He had personally experienced these changes and spoke of them with authority.

Lawren Harris' willingness to move into new creative adven-

tures is perhaps most eloquently expressed in his essay on abstract painting, which was published by Rous and Mann Press in June 1954, when the artist was sixty-nine years old. His definitions of abstract styles remain useful and valid today: "There are four main kinds of abstract painting. The first is when the painting is abstracted from nature. That has been going on in part for a long time. Most of the great artists of the past had looked beyond the appearance and 'abstracted'—that is, they extricated from the surface plenitude of nature its essential forms in order to give their works a basic aesthetic underpinning, and thus a greater coherence and unified force of expression. They were at the same time, however, dedicated to a recognizable representation of the world we see.

"The second kind of abstract painting is non-objective in that it has no relation to anything seen in nature. It does, however,

A.J. CASSON *Winter Sun* 1961 40x30 Toronto-Dominion Bank Collection

contain an idea, a meaning, a message. This meaning, idea or message dictates the form, the colours, the aesthetic structure and all the relationships in the painting, the purpose being to embody the idea as a living experience in a vital, plastic creation.

"The third kind of abstract painting is simply a fine organization of lines, colours, forms and spaces independent of anything seen in nature and independent of any specific idea or message. In the best paintings of the late Dutch artist Mondrian, for instance, there are severe, exact and beautiful proportions carried to the last degree of simplicity and perfection. These and others of their kind may seem arid at first, but on attentive acquaintance they can move one into a rewarding satisfaction.

"The fourth and most recent kind of abstract painting is called abstract expressionism and today [1954] engages the attention of many modern artists. It has increased the range of possible subjects in art beyond anything known before.... Every style is of course a limitation. But recent expansion of abstract painting into the realm of abstract expressionism has led artists to employ many different styles and invent new ones to accommodate the great increase in expressive visual ideas."

□ In writing of expressionism, Lawren Harris might easily have had his friend Emily Carr in mind. Emily Carr, during her final creative years, in fact, achieved the most intense peaks of expressionism ever seen in Canadian art. Nothing so sweeping in emotional power had been seen in our national art before, and few landscape painters anywhere had wrought more dramatic images from earth and sky. Emily Carr courted the lights and shadows of the darkling British Columbia forests; she coaxed its moods, brooding or sun-shot, on to paper and canvas. Toward the end of her long career, she virtually tore the spirit

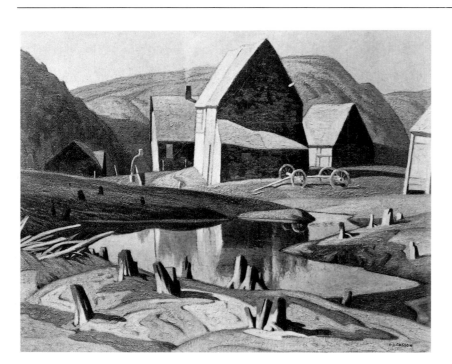

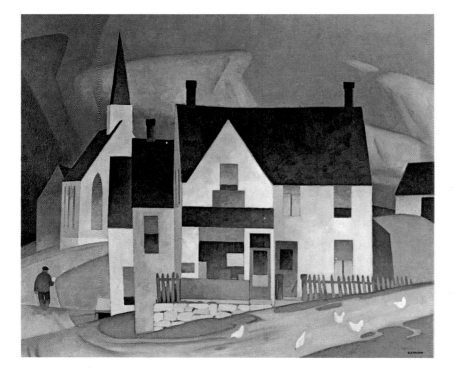

A.J. CASSON *Frosty Morning* 1949 24x30 Private Collection
A.J. CASSON *Country Store* 1945 30x36 Art Gallery of Ontario

from the forest with her voracious need to set down its soul and substance.

The first paintings of Emily Carr exhibited with The Canadian Group of Painters were her masterpieces, Indian Church and Wood Interior. The Group offered the great, solitary artist her only national showcase at that time, and she sent her magnificent, unheralded compositions to exhibition after exhibition. Mountain, Swirl, Little Pine, A Rushing Sea of Undergrowth, Old and New Forest—these were some of the then-strange green icons she shipped to Toronto and Montreal where the exhibitions were being held. In the 1936 Canadian Group catalogue her Wood Interior and The Forest were priced at forty dollars each, and a third canvas, British Columbia Landscape, was on loan from the collection of C.S. Band, the first collector to acknowledge and support her genius. It was her membership in the Group and the encouragement she received from it—particularly from Lawren Harris—which helped to give the valiant and dedicated genius the courage to continue painting during the trying period of the thirties.

Anyone who questions the importance of the Canadian Group to many artists at that time need only read Emily Carr's journals. To attend its first exhibition in Toronto, she travelled across the continent from her home in Victoria. On that 1933 trip, she spent nine days in Toronto visiting with Harris and other members.

On Tuesday, November 7th, *en route* to Toronto, she wrote in her journal (later published by Clarke Irwin under the title *Hundreds and Thousands*): "I do look forward to seeing those dear folk in Toronto, and their pictures and to some inner talks about all the best things."

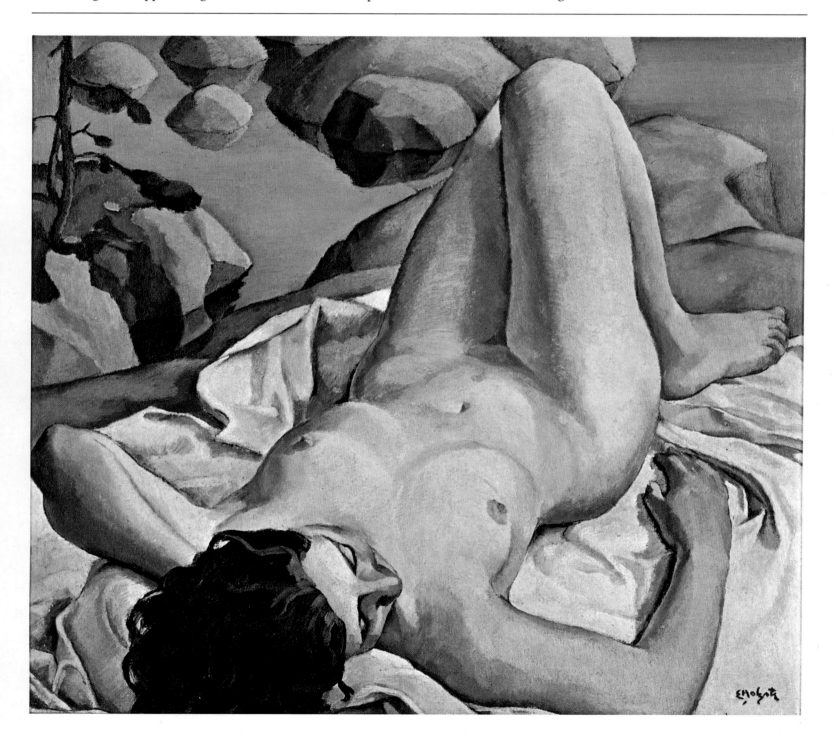

EDWIN HOLGATE *Nude* 1930 26x29 Art Gallery of Ontario

Again, about a gathering with members of the Group, she wrote on November 10th: "It is a rare thing to be in a company of doers instead of blown-out air cushions. At home I want to sneak off and yawn but this party lived."

On November 17th, getting ready to return to Victoria after the opening of the show, she enthused: "Now I am going home happy, contented, equipped for further struggle.... There was a rounded out completeness about this visit—nine days of refreshing content spent with those toddling along the same path, headed in the same direction. And I was one of them. They accepted me. My own two pictures [In a Wood, British Columbia and The Mountain] (they did not hang the third) were very unconvincing hanging there. To a few people they spoke, saying nothing but hinting at a struggle for something."

Despite her personal modesty, Emily Carr had taken heart from her contacts with the other members of the Group. That organization was obviously fulfilling its declared aim "to encourage and foster the growth of Art in Canada."

Emily Carr's dependence on Lawren Harris' good opinion was crucial. In October 1933, she wrote in her journal: "Didn't I see my way through Lawren? Didn't I know the first night I saw his stuff in his studio that through it I could see further? I did not want to copy his work but I wanted to look out of the same window on life and nature, to get beyond the surface as he did."

Emily Carr's greatest teacher was nature, within and without. She returned from her painting trips each night, emptied physically and emotionally, yet the next morning she would go back to her trees and totems. On June 17th, 1933 she wrote: "What is it you are struggling for? What is that vital thing the woods contain, possess, that you want?"

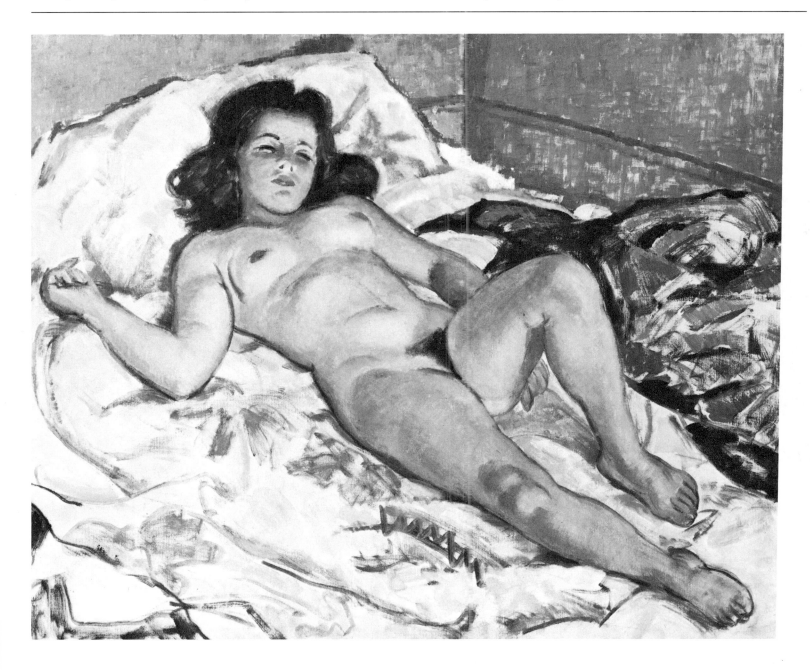

RANDOLPH HEWTON *Slumber* c. 1935 32x40 McMichael Canadian Collection

Clearly, Emily Carr could not answer her own question in words, but she did, triumphantly, in paint. From her famous Indian Church (exhibited in the Canadian Group Atlantic City show, 1933) onward, her art was a pursuit to find the image of her own soul in the landscape of her native British Columbia. Until her death in 1945, she dedicated herself to that purpose. I wrote in a *Saturday Night* review of the great 1945 exhibition of her work at the Art Gallery of Toronto: "Her Indian Church reveals her search for those deliberate juxtapositions of shapes which would provide her paintings with the maximum interplay between volumes moving in and out, and across, the picture plane.

"In fact, this elasticity of volume movement eventually led her, in her last canvases, to seemingly abandon all concern for space design and to slash on her compositions in purely linear rhythms. Here, her earlier concentration upon harmonic space variations stood her in good stead, and her search for more intense rhythms, even at its wildest, rarely destroyed the prevailing architectonic structure."

The last, vehemently vital period of Emily Carr's work strikingly recalls the last, abstractly rhythmical period of another great artist—Turner. Such Turner oils as Snowstorm at Sea and Rain, Steam and Speed complement Emily Carr's A Rushing Sea of Undergrowth and Scorned as Timber, Beloved of the Sky. Both of these artists, in their late years, seem to have been stimulated into a riotous affirmation of the forces of life. Their positive affirmations were a defiance of death. This element seems to characterize the last works of most solitary creators. Carr, Turner, Michelangelo, Van Gogh were far apart in total achievement, and had widely differing life spans, but

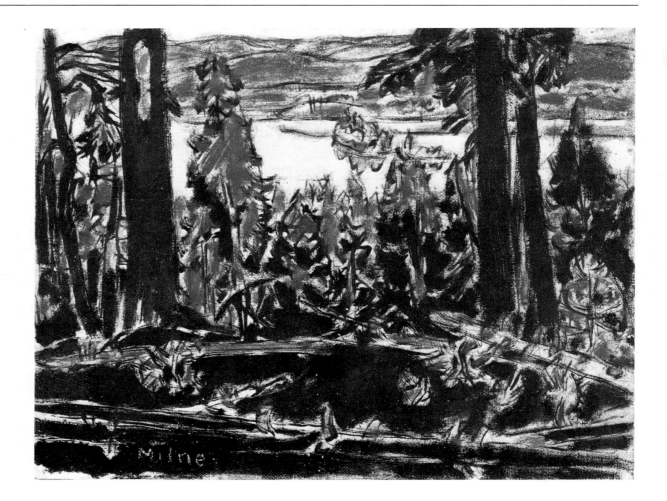

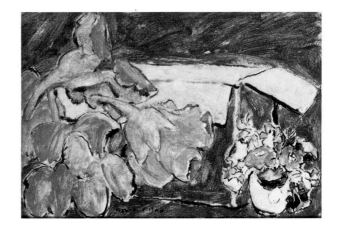

DAVID MILNE *Painting Place: Brown and Black* c. 1926 12x16
McMichael Canadian Collection

DAVID MILNE *Nasturtiums and Carton* 1937 18x26
McMichael Canadian Collection

the last few years of each were marked by a sudden loosening and intensification of their styles as though, prescient of their end, they clung more passionately to the sources of life through the one thing they had to love and possess—the medium in which they created.

Like most prodigious producers, Emily Carr was sometimes capable of hurried and tentative works. But in such canvases as Vanquished, Scorned as Timber, Study in Movement and Grey she gave us the fruits of a highly original vision. She created a new and unique world for the imagination to dwell in and the eye to dwell upon.

Though she could not realize in words equivalents for her paintings, Emily Carr did accidentally produce an indelible self-portrait when she wrote in her journal on November 8th, 1933:

"I like to travel alone, to sweep along over space and let my thoughts sweep out to it. They seem to be able to go so far over the open, flat spaces that run out and meet the sweep of the sky and the horizon like body and soul meeting, the great sky illuminating the earth, the solid earth upholding the sky."

□ Alfred Joseph Casson, who had joined the Group of Seven in 1926, was also a founding member of The Canadian Group of Painters. Throughout his long career, Casson has, for the most part, divided his attention between Northern Ontario landscapes and Southern Ontario villages. His early work, prior to the mid-1920's, was closely based on the examples of Franklin Carmichael and Tom Thomson. Although he studied briefly at the Toronto Central Technical School and the Ontario College of Art, Casson developed as a painter only after his meeting with Carmichael in 1919. He worked for Carmichael as an assistant designer for several years, and his employer taught

EDWIN HOLGATE *Uncle George* 1947 28x24 Art Gallery of Hamilton

him the basics of watercolour painting and pictorial composition. It was through Carmichael that Casson met the members of the Group of Seven.

Casson's crisp, personal style first emerged in 1924, and shortly afterwards he painted the first of his hundreds of impressions of rural Ontario communities. In my book on Casson I remarked: "The village allowed full play for his acute sense of pattern, permitting him to counterpoint sharply defined colours and shapes against one another into telling transformations. . . . Although he is not a painter of people, Casson has always been aesthetically concerned with structures possessing overtones of human drama. Churches, stores, village meeting-places—wherever the inhabitants congregate for religion, commerce or politics."

Among Casson's major works to appear in Canadian Group shows were Magnetawan (1933), Elms (1933), Aftermath (1936),

Autumn Evening (1939), Summer Storm (1942) and Country Store (1946).

Like Casson, Edwin Holgate was a late addition to the Group of Seven, and a founding member of The Canadian Group of Painters. Holgate has been the least prolific of that original Group and most of his major paintings were done during the 1930's and early 1940's. Like many early Canadian Group members, Holgate was a student of William Brymner in Montreal, and studied in Paris at the various academies. He has remained devoted to a brisk and direct kind of figurative painting throughout his career. His reputation has been based mainly upon a group of statuesque nudes portrayed in outdoor settings, suggestive of the Laurentians or Northern Ontario.

Holgate's work appeared regularly with The Canadian Group of Painters until the late 1940's (his portrait, Uncle

DAVID MILNE *Scaffolding, Yonge Street* 1947 18x24 Art Gallery of Ontario

George, was shown in 1947) and, like so many of the forerunners, carried on an earlier tradition.

☐ David Milne exhibited his canvases Bare Rock Begins to Show, Raspberry Jam, and Scaffolding, in the Canadian Group shows of 1937, 1939 and 1947. Since he was very much of a loner, his submissions to the Canadian Group reflected its reputation among independent Canadian artists.

Milne was one of the most original of this country's painters. He combined a unique sensibility and technique to compose canvases which state the most profound pictorial truths with a minimum of pictorial verbiage. He studied his themes, lived with them and became virtually one with them, before he took his brush in hand to execute those many masterpieces which are among the richest jewels of all our artistic legacy. Whether he involved himself with a simple shoreline, a bowl of poppies or a box of toys, Milne gave each such a personal stamp that we are made to see such things anew.

Quiet, and as sparse of words as he was of brush strokes, David Milne, like Emily Carr, was a silent giant of Canadian art. Without fanfare, without screaming for public attention, without controversy, he gathered a small but intensely loyal audience during his lifetime, which has since grown to legions. It is a paradox that Milne is one of the most truly Canadian of painters, and at the same time, more deserving than almost any artist of his nation of international attention. As a painter in watercolour or oil and as a print-maker, Milne truly deserves a special place in the mainstream of twentieth-century art.

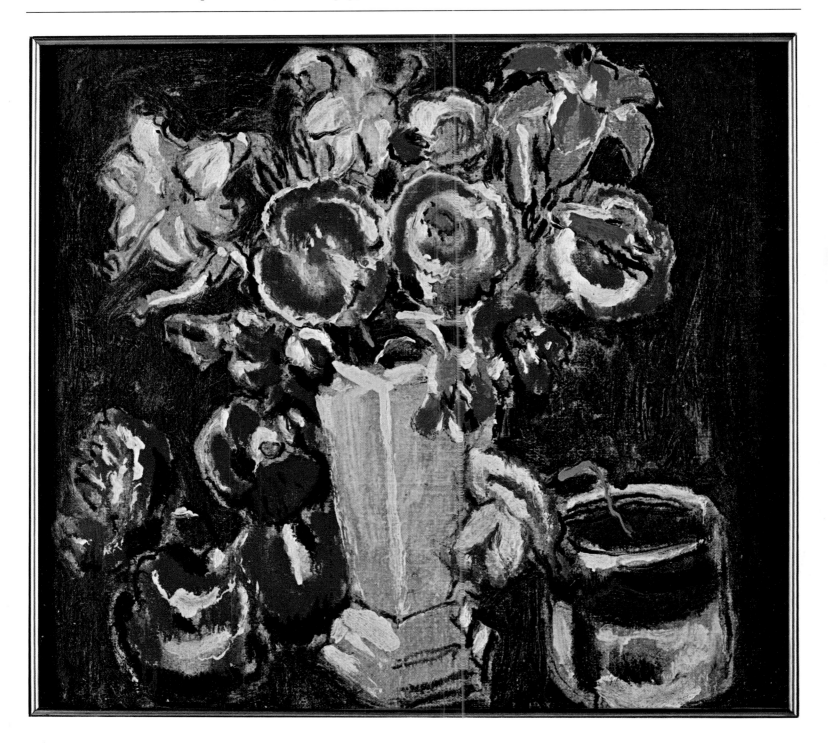

DAVID MILNE *Poppies and Lilies* 1944 18x16 Collection: Mr. and Mrs. Max Merkur

3 / A fresh outlook

Despite the omnipresence of the Group of Seven during the 1920's, by 1930 many younger painters had developed a very personal approach to Canadian landscape. Their paintings not only utilized new styles and techniques, but represented a very different kind of topography, often one much closer to their own homes.

The Ontario landscapes of Carl Schaefer, for example, emerged from the sure knowledge and quiet affection of one who was a native son of the area he portrayed. Schaefer did not feel the need to pack knapsack, shoulder canoe and travel hundreds of miles in search of subject matter. He found his most rewarding material just beyond his own back door, among the ploughed fields, apple orchards and weathered farmhouses of Bruce and Grey Counties near his Hanover birthplace.

In an era when the word "regional" has often been used in a derogatory way, Carl Schaefer has always readily confessed to being a regional painter. He has said: "I find that the best subjects for me are concentrated in a pretty small area." Within his own small area, around Hanover, between 1930 and 1940, Schaefer created some of this century's best Canadian landscapes. His minimal palette, dominated by earth colours, seemed ideally suited to his themes. He counterposed earthy ochres and siennas against the bruised blues of storm clouds or the silvery grey mist of morning. He painted the flat fields of Hanover in all seasons, but his finest early works are of spring and harvest time.

Schaefer was represented in Canadian Group exhibitions from the very first, and his presence symbolized a fresh approach to landscape painting which was shared by many of his fellow exhibitors. His Summer Harvest, in the 1936 show, struck a near-Gothic note with its dramatic backlighting, and aroused

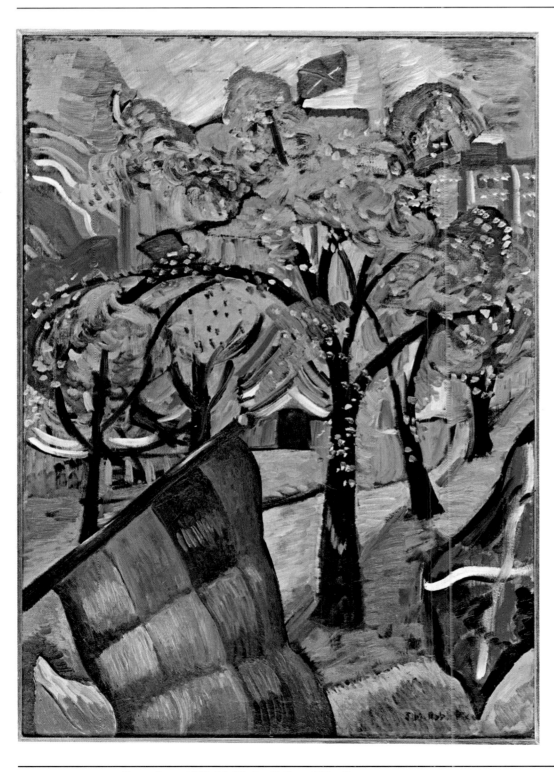

SARAH ROBERTSON *Coronation* c. 1937 33x24 Art Gallery of Hamilton

a storm of protest in the press. It seems surprising now that this canvas should have been the object of cartoons lampooning it, but such facts underline the rapidity of changing values in the twentieth-century art scene. Schaefer is now primarily known as a watercolour artist, but a number of large oil canvases paralleling Summer Harvest were created during the 1930's. The quality of the best of these causes regret that they number only thirty-two, all executed before 1941. Those exhibited with Canadian Group shows included Spring Plowing (1935), Harvest Festival (1936), The Willows (1936), and Wheat Field, Hanover (1936).

Schaefer has always spoken fluently about his craft. Perhaps he best sums up his own approach to art when he says: "I know the land I paint. I know it intimately and have known much of it since I was a child. I rarely look at it directly while I am painting. It is to render that space and the light that strikes through it which are my prime goals. For this, it does not matter whether the subject is a wheat field, a barn or a bowl of apples."

☐ Nine of the founding members of The Canadian Group of Painters were women. Two of these, Yvonne McKague Housser and Isabel McLaughlin, had already followed the Group of Seven northward to the mining country of Cobalt. Yvonne Housser taught at the Ontario College of Art, and brought to her portrayals of the wilderness a highly sophisticated art background that included classes at the Académie Grande Chaumière and the Académie Colarossi in Paris. There she had worked, over a four-year period, under such great teachers as Lucien Simon and Maurice Denis. Subsequently, in 1930, she had studied in Vienna. It was thus a desire to contribute to a native Canadian school of

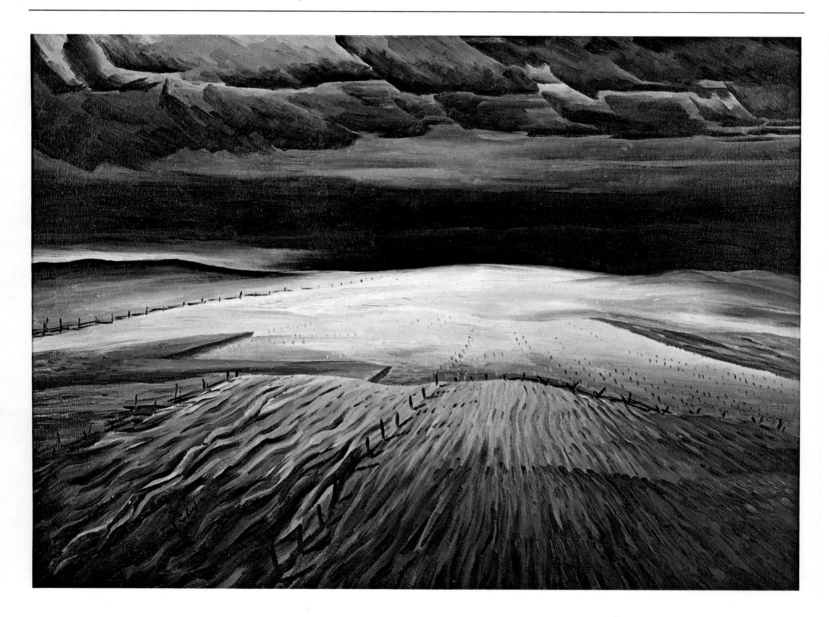

CARL SCHAEFER *Storm over Fields, Hanover* 1937 27x37 Art Gallery of Ontario

art, and not necessity, which brought her to portray northern communities of Ontario. Concerned with the North as an inhabited place, however sparsely populated, she painted the mining towns and Lake Superior villages, with their clapboard wooden structures, as outposts of human determination, as they certainly were in the desperate 1930's. The green, yellow and powder-blue houses seemed to cling to their barren foundations like limpets. At their best, her Cobalt canvases rival the desolate, empty-eyed structures of Lawren Harris' Halifax period.

Yvonne Housser soon left the influence of the Group of Seven behind her, and by the time The Canadian Group of Painters was formed she had found her own subjects and an increasingly personal style. She painted a series of Indian studies which appeared in Canadian Group shows of 1937 to 1942. She also exhibited such overseas canvases as Views of Cornwall. During the 1940's, her landscapes became increasingly imaginative in formal structure and colour, and since then she has divided her art between figurative compositions and totally abstract canvases. ◻ Isabel McLaughlin possessed the most original vein of fantasy of all the Canadian Group founders. The very titles of her contributions to the first Toronto exhibition—Grey Ghosts of Algonquin, Little House at Night, Looking Down—suggest the light, imaginative bent of her talent. Although she studied widely, both at home and abroad, the Oshawa-born artist retained, throughout, her consistent personal wit. Her early mining-town canvases are of structures highly coloured and lit by her imagination. They are comparable to the work of such American fantasists as Arthur Dove and Joseph Stella, and perhaps Georgia O'Keefe.

The impact of Isabel McLaughlin's art brought her wide

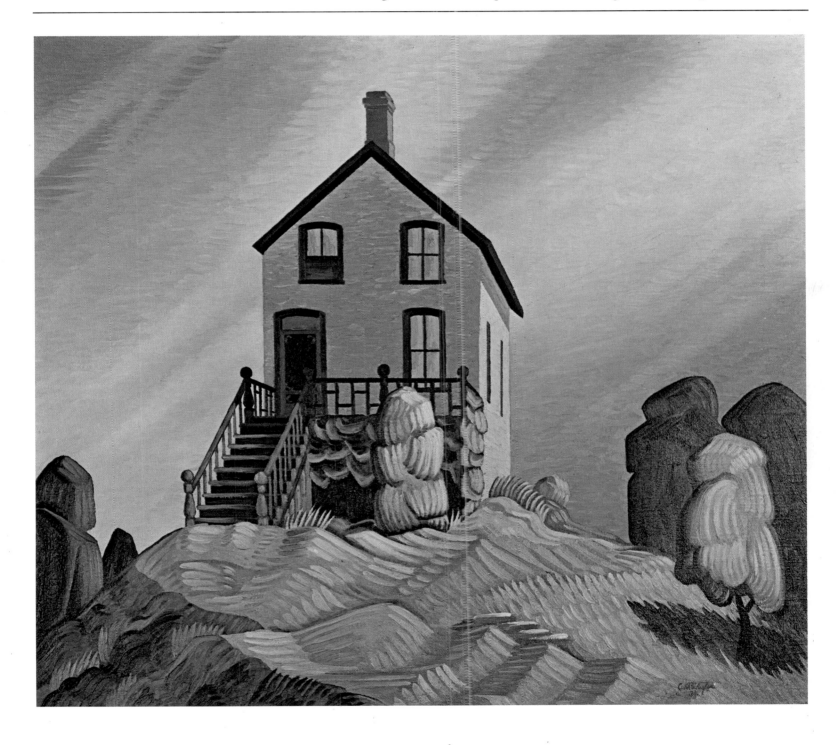

CARL SCHAEFER *House on the Hill* 1934 34x38 Collection: The Artist

attention in 1936 during a Canadian Group show, when her painting, Tree, was attacked by cartoonists and writers in the daily press. In the years since, she has continued to portray her world with a light and fanciful brush.

□ An artist who shared Isabel McLaughlin's bent for caprice in art was Sarah Robertson. One of the country's most original colourists of her period, she brightened the early Canadian Group exhibitions with a series of luminous, high-keyed canvases. She had a special skill for combining in her paintings rich lozenges of colour with spacial rest periods of black. Like many outstanding Canadian artists of her generation, Sarah Robertson studied at The Art Association of Montreal, under William Brymner (as did A.Y. Jackson, Edwin Holgate, Helen McNicoll, and Randolph Hewton). She was one of the few to continue to live in Montreal until the end of her career. In that city and throughout rural

Quebec, she found the raw material for such canvases as In the Nuns' Garden (1933–Art Gallery of Ontario), Coronation (1937–Art Gallery of Hamilton), and Les Repos (1926–National Gallery of Canada). The National Gallery held a memorial exhibition of Sarah Robertson's paintings in 1951, three years after her death–a richly deserved tribute to her art.

□ Another artist who often painted with Isabel McLaughlin was Prudence Heward, one of the five Montreal women who were among the founding members of The Canadian Group of Painters. (The others were Mabel May, Lilias Torrance Newton, Sarah Robertson and Anne Savage.) In 1920, these five joined with a number of other women artists–all former students of William Brymner–and rented rooms on Montreal's Beaver Hall Hill. Here they shared studios and founded what became known as the Beaver Hall Hill Group.

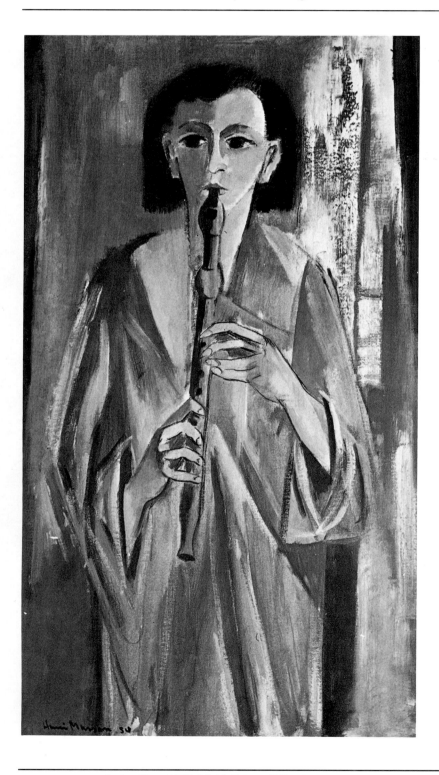

HENRI MASSON *Ancient Muse* 1950 24x14 Private Collection

ISABEL MCLAUGHLIN *The Tree* 1935 80x36 Collection: The Artist

Although this group lasted only a few years, because of financial difficulties, it provided a strong impetus to the careers of many of the finest women painters Canada has so far produced. In addition to the five mentioned above, there were Ethel Seath, Kathleen Morris, Mabel Lockerby and Emily Coonan.

Prudence Heward's career spanned a brief period of less than twenty years. She was only fifty-one when she died, and much of that time was spent in convalescence. Her determination to paint gave her the will to create canvases which were, as her friend A.Y. Jackson has said, "works as robust and vigorous as any in Canadian art." She created figure studies and portraits which surpassed in richness and sensibility most of those by her contemporaries. Among the finest of these are Rosaire (1935—Montreal Museum of Fine Arts), Rollande (1929—National Gallery of Canada), Sisters of Rural Quebec (1930—Art Gallery of Windsor) and Farm House Window (1938).

Prudence Heward often played host to The Canadian Group of Painters at her Peel Street home in Montreal. She continued to support its intentions and activities until her early death. In a review of the memorial exhibition of her work organized by the National Gallery of Canada in 1948, I wrote in *Saturday Night*: "Enchanting is a much misused word, but one which may be fairly applied to this artist's most characteristic works. She has created a world of visual enchantment which is both singular and memorable. Such portrayals as Rosaire, Little Girl with an Apple, Rollande, Farm House Window, and Barbara Heward take their place among the small number of important paintings of people by Canadian artists." In the perspective of Prudence Heward's lifetime, those words still apply.

☐ Both Ethel Seath and Anne Savage spent much of their

YVONNE HOUSSER *In the Park* 1941 24x30 Collection: Mr. and Mrs. Max Merkur

lives pioneering art education in Montreal. In the early part of the century, they brought imagination and freedom to an art curriculum that was still corseted by rigid Victorian discipline. In 1937, they began the classes at the Montreal Museum which were later to be taken up by Arthur Lismer. In their spare time and on holidays, they produced works which were modest, but lyrical. They contributed to The Canadian Group of Painters exhibitions from the very beginning.

Anne Savage, perhaps the more vigorous and productive creative figure of the two, described her own work as "simple statements of things I have seen." Her landscapes were painted in many places, but most of all in the Laurentians the artist knew so well. She added to the Group of Seven landscape tradition a sensitive line and quiet mood that were her very own. ☐ Mabel May and Kathleen Morris were both devoted to

Montreal street scenes, as well as the landscape areas around that city. Mabel May, like so many of her colleagues of the period, was deeply involved in child art education, and supervised the classes at the National Gallery of Canada from 1938 until 1947. Her own painting evolved from an almost pure impressionism to a broad, square-edged style.

Kathleen Morris restricted herself almost exclusively to snowscapes. Her two favourite themes were probably horse stands and the old buildings of Montreal. Her pictorial signature seems to have been blanketed horses and the black silhouettes of nuns, and few of her paintings are without them. ☐ Canada has not produced many portrait painters of distinction. Of these, Lilias Torrance Newton must be ranked among the best. Her compositions have ranged from formal portraits to more relaxed studies of her friends and fellow

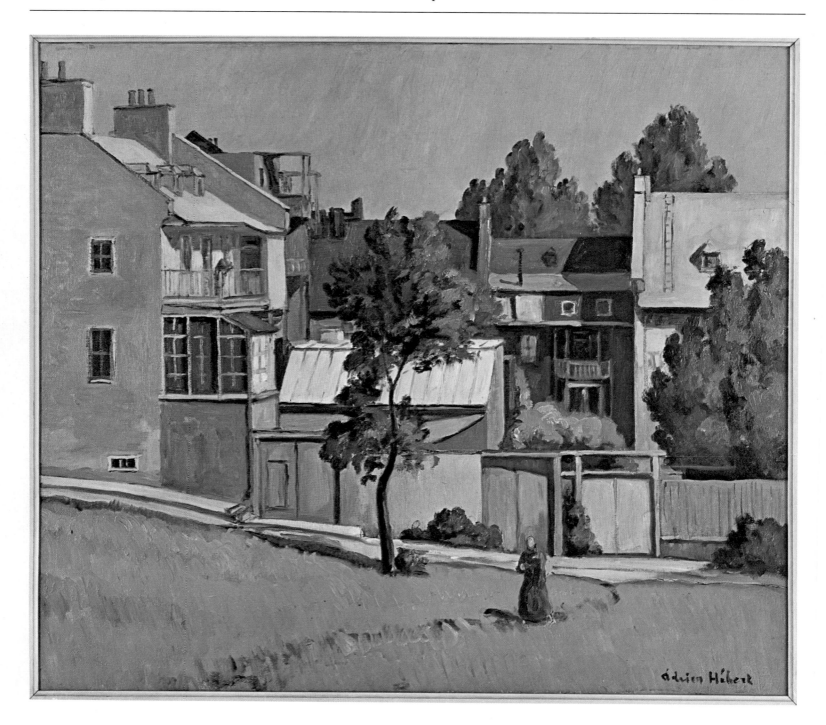

ADRIEN HÉBERT *Back Gardens, Quebec* c. 1946 27x31 Art Gallery of Hamilton

artists. The latter works are of lasting interest and, with a series of incisive nudes that she painted during the thirties, these form a solid contribution to Canadian figurative art.

□ Pegi Nicol (MacLeod) made her first appearance with The Canadian Group of Painters in 1936, with Self-Portrait and Begonias. It was to be the first of many memorable paintings sent to the Group shows by one of the most original Canadian artists of the thirties and forties. Her early death in 1949, at the age of forty-five, removed from the world of art in Canada one of its most vigorous and spontaneous talents. She painted with an expressionist abandon, based on a solid foundation.

Pegi Nicol was happiest wherever human action was—in big cities, with their teeming crowds and spaghetti networks of streets. Her paintings of Toronto and New York are laced with weaving, richly coloured strokes, wandering in seeming disorder. At a time when most Canadian artists painted the single figure—or at most two—isolated like a specimen from the rest of humanity, Pegi Nicol threw bodies together by the dozen, in sometimes dizzying confusion. She had the joyful approach of a Raoul Dufy, and the intensity of a Kokoschka. She was a woman of singular determination and talent, and she used both to express her enormous affection for life.

Pegi Nicol studied under Franklin Brownell in Ottawa and at the Ecole des Beaux-Arts in Montreal. It was not until she was almost thirty that she broke out into the pink, blue and green expressionist watercolours which assure her a lasting place in Canadian art. In the best of her paintings done in Toronto between 1934 and 1937, and those done in New York from 1937 until her death in 1949, figures overlap figures until

ANNE SAVAGE *Dark Pool* c. 1945 31x40 Art Gallery of Hamilton

they flow into one another in a fabric of shapes which closely patterns her paper from corner to corner. From these busy surfaces emerge the flower sellers, skaters, children at play, parades of soldiers and sailors, pigeons and horses whose movements she delighted to capture in paint. Her art has its limitations, however—shortcomings which arose from her need to put all she felt down at once, in a single rush.

☐ Paraskeva Clark introduced a markedly European note into the early Canadian Group shows. Born in Leningrad, Russia, she did not come to Canada until 1931, at the age of thirty-three, and she first exhibited with The Canadian Group of Painters in 1933. By that time she knew Canada well enough to exhibit a canvas painted in Muskoka in the Ontario resort area.

Paraskeva Clark has never shown any preference for theme. She creates landscape, portrait and still life subjects equally.

Some of her finest landscapes have been painted of Northern Ontario and the St. Lawrence shore, but a large percentage of her compositions have been executed within a mile of her home in the Rosedale area of Toronto. These include such works as Snow in the Backyards (1942) and Building Clifton Road (1947), both in the Art Gallery of Ontario, and Our Street in Autumn (1947). A politically aware artist, she gained notoriety in the thirties and forties for her protest pictures.

In her style of painting, Paraskeva Clark cannot be described as a revolutionary, however. Over a period of forty years, her technique has changed very little. Her deliberate brush work and broken colour still reflect the training of a Cézanne-oriented teacher. She abhors the spontaneous telegraphic gesture or the careless accident in painting. For her large works she prepares a carefully plotted drawing, with each seg-

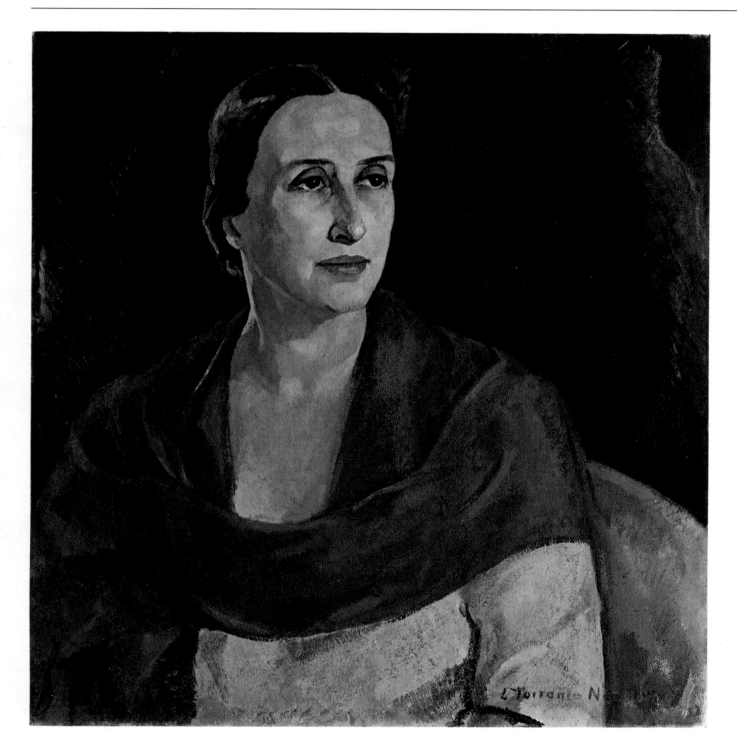

LILIAS TORRANCE NEWTON *Frances Loring* c. 1942 25x24 National Gallery of Canada

ment of the composition numbered for transference to canvas. Her finest works include Pink Cloud (1937—National Gallery of Canada), Swamp (1939—Art Gallery of Ontario), Tadoussac (1944), In the Woods (1939—Hart House Collection at the University of Toronto), Canoe, Lake Woods (1952—National Gallery of Canada), and her portraits of Philip Clark and Naomi Yanova.

☐ A painter in an admittedly minor vein is Rody Kenny Courtice. Her best paintings are wry or humorous asides on mankind and the animal world. Born in 1895, she first studied under Arthur Lismer at the Ontario College of Art and later worked with him as a child art educator for many years. After studying with Hans Hofmann in New York, her later light-hearted comments on life assumed a semi-abstract character.

☐ There have been many husband-and-wife art teams in Canadian painting. Two notable ones were among the founders and early members of The Canadian Group of Painters.

Peter and Cogill Haworth both exhibited in the first show of the Canadian Group in 1933 and continued to exhibit with it until its demise. Throughout their long careers they painted and travelled together throughout most of Canada. As long-time educators, they made a rich contribution to the development of artists in the Toronto area. Such painters as Kazuo Nakamura and Aba Bayefsky were among their students.

When he arrived in Canada in 1923, at the age of twenty-four, Peter Haworth had graduated from London's prestigious Royal College of Art, where his teachers had included the famous Sir William Rothenstein. He made his first reputation in Canada with a crisp series of watercolours of Ontario and the St. Lawrence. These brisk, realistic renderings of barns, lighthouses and coastal rockscapes formed the basis for the

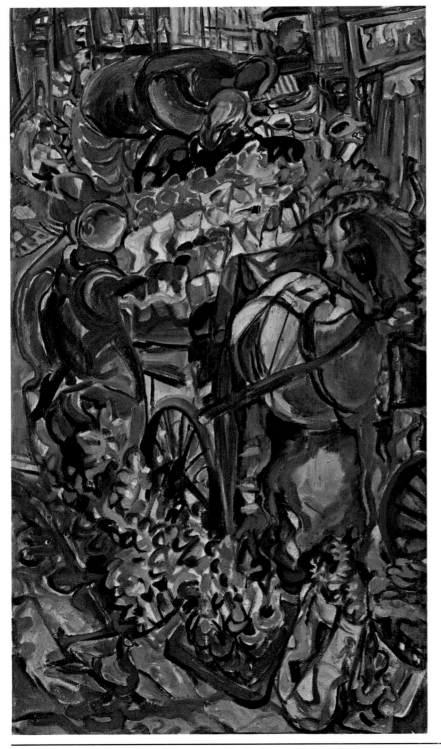

PEGI NICOL MACLEOD *Flower Wagon* c. 1942 40x22 Art Gallery of Hamilton

semi-abstract compositions which he began in the 1950's. The latter paintings, in acrylic, possess the same studied approach of these earlier landscapes, but possess a much more imaginative design structure and reveal a heightened concern with texture and colour.

Cogill Haworth studied at the Royal College of Art with her husband. Her approach to the Canadian landscape has always been extroverted, and experimental in technique. Her lifelong affection for pattern and texture exhibits itself in her early pre-occupation with pebbly beaches, boats and whitecaps, all painted with an almost Dufy-like verve. A strong element of wit and humour comes through in much of her work, and has persisted from the early 1930's through to her happy abstract comments on the Ontario countryside.

□ A Canadian-born pair who exhibited with the first Canadian Group show were George Pepper and Kathleen Daly, who were married in 1929. George Pepper was a founding member, and showed two of his Gaspé canvases and a Skeena River, B.C. composition in that first show. Pepper's early canvases reflected his close association with the Group of Seven, several members of which were teaching at the Ontario College of Art when he was a student there from 1920 to 1924. Both the subject matter and the pattern of linear rhythms owed much to Jackson and Lismer. However, he soon evolved a style of his own, characterized by a choppy, vigorous rhythm—masculine and well suited to the scenes of the Maritimes and the Labrador Coast which were among his favourite themes.

Pepper was an observant portrait painter and, with his wife, executed many effective studies of Eskimos and Indians. One of his most memorable pictures, however, was a city subject,

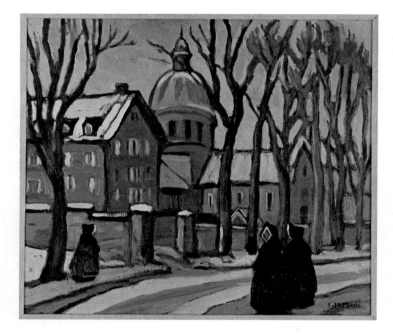

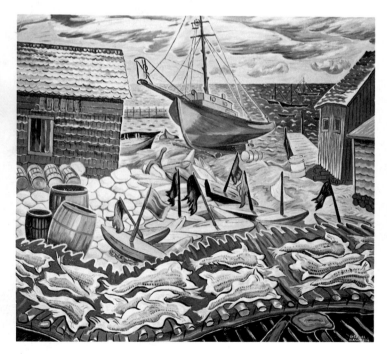

KATHLEEN MORRIS *Winter Street* c. 1949 18x21
Collection: Mr. and Mrs. J.A. McCuaig

B.COGILL HAWORTH *Harbour Paraphernalia* 1952 28x42 Collection: The Artist

PARASKEVA CLARK *Swamp* 1939 30x20 Art Gallery of Ontario

Backyards, a telling memento of the Depression era which was exhibited at the New York World's Fair in 1939.

Kathleen Daly Pepper painted annually in Europe for many years before her marriage. Her works of this period are impressionistic, compared with the earth-coloured landscapes and portraits she began in Canada's North and West from the 1930's onward. Her most successful works are, unquestionably, her interpretations of French-Canadian habitants, Eskimos and Indians. Some of the finest of these were painted when she and George Pepper were commissioned by the Canadian Government in 1960 to make a three-month voyage to the Eastern Arctic to portray the inhabitants of the area.
□ One of the best canvases at the 1933 Group show was André Biéler's Les Patates. Swiss-born Biéler began to record the rural life of Quebec early in his career, and—after

Charles Gagnon—has probably achieved the warmest portraits of the early lives of its people. His experimental turn of mind led him to paint with many media, including tempera, water-colour and oil. Despite his variety of techniques, Biéler has continually maintained his concern for rural existence. The local marketplace, the village shrine, the country election, fishing from the river pier—all form part of the bucolic world portrayed by his affectionate and designing brush.
□ The first Canadian Group show at Toronto included a painting by Marc-Aurèle Fortin, the now famous Landscape at Hochelaga, formerly in the Vincent Massey Collection. Fortin was then already forty-five years of age, but was little known in his native Quebec and virtually unknown elsewhere.

Fortin's art was the sum of many influences and much economic struggle. In the early part of the century he studied in

GEORGE PEPPER *Backyards* 1938 36x42 Estate of the Artist

Montreal under the arch-academician Edmund Dyonnet, a strict disciplinarian of limited imagination. During the following years, between 1908 and 1914, he studied under a series of academic teachers in Chicago and New York. With this background, it is remarkable that he was able to develop such a markedly fresh and personal vision.

Fortin's best landscapes are unmistakably French Canadian in imagery and execution. The linear pattern he weaves around his forms, with brush or charcoal, give them, at times, an almost embroidered air. Anything Fortin may have owed to the Group of Seven and his earlier teachers he transmuted into his own luminous colour and patterns. He is not a giant of Canadian art, but he is an estimable and unmistakably important figure.

□ Two other Group artists closely concerned with the Quebec scene were Adrien Hébert and Henri Masson. Adrien Hébert exhibited only in the first two Canadian Group shows, but his *From an Elevator* and *Montreal Harbor* sum up his lifelong love affair with that great city, and in particular with its waterfront. In 1933, Hébert was already forty-three years of age, but full appreciation of his quality as an artist has only come after his death, with a major memorial exhibition organized by the National Gallery of Canada. Hébert's many depictions of Montreal streets and harbour scenes painted during the 1920's and 1930's have the monumental reserve and mastery of tone of the American artist Edward Hopper.

Henri Masson belongs to a younger generation than Hébert, but he shares his interest in city life, though he paints with a more wayward style. Masson splashes bright mosaic strokes into impressions of movement in the streets and parks of Hull

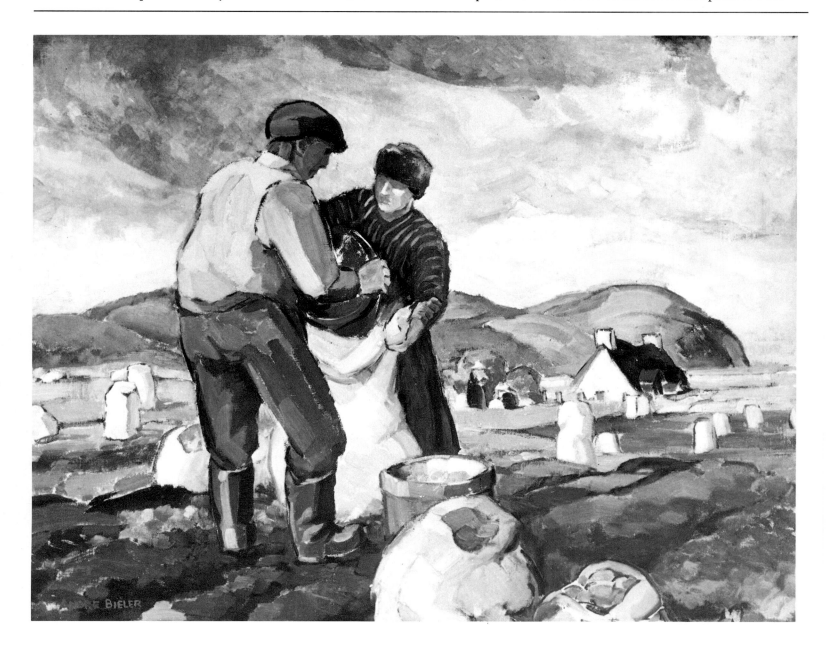

ANDRE BIELER *Les Patates, Argentenay* 1929 26x34 Collection: The Artist

JOCK MACDONALD *Fall (Modality 16)* 1937 28x24 Private Collection

and Ottawa. He does not freeze the contours of his playing children, strolling monks and impatient commuters, but catches them loosely with quiet expressionism and high-keyed colours.

Masson is a loner standing outside the main current of fashion in Canadian art. He has justified his stubborn adherence to figurative painting by the vigour and warmth of his observations on the Canadian human comedy.

☐ Three Vancouver-based artists who did much during the 1930's to open up the eyes of British Columbia citizens to a new outlook in art were William P. Weston, Charles H. Scott and J.W.G. (Jock) Macdonald. These men, along with F.H. Varley—all of them British-trained—laid the first foundations for a wider appreciation of art in British Columbia. Weston, who had been born in London, England, came to Vancouver in 1909 and taught in the city's school system until

1946. He was a founding member of The Canadian Group of Painters, and his crisp, decorative mountain landscapes brought a new design note to West Coast painting in the late twenties and early thirties. Much of the basic training for future artists in British Columbia was patiently overseen by people like Weston and Scott.

Charles H. Scott, a graduate of the Glasgow School of Art, came to Canada in 1912 as supervisor of art in the schools of Calgary. In 1914 he moved to Vancouver to assume a similar role, and in 1926 became Director of the newly-founded Vancouver School of Art. He remained Director for twenty-six years, until his retirement in 1952. Among his graduates were the people who were to lead West Coast art to its full creative emergence—Jack Shadbolt, B.C. Binning and Gordon Smith. Scott's sister-in-law, Grace Melvin, a distinguished illustrator,

WILLIAM WESTON *Cheam* 1933 42x48 Hart House, University of Toronto

was also a member of The Canadian Group of Painters.

Among Charles Scott's first employees at the Vancouver School of Art was Jock Macdonald who had been hired to be the Director of the Design Department. Macdonald had studied design in his native Scotland and began his career as an architectural draughtsman and textile designer. He had never painted when he arrived in Canada, but encouragement by his wife, who had been trained as a painter, and by F. H. Varley who was Director of Painting and Drawing at the Vancouver School, set him upon a new career. Between 1927 and 1934, Varley took Macdonald painting in the mountains, particularly in the area of Garibaldi Park. Within six years of making his first painting, he became a founding member of The Canadian Group of Painters. Such landscapes as Black Tusk, Garibaldi Park have since been recognized as among the most compelling landscapes to emerge from British Columbia.

In the middle thirties Macdonald began a series of abstracts that he called Modalities. Some of these reflect his early training as a designer, but at their best, as in Fall (1937), they helped pioneer abstract art in this country. When Lawren Harris arrived to live in Vancouver in 1940, he hailed Macdonald's Modalities as important landmarks in Canadian art. Macdonald himself told me in 1957 that he felt the Modalities and Harris' appreciation of them gave him the courage to continue exploring toward an increasingly personal art. By the time he moved to Toronto in 1947, Macdonald's twenty-one years in British Columbia had seen him fully launched as one of the nation's most experimental painters.

PEGI NICOL MACLEOD *Descent of Lilies* 1935 48x36
Mr. and Mrs. T. E. Nichols, Hamilton

ETHEL SEATH *Montreal Street Scene* c. 1940 24x24 Private Collection

4 / Three from the West

The youngest founding member of the Canadian Group in terms of experience was Bertram Brooker. A self-taught artist, Brooker had been painting for less than ten years at the time of the first Canadian Group exhibition. In 1933, Brooker was forty-five years old, but a mere novice in art experience. He brought to the Canadian Group wide cultural background and creative energy.

Since youth, Brooker had been too multi-gifted to restrict himself to any one creative field. He had come to Canada from England when he was seventeen, and his early career in Manitoba included operating a movie theatre in Neepawa, writing and acting in local theatrical productions, producing movie scenarios, editing the *Portage Review*, and serving as music and drama critic for the *Winnipeg Free Press*.

Wherever he went, Brooker was at the centre of creative activity and a prime mover in the arts. In 1929, he switched his activities to Toronto. In 1936, he won the Governor-General's Literary Award for his novel *Think of the Earth*. As an editor, he created *The Year Book of the Arts in Canada* in 1929 and 1936. These now-famous publications did much to focus national attention on the arts. As an illustrator, Brooker's drawings for *Elijah*, published in 1929, brought him international attention and a half-page in *The New York Times* Book Review.

Brooker was Canada's first abstract painter. His canvases of the late twenties include some of the finest non-figurative compositions ever done in this country. Such works as Alleluiah, Resolution, and Prelude came as a shock in their initial appearance at the 1929 Ontario Society of Artists Exhibition, where Brooker first exhibited.

CHARLES COMFORT *The Dreamer* 1930 40x48 Art Gallery of Hamilton

Brooker showed two paintings at the 1933 Atlantic City exhibition and four at the inaugural Canadian Group show in Toronto. He continued to exhibit regularly with the Group until his death in 1955. His fine Entombment canvas and Blue Nude were features of the 1937 show.

A survey of The Canadian Group of Painters exhibitions readily reveals that Brooker was one of the most restless and experimental artists this country has known. He found it impossible to maintain a continuing interest in one theme or style. Landscape, still life, pure abstraction, religious themes, figures and portraiture took his attention.

Considering the breadth of his intellectual interests, it is surprising that Brooker completed the large body of work that remains. After his death, I catalogued and stamped, in 1957, some three hundred works which still remained in the artist's estate. Among these were compositions of an authority and dexterity which revealed the dedication of this self-taught, part-time artist. Crisp, detailed still lifes of a green pepper and a brown bag, or a pair of old ski boots or a chunk of driftwood were stacked among his abstract interpretations of Handel, together with figure pieces and landscapes.

Despite his position as a major innovator in Canadian art, most of Brooker's works remained unsold. Though he had exhibited regularly throughout his career with The Canadian Group of Painters and other major art societies, the National Gallery of Canada failed to recognize the painter's existence with a single purchase of his work. It was not until almost fifteen years after his death that the National Gallery, under Director Jean Boggs, finally acquired canvases by this neglected pioneer of modern painting in Canada.

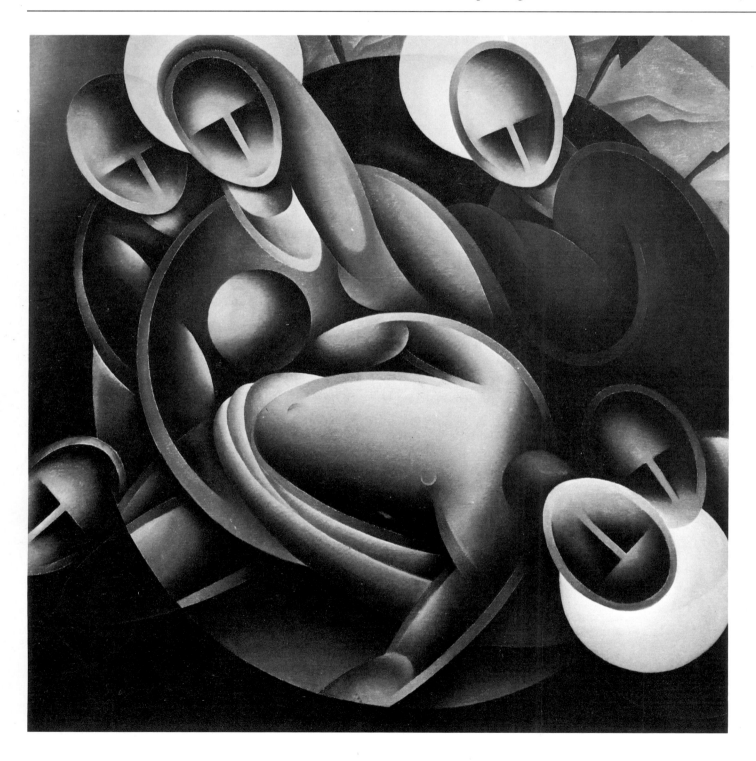

BERTRAM BROOKER *Entombment* 1937 40x40 Estate of the Artist

In the light of such lack of recognition, Bertram Brooker was prophetic, and perhaps a little bitter, when he wrote to me in 1952, after the publication of one of my books: "Don't look for recognition or appreciation from the establishment. They grow calluses from sitting at their desks. The joy is in the doing and the achievement is its own reward."

Much of Brooker's deepest satisfaction came from his social and professional contacts with other artists. His close friend, painter LeMoine FitzGerald, wrote in a memorial tribute to Brooker: "No single work was ever final, and when the emotional upsurge had subsided it was replaced by a renewal of energy to build something still better into the broad structure of his art, nothing short of perfection his ultimate goal" (Ontario Society of Artists Exhibition Catalogue, 1956).

FitzGerald was in a better position to understand Brooker's art than anyone. The two artists had known one another since 1929, years before they became fellow-founders of The Canadian Group of Painters.

Brooker had sought out FitzGerald after he had been impressed by, and purchased, a charcoal drawing of a tree by the Manitoban. Their meeting in Winnipeg developed into one of the closest and most productive friendships between Canadian artists. Their association lasted until their deaths, which occurred within a year.

Brooker and FitzGerald were born only two years apart. In temperament and in their approach to art they were remarkably similar. They were both Westerners, FitzGerald by birth and Brooker by adoption. A reading of their correspondence illuminates the loyalties and affection which members of the Canadian Group felt for one another.

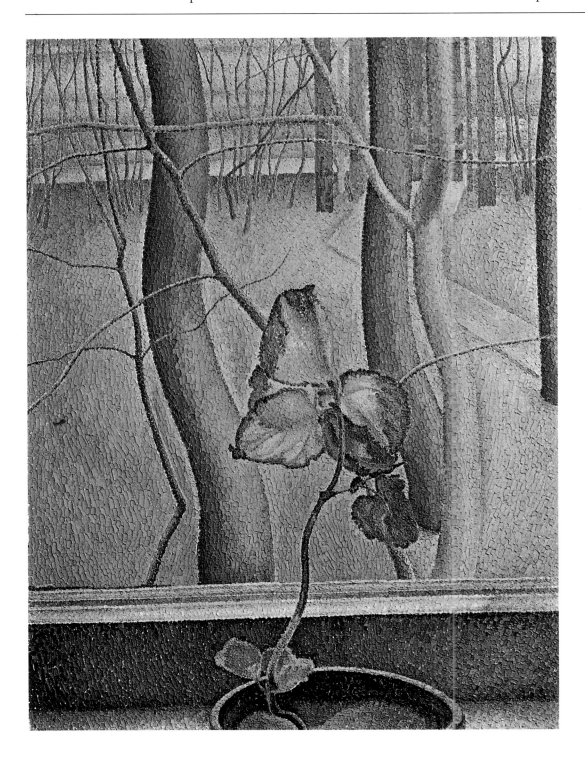

LIONEL LE MOINE FITZGERALD *The Little Plant* 1947 24x18 McMichael Canadian Collection

In a letter to FitzGerald sent after the opening of the first Canadian Group show in Atlantic City, Brooker wrote: "Your patience, your industry, your singleness of purpose, your adherence to the natural, and above all your achievements, are a greater inspiration to me than any other influence I have met with in Canada. I think it is because that in attitude and method you seem closer to the old masters than is the case with any other painter I know at all intimately."

Spending much of his life in the highly competitive world of advertising, Brooker found in FitzGerald a source of balance: "I am so much among people who dash things off that I am influenced, at least to an extent, by their example. My contacts with you are therefore very valuable in that they restore me to my natural slower pace and more thoughtful procedure.... You seem to know so well what you want and how to go about it."

□ Deliberate, FitzGerald certainly was. In what time he could spare from his position as principal of the Winnipeg School of Art, he achieved a small, but pristine and completely realized body of work. Sometimes, because of his deliberate approach, FitzGerald would not be able to complete an oil painting for the Canadian Group exhibitions and would be represented instead, as he was in 1937, by four drawings. He would apologize for his failure to submit a canvas, but nothing deterred him from his patient, painstaking ways.

FitzGerald's oil paintings are relatively few in number and constitute collectors' rarities. This fact is explained by such communications to Brooker as this letter of January 11th, 1929: "During the two weeks of the Christmas holidays, I put some time each day working on a large canvas of some trees in the front yard with the buildings next door. This will keep me busy

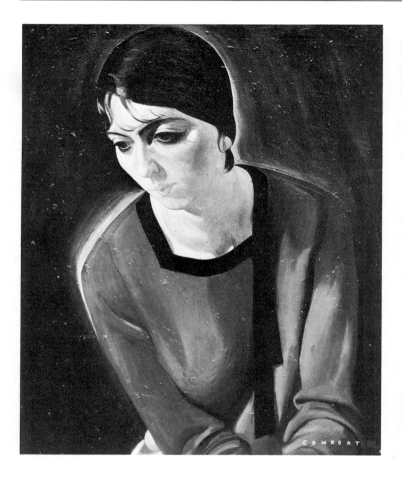

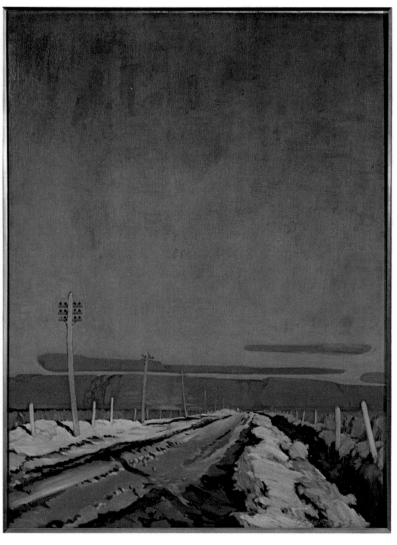

CHARLES COMFORT *Louise* 1927 26x20 Collection: The Artist

CHARLES COMFORT *Prairie Road* 1925 46x34
Hart House University of Toronto

for the rest of the winter."

FitzGerald's reflective genius was directed mainly to quiet landscapes or still life. The forms of a barn, a garage, a jug or an apple were enough to coax forth his delicate and crystalline compositions. His sensibilities filtered slowly through an almost painfully deliberate technique, which placed one minute brush stroke against another to build up volumes that proved as solid as they were subtle.

FitzGerald never sent any of his rare figure subjects to the Canadian Group exhibitions, and it seems clear that he himself was rarely entirely happy with them. Even as subject matter, the human form had small attraction for him. He admits in a letter to Brooker on February 19th, 1937: "The seeing of a tree, a cloud, an earth form always gives me a greater feeling of life than a human body. I *really* sense the life in the former and only occasionally in the latter. I rarely feel so free in social intercourse with humans as I always feel with trees."

Like Brooker, FitzGerald sometimes looked southward for his creative sustenance. Both had a stylistic kinship with the American precisionist school of Charles Sheeler, Charles Demuth, Georgia O'Keefe and Preston Dickinson. In 1921, FitzGerald had studied in New York at the Art Students League under Boardman Robinson and Kenneth Hayes Miller.

(Many other artists who studied at the New York Art Students League also exhibited with The Canadian Group of Painters. These included Charles Comfort, David Milne, Goodridge Roberts, Jack Humphrey, Will Ogilvie, Jack Shadbolt and B.C. Binning.)

☐ A third Manitoba artist with a similar background and precisionist style was Charles Comfort. Comfort had arrived in

LIONEL LE MOINE FITZGERALD *Green and Gold* 1954 28x36 Winnipeg Art Gallery

58

Manitoba from Scotland in 1912 and studied at the Winnipeg School of Art. Like FitzGerald, he went to the New York Art Students League, and studied under Robert Henri and Joseph Pennell.

Comfort first established his reputation in Winnipeg as a commercial artist. His phenomenal technical skill and versatility in handling any subject with ease created great demand for his work. When Comfort's skills took him to Toronto in 1925, he immediately became the star commercial designer of the country, and his published work was an inspiration for a generation of art students who were not much younger than himself.

Comfort spent as much time at his studio easel as he did at his designer's table. By 1925, he had already painted his richly coloured Prairie Road (Hart House Collection, University of Toronto). By 1933, he had firmly established his own crisp,

dramatic style of painting. He had a fondness for painting buildings—rural and industrial structures, silos, smelter stacks, factories and farmhouses—and Comfort was the first Canadian artist to create lasting compositions from such raw material. His brilliance at combining cast shadows and silhouettes, together with his special flair for backlighting his subjects, allowed him to achieve paintings during the thirties that remain compellingly alive today.

Comfort exhibited some of his finest landscapes-with-buildings in the Canadian Group shows of the 1930's. One of these, a bird's-eye view of Tadoussac (National Gallery Collection) was one of the outstanding canvases in the 1936 show and was reproduced as a frontispiece to the catalogue. This painting contains all of the qualities which mark Comfort's landscapes of the period: precision of contours, smoothness of surface,

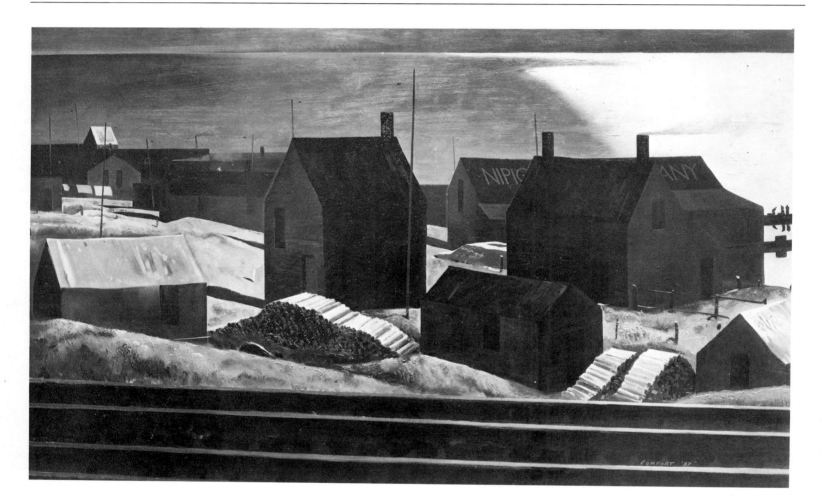

CHARLES COMFORT *Lake Superior Village* 1937 42x70 Art Gallery of Ontario

and a silvery, almost monochromatic, palette.

Lake Superior Village, exhibited in the Canadian Group show of 1937, remains one of the finest major Canadian paintings of its time. In 1938, it won the important Great Lakes Exhibition prize over the entries of some of America's ablest artists.

The lack of public notice of this award once more brought forth the fierce loyalty that existed among many members of The Canadian Group of Painters. Bertram Brooker, who was a fellow-member of a small life-class group that met regularly in Comfort's downtown commercial studio, wrote bitterly to Le-Moine FitzGerald in 1938: "It is almost unbelievable, but true, that this honour should be noted in the papers in such an inconsequential way.... It is especially sickening when you think of the nurses in Orillia who win some bloody prize for a first year course in blowing noses, get their pictures smeared all over the paper, or some duck who makes a battleship out of postage stamps gets a two-column picture of himself and the ship all over the front page of the second section of the Star."

Comfort has painted some of the most telling Canadian portraits. His best works in this field have been his portraits of his wife, Louise, and his artist-colleagues. His 1932 painting of Carl Schaefer, The Young Canadian (Hart House Collection, University of Toronto), is probably the most reproduced portrait in Canadian art. He painted two later studies of Schaefer, as well as a number of Will Ogilvie, sculptor Emanuel Hahn, violinist Alexander Chuhaldin, and a remarkable canvas called The Dreamer (The Art Gallery of Hamilton). The latter is one of Comfort's most original and powerful compositions.

BERTRAM BROOKER *Blue Nude* 1937 40x20 Estate of the Artist

BERTRAM BROOKER *Prelude* c. 1930 30x24 National Gallery of Canada

5/ Four from the Maritimes

Artists in the Maritimes have always worked under a geographic and social handicap. Isolated from the main art centres of the country, they have a very small immediate art audience. This isolation in the past has caused many Maritime artists to feel they have been ill-treated and misunderstood, and, in turn, they have misunderstood the intentions of museums, collectors, and other artists in the more populated parts of the country. Despite these causes of potential bitterness, however, there have been a number of Maritime painters over the past four decades who have achieved highly original and significant works of art.

Jack Humphrey must be considered the forerunner of recent advances by painters of the three Atlantic provinces. New Brunswick has been the unquestioned centre of important and original painting in the Maritime area, and Jack Humphrey was a stubborn and dedicated citizen of that province. He devoted his entire career to establishing Saint John as a respected centre of creative art in this country.

Humphrey was fortunate in being able to fortify his lifetime's creative campaign with a bulwark of international art training. Before he was twenty, he was able to study at the Museum of Fine Arts in Boston under Philip Hale. For five years, from 1924-1929, he attended classes at the National Academy of Design in New York, under the great teacher, Charles Hawthorne. The prime catalyst of his career came in 1929, however, when he made his first trip to Europe and came under the tutelage of Hans Hofmann at the latter's school in Munich. The pioneer German abstractionist brought new breath and freedom to the Canadian's approach to art. "Hans Hofmann," Humphrey wrote in a letter of March 15th, 1956, "had the biggest influence on me of anybody, and I guess his teaching and his theories have had

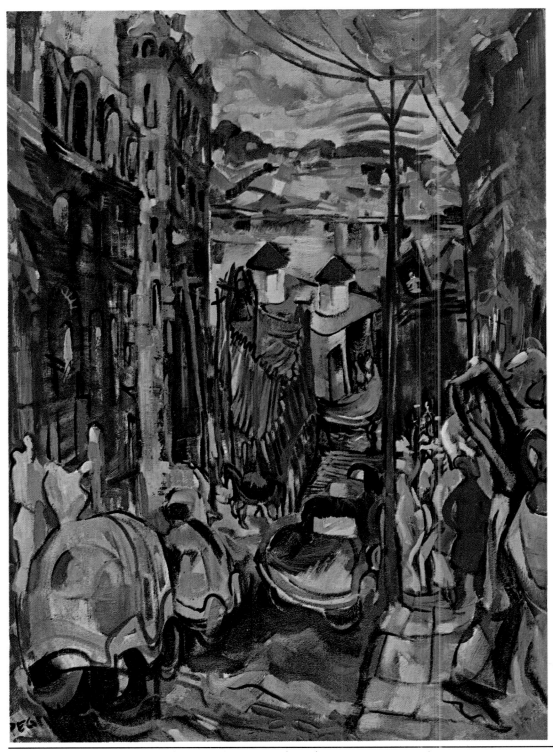

PEGI NICOL MACLEOD *Street Leading to Harbour, Saint John* 1947 37x27 Art Gallery of Hamilton

something to do with just about everything I have done, whether figurative or abstractive."

It required courage for Humphrey to return to the bleak cultural opportunities offered by his native Maritime province, but stubbornness was a quality that Jack Humphrey had plenty of, as can be readily seen in the face of his 1931 self-portrait, Draped Head (Hart House Collection, University of Toronto). This and his other portraits were drawn with an old master's concern for detail and proportion. The expressions on his sitters' faces are almost always serious, if not sad, but there is nothing drab about the rich luminosity that characterizes the technique of these highly personal canvases. Despite his pessimism about the lack of public appreciation, Humphrey did have an appreciative, if small, audience during his lifetime, and his works were purchased by the National Gallery of Canada as early as the 1930's.

Jack Humphrey put himself on record in a statement he made to accompany an exhibition at the Fine Art Gallery of the T. Eaton Company in Toronto in 1944: "The world of painting is a tremendous field for exploration. While the artist, as such, is an integral being, the public is largely responsible for environment. In so far as environment is good, art flourishes, makes life more beautiful, more meaningful. If the environment is bad, and much of our Canadian background can be thus classified, art struggles on anyway, hampered and retarded, perhaps, but sustained by faith in its purpose and its existence."

In 1952 Humphrey received a government fellowship to paint in Paris. There, his work underwent a drastic and precipitate change. The French atmosphere seemed to release all of the Hans Hofmann training in abstract art which had remained for the most part dormant, and he created a series of landscapes wherein

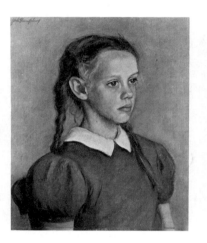

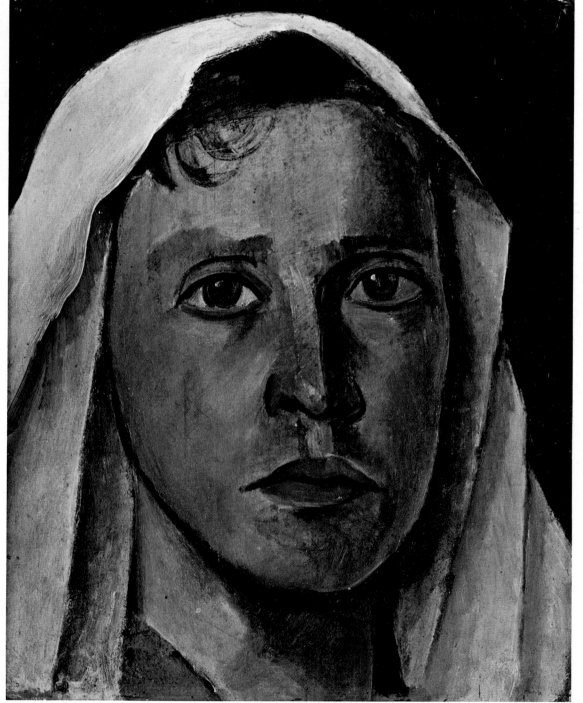

JACK HUMPHREY *Joanne* 1947 24x20 National Gallery of Canada

JACK HUMPHREY *Draped Head* 1931 16x12
Hart House University of Toronto

recognizable forms are almost totally abstracted into designs of primary colours and slashing contours. The sudden change in style surprised and disappointed some of the artist's followers. Their unwillingness to follow him on his creative path probably upset Humphrey more than anything in his career. "If there is a myth about the superiority of the *old* Humphrey," he wrote in a letter to me, "then it springs from ignorance about the new Humphrey, possibly willful ignorance in some quarters While others enjoy expert and highly effective promotion, not only sales promotion which enables work in large format, but the kind of promotion which influences people in high places and results in very definite and substantial prestige, it is thought, no doubt, that here one should always keep patiently silent and meek, and accept a thrust-on inferiority which is not authentic. People in Ottawa now realize that while 100% of the work in central Canada is easily accessible to them, they seldom see more than 5% of paintings done here. This has led to some neglect and a good deal of ignorance. But I am trusting you to dispel some of it." Humphrey's complaint was a fair one.

☐ The unwavering loyalty of New Brunswick artists to their home base is further illustrated by Miller Brittain and Alex Colville. Like Humphrey, Miller Brittain was born in Saint John, and the early part of his career parallels that of his older contemporary. Eleven years younger than Humphrey, Brittain studied briefly with him. Before that, he had attended the New York Art Students League, from 1930 to 1932.

Miller Brittain was much more mystical and romantic in his approach to painting than Humphrey. All of his early work seems to have been a preparation for the intense series of biblical studies he began in the late 1940's. No Canadian artist has ever

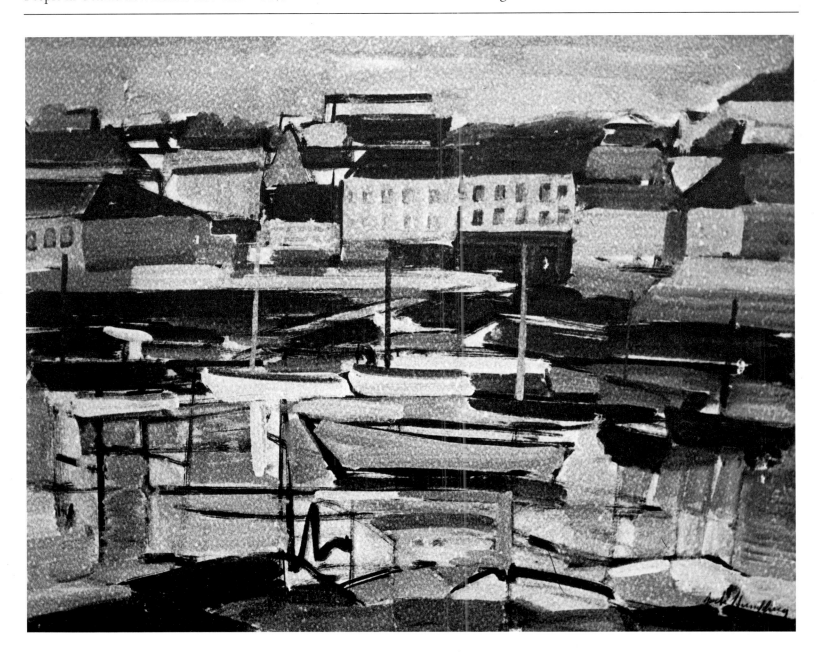

JACK HUMPHREY *Outer Harbour, Concarneau* 1953 22x30 Private Collection

become more personally involved in the expression of religious passion than Brittain. Although he was diminutive in size, these late biblical compositions bespeak enormous physical energy. They are clearly the work of an artist obsessed and careless of public applause. It has been suggested that Brittain's wartime experience as an Official War Artist prompted his turning to the Bible for his themes, but he personally denied this. Although there are plenty of grounds for debate about the success of his biblical art, there can be little question that he was one of the best draughtsmen this country has produced.

Miller Brittain was a difficult, illusive artist for the general public to appreciate. Many of his fellow painters, however, deeply admired his skill and dedication, and did not hesitate to speak of it. The late Pegi Nicol wrote: "The first Miller Brittain came as a therapeutic shock, setting free the spring of my wish. Man at last. Not archaic man, but present day man; complicated and modern. Just like all of us."

About his own approach to art, Miller Brittain wrote: "I have no patience with those individuals who think of pictures merely as embellishments to a decorative scheme A picture ought to emerge from the midst of life and be in no sense divorced from it And I think artists should be rooted in their native heath, not self-consciously, but naturally."

☐ Another New Brunswick painter whose art is truly rooted in his native heath is Alex Colville. Although born in Toronto in 1920, Colville moved to the Maritimes when he was nine years old, and has lived in Sackville, New Brunswick for most of his life. Except for his years of war duty and an occasional trip, he has found most of the subjects for his art within a few miles of his home.

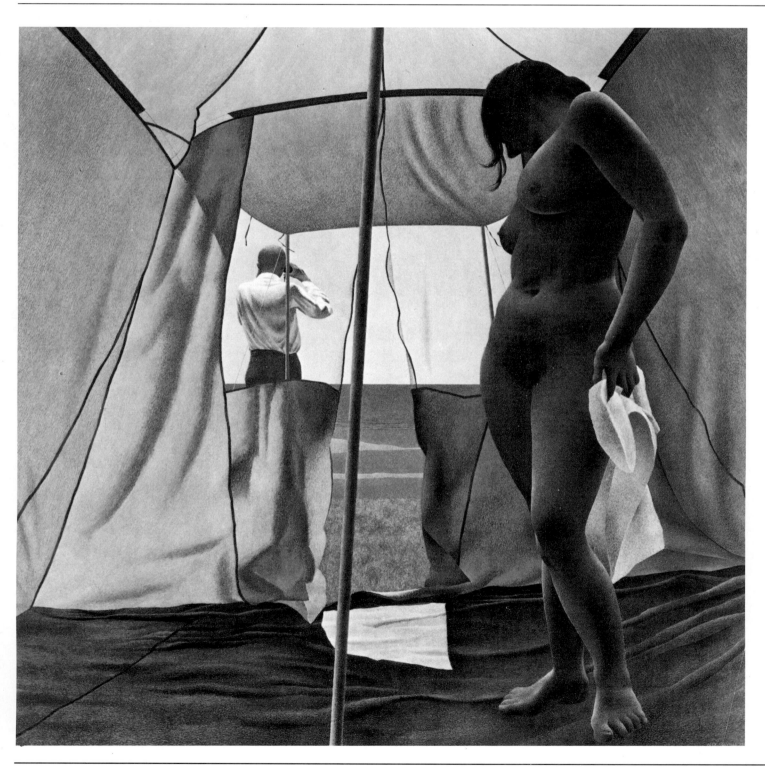

ALEX COLVILLE *June Noon* 1963 30x30 Collection: Mr. Victor Lownes

Colville studied painting under Stanley Royle at Mount Allison University in Sackville, and was already attracting wide attention for his ability while still a student. In his graduating year of 1942, he designed a mural called Sackville Railway Station, which contained within it all of the qualities for which his paintings later became justly famous. The steam rising from the train, the headlights of a car cutting through the mist, a soldier and his wife saying good-bye — all of these are the stuff from which he later evolved his increasingly detailed and stylized art.

Immediately after graduation, Colville enlisted in the Canadian army. For the first two years of his service, he had little opportunity to touch brush or pencil, but after his appointment as an Official War Artist overseas he was able to draw every day. He credits that wartime opportunity for constant drawing and painting, plus his association with senior Canadian War Artist Major Will Ogilvie, for establishing his confidence as a professional artist.

In 1946 Colville returned to Mount Allison University as a teacher. It was then he began that continuing series of paintings which have established him as one of the world's foremost realists. His first exhibits with The Canadian Group of Painters were Group of Horses (Art Gallery of Toronto) and Railroad Over Marsh, but it was not until the 1951 exhibition that he displayed what he considers his first mature painting — Nude and Dummy (New Brunswick Museum). Although some of his most important pictures are in foreign hands, and though his major exhibitions have been in the United States and in Europe, Colville retains a deep emotional attachment to the Maritimes.

□ A late arrival on the New Brunswick scene was Lawren P.

ALEX COLVILLE *Dog, Boy and Saint John River* 1958 24x32 London Public Library and Art Museum

LAWREN P. HARRIS *Chevrons* 1970 64x34 Winnipeg Art Gallery

Harris, the son of Lawren S. Harris. The most outstanding abstractionist in the Maritimes, he became Director of the Mount Allison School of Art, Sackville, in 1946.

Harris first exhibited with The Canadian Group of Painters in 1936, at the age of twenty-six. His paintings then represented the skilful, painstakingly-executed realism he had learned during his studies at the Boston Museum of Fine Arts. Portraits were Harris' early interest, and Presiding Elder at Tamra in that 1936 Group Show was among the first of the many portrait studies he was to do throughout his career.

Despite his continuing interest in portraiture, Harris turned to abstraction after the war. His total commitment to abstract art in the late forties was in part a reaction to the reportorial demands made upon his talents as a War Artist. Harris, himself, remarked in a 1954 gallery lecture: "Having been appointed a War Artist, and more or less obliged to paint for the paymaster in a rather starkly realistic fashion, I became more than ever convinced that some form of abstraction would be my eventual mode of expression Prior to my release from the army, I also made a large series of non-objective drawings [which] served their existence by paving the way for the group of total abstractions to follow." Harris' abstracts are cool and clean in colour, and very deliberate in construction. He himself has written of his work: "I no longer work directly from nature. The designing of the idea is uppermost, which is then stated as simply as possible in an effort to reach the core of the matter. Considerable self-discipline is exercised in the formation and execution of my paintings and little is left to chance or accident."

MILLER BRITTAIN *The Gold Drum* 1954 30x24 Estate of the Artist

6 / Depression faces

Every period of Canadian art has had its own pictorial preoccupations and passions. Inevitably, these alter with the social scene from generation to generation, and even from decade to decade. Changing mores, economics, science and materials, can bring about radical new modes of expression. What was the absolute conviction of one era of artists may rapidly earn the scorn of the next — a fact which does not lessen the effectiveness of the earlier style as an expression of its own time.

Today, it is often the fashion to downgrade the social comment art of the thirties and early forties, but at the time it was born of a terrible necessity. It was almost inevitable that artists who were hemmed in by breadlines, civil strife, political unrest, and who were often themselves hungry, should use their talents to portray the misery around them or protest it in paint. Many of the social-realist pictures of the Depression era may seem dull

to the eyes of a member of a later and more affluent society, but at their best they are graphic and eloquent illustrations of historic significance. The very existence of Depression art speaks for the sincerity of the commentators who could barely afford materials and who could look forward to no sales.

In Canada, Depression art was inevitably centred in the large cities — particularly Toronto, Montreal and Saint John. The transients and slum-dwellers of those cities were painted by such notable artists as Jack Nichols in Toronto, Louis Muhlstock in Montreal and Miller Brittain in Saint John.

Jack Nichols first made his impact with drawings based on subjects from the Toronto ghetto area. In penetrating turpentine-wash studies he showed the boredom and suffering of the poor. His portraits were not of specific subjects, but dramatic, if deeply human, symbols of a general social condition. Nichols, like

PRUDENCE HEWARD *Sisters of Rural Quebec* 1930 62x42
Art Gallery of Windsor

PRUDENCE HEWARD *Farmhouse Window* 1938 27x22
Art Gallery of Hamilton

Daumier, rarely used models; he relied upon memory and imagination to create his mood-filled and memorable studies.

In Montreal, Louis Muhlstock was making similar striking records of Depression faces, only in his case the drawings were from specific models and had the incisive character of psychological portraits. In total, his drawings reflect a time in our social history, each one executed with the skill and authority that establish him as one of Canada's finest draughtsmen. His studies of unemployed men, destitute women and immigrants form a graphic gallery of bitter times. Usually rendered in chalk, his portraits are richly modelled examples of classic drawing technique, and are attuned to the emotional aspects of his subject. Apart from his studies of people, Muhlstock during that era created a number of oil paintings of empty, plaster-cracked rooms which in themselves are tellingly evocative of the Depression years.

Socially conscious artists wrote of the need for their fellow-painters to engage in the earnest business of describing the state of a depressed society through portraits of its people. André Biéler declared, of a Canadian Group of Painters exhibition in 1942: "Since the Group's formation, significant art in Canada has truly expressed its period: a period of escape. By crowding the walls of our galleries with pictures showing only the untainted beauty of our land, we have left no room for the expression of that deep uneasiness and sorrow that is in our souls. The Depression did not hit us as it did the United States. That sudden bringing-down-to-earth so beneficial to our friends across the border did not occur here. We have not had an exhibition to equal or approach the World's Fair Section of Fine Arts [1939], where the social scene was depicted by the majority of painters."

In 1941, painter Pegi Nicol complained: "For years one

YORK WILSON *Welfare Worker* 1940 36x30 Collection: The Artist

wished our vigorous Canadian painters might focus a little on man. There were portraits in the yearly shows, but portraits are reflections of individuals. Man in his environment and doing have been considerably neglected as a subject. The Americans have their Marsh, Curry, and Wood, crossing their canvases with the people they know. Man moving and acting; persons by shape and form, by personality, and feeling, juxtaposed against each other. This sort of painting has been decidedly missing from Canadian art."

The response to these pleas in Canada was not comparable to the art movement in the United States where Depression artists were sponsored by the Federal Government to design murals in post offices and other government buildings. The times being what they were, however, many Canadian artists *did* reflect the unhappy era in their paintings, if only in unhappy faces. In

The Canadian Group of Painters exhibitions of the period, there were canvases of both compassion and protest. In the 1937 show of the Group, Paraskeva Clark exhibited a violently anti-capitalist satire, Petroushka, which showed a top-hatted capitalist and a policeman beating a worker. Alongside it were hung such works as Pegi Nicol's sad commentary on the plight of poor children, Children at Play Anywhere; Nathan Petroff's pointed, if melodramatic, note on the social impact of the Spanish Civil War, Modern Times; Philip Surrey's melancholy Going to Work; and John Alfsen's muted The Guitar Player. John Lyman's rooming house scene, Lassitude, and the famous Dr. Norman Bethune's Light Operation rounded out a gallery which revealed the temper caught up in them.

For the next five years, until the terrible Depression was brought to an end by an even more disastrous war, the Canadian

ABA BAYEFSKY *Market Forms* 1955 38x50 Art Gallery of Hamilton

Group exhibitions provided a showcase for social art. In 1939, Prudence Heward showed her painting of a pensive child's face, At the Farmhouse Window, Jack Humphrey portrayed the pinched face of Edgar Price, York Wilson introduced a note of Depression recreation in Burlesque Number Two, and Louis Muhlstock reached into the ghetto for his Rabbi.

These paintings of the human situation may not have been creative masterpieces, but they were true and able descriptions of their era. If nothing more, they should serve to remind Canadians of days when people were rarely happy, and contentment was only a dream for most. History being what it is, it would be foolish for us to forget such times.

The emphasis on figurative art during the Depression years had a continuing effect upon the work of many painters. The career of Jack Nichols has remained centred around the human figure. The poignant emphasis of his poverty pictures gave way, successively, to studies portraying the strain of war; a long, happy series of playing children and, finally, humanity symbolized in a dramatic group of metaphysical lithographs. York Wilson maintained his interest in the human comedy through his ballet studies and satiric canvases of the forties. Louis Muhlstock eventually left behind his transients in the park for lyrical nudes, but John Alfsen continued as a painter of portraits until his death. Aba Bayefsky has never deserted society around him and Philip Surrey still paints city life with increasing authority.

The Depression probably did more than anything else to direct the attention of Canadian artists away from the landscape which had preoccupied the Group of Seven. Creative concern turned inward, to the emotional and physical suffering brought about by poverty. The Group of Seven members, themselves, continued

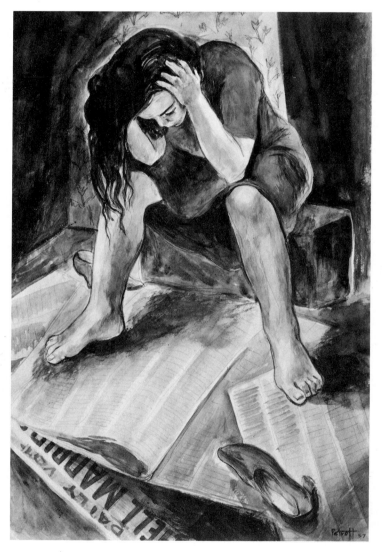

LOUIS MUHLSTOCK *William O'Brien, Unemployed* c. 1940 27x20 Collection: The Artist

NATHAN PETROFF *Modern Times* 1937 22x14 National Gallery of Canada

in their portrayal of the physical wonders of the nation, but few younger artists followed them. Their emotions were fully involved in compassion for their fellow-citizens and in their battle for survival as artists. The bread line was a more dramatic reality for them than any Lake Superior shoreline.

Throughout history, prosperity has tended to draw art away from a profound concern for basic human affairs. Affluence has favoured the decorative, the high-spirited, the witty and the facile. Court art, for all its glorious pageantry, rarely displays the pathos of man's condition; it has been left to the modest or poor painter to plumb the deepest reaches of our common humanity. Artists like Chardin, LeNain, Rembrandt (in his impoverished years), Van Gogh or Daumier touch a chord of humanism which, in its own way, is as fundamental to our spiritual and emotional nourishment as the heights of religious expression. Such art brings about a recognition of self which can move us to view our fellow man with a more ready and complete understanding. In its own modest way, Canadian Depression art achieved this for its era.

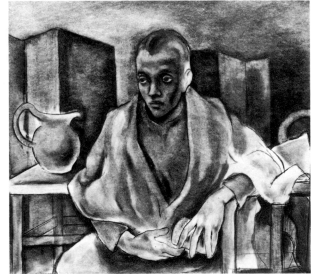

JOHN ALFSEN *The Guitar Player* 1937 44x36 Art Gallery of Hamilton

JACK NICHOLS *Sick Boy with Glass* 1942 24x27 Art Gallery of Ontario

7/ *Artists at War*

War was a special feature of The Canadian Group of Painters Exhibition of 1945. More than a dozen members of the Group were serving as Official War Artists overseas, and twelve of their paintings were hung in the exhibition to symbolize those artists' years of service abroad on the battlefronts of Europe. Among the twelve canvases on view were some of the best to come out of the services: Charles Comfort's Canadian Armour Passing through Ortona, Will Ogilvie's Bombed Houses, Caen, Carl Schaefer's Q for Queenie, Jack Nichols' Rescue at Sea and Lawren P. Harris' Tank Advance.

War service acted as a creative stimulant upon some Canadian Group artists and they did much of their best work between 1942 and 1946. There is nothing surprising about this; war has acted as a creative catalyst throughout the history of art. Such masters as Leonardo, Rubens, Uccello, Velásquez, Goya and Picasso recreated the fruits and terrors of war, each in his own temper and time.

During modern times, art has assumed an important function as a recorder of history. During World War II, a dramatic and irreplaceable portrait of this country's efforts was made by Canadian artists who shared most of the dangers and difficulties of front-line troops. Their creative subject matter was the preparation for and engagement in battle, death and destruction. Their studios were air bases, destroyers and battlefields. Their uniforms were the standard battle dress of commissioned officers.

One of the earliest Official War Artists was Charles Comfort, who spoke for most of his fellow painters-in-uniform in his book *Artist at War*. In its pages he captured the perils of painting in the midst of battle: "One of the risks of our work was that one became deeply preoccupied, and danger was upon one

MICHAEL FORSTER *Submarine Pens, Brest* 1945 22x36 The Public Archives of Canada

before it was realized. Danger could disclose itself in many ways. Sometimes a noisy ricochet would alert me to the fact that artillery targets were shifting....occasionally ME's or FW's dived from the clouds surrounded by ack-ack bursts and tracer. Down they would come, with those funny little black crosses on their wings, and then came the bombs. Depending on how close they were, we made notes on the spectacle for future reference or we got into cover we had previously recced.... What we painted under those conditions was never what we might have done in the contemplative quiet of a studio, but we were getting the raw material, the eye-witness experience, which should lend authority to anything we might eventually do in relation to the campaign."

Of necessity, war artists on duty at the front carried a minimum of supplies. Most of them used light, portable sketching easels, a drawing board and a collapsible stool. Their media were watercolour, pen and ink, pencil, chalk and charcoal, any of which permitted speed of execution and ease of storage. Later, many of these on-the-spot studies would assist in composing larger studio canvases. In this way, literally thousands of paintings and drawings were accomplished by the thirty or so painters who were appointed as Official War Artists.

Despite the portability of their equipment, nothing could improve the elements under which they often laboured. Comfort reported: "These winter experiences were uniformly miserable. The Abruzzi coastal plain has a penetratingly damp chill climate, a fact which could in no better way be appreciated than by sitting out all day on a sketching stool."

☐ The first of the Canadian Army War Artists to go to the front was Will Ogilvie, who landed with the 1st Canadian Division in

ABA BAYEFSKY *The Pit, Belsen Concentration Camp* 1946 36x48 The Public Archives of Canada

Sicily. Ogilvie covered the battle activities of both the 1st Division in Italy and the 4th Canadian Division in Northwest Europe. During his service from 1941 to 1946, first as a service artist and then as a commissioned Official Artist, Ogilvie realized the most important oil paintings of his career. Such memorable compositions as Bombed Houses, Caen; Dead City and Escape Route are compelling by the very simplicity of their design and solemnity of tone. Behind these major canvases stood the many hundreds of studies made in the field. Like the great British war artist, Paul Nash, Ogilvie could crystallize and hold a moment of conflict which contained within it all of the tenseness and danger of the actual holocaust.

☐ Charles Comfort's war reports from the front in Italy have the surety, ease and inevitability of a master watercolour artist. There are no accidental dribbles, no fake textures, no fiddling details in these watercolours about war; they are masterpieces of their kind and deserve to be hailed as such. They can be contemplated as exceptional works of art quite apart from their value as factual records of warfare.

☐ Another artist who did some of his finest paintings during the war was Michael Forster, who was attached to the Royal Canadian Navy. Forster produced a relatively small body of work during his year and a half as an Official War Artist, but the best of this belongs in the mainstream of Canadian painting. The glowing colours and ghostly forms of his impressions of bomb damage to the German submarine pens at Brest almost enter the realm of romanticism in art, just as do Henry Moore's wartime studies of sleepers in London's subway shelters.

☐ Artists associated with The Canadian Group of Painters worked on many fronts during the war. The noted magic realist

LAWREN P. HARRIS *Tank Advance, Italy* 1945 30x40 The Public Archives of Canada

Alex Colville served with the 3rd Canadian Infantry Division in Northwest Europe and produced an immense body of work, most of it in pencil and charcoal. Probably Colville's most memorable studies were his poignant drawings of casualties – Dead Paratrooper, Young Prisoners, Exhausted Prisoners and Dead Women. They reveal the same intimate look at the human side of existence which marks his later paintings of people and places in his native New Brunswick.

☐ Undoubtedly the most nightmarish Canadian war paintings were those by Lawren P. Harris. His haunting visions of the Italian campaign happen in a near surrealistic world, each form as smooth as glass, without any reassuring surface textures of reality to fix upon. Melfa River Crossings, Tank Advance, Night Attack Before the Hitler Line are truly terrible paintings in their dramatic impact, portraits of a world as far out of normal

human existence as any subject by Salvador Dali.

☐ A close friend of Comfort and Ogilvie, Carl Schaefer, found himself directed to a very different theatre of war. Schaefer's skill as one of this country's outstanding watercolour artists fitted him ideally as an Official War Artist. For more than two years overseas, Schaefer followed the activities of Bomber Command and Coastal Command operations in Britain and Iceland. He flew on several operations which he portrayed in such dramatic studies as Bomb Aimer, Battle of the Ruhr and Flying Against Berlin. Like other war artists, Carl Schaefer worked under the same discipline as other military personnel.

As I wrote in a *Saturday Night* essay on Schaefer at the time: "All Official War Artists receive commissions, but they get none of the special privileges and more easy-going freedom which is the lot of the average civilian war correspondent. Schaefer and

E.J. HUGHES *Canteen Queue, Kiska* 1945 40x43 The Public Archives of Canada

his colleagues are subject to all of the rules and regulations of enlisted military personnel. The strict formalities of dress are probably the most trying discipline to artists like Schaefer who always affected a slightly sloppy individualism in their peace-time dress."

Schaefer and many other artist-recorders carried small but first-rate cameras with them when covering assignments, to make notes of mechanical details which it would be impossible to retain in the memory, yet which were essential to the factual reporting that was expected of them.

The long war experience had a profound, if temporary, effect upon the creative approach of the artists involved. This fact was illustrated by Schaefer. When he went on a few days' leave up into the quiet pastoral lands about fifteen miles north of Greater London, he decided to return to his first love of landscape paint-

ing. He sat down with his easel to portray, after a year-and-a-half's layoff from such things, a small rural scene under a light summer sky. It was the sort of thing he had painted so often in his native county of Hanover, Ontario. But when he set his brush to paper, he found he could not function creatively. More than eighteen months of visual concentration on fuselages, hangars and wind socks, searchlights, flak and wrecked hulks of planes had completely neutralized his feeling for peaceful landscape.

☐ Another artist affected deeply by the tragedy of war was Jack Nichols. At twenty-three, he was one of the youngest Official Artists. Nichols had worked as a deck hand on Great Lakes freighters in his teens, but that was a very different nautical experience from those he underwent on board destroyers in action. As a naval war artist, Nichols was involved

CARL SCHAEFER *C. for Charlie* 1945 16x10 The Public Archives of Canada

JACK NICHOLS *Action Stations HMCS Iroquois* 1944 29x23 The Public Archives of Canada

primarily in the Normandy Invasion landings and destroyer action near the Nazi submarine pens at Brest. The tension and danger of such events stripped men down to their most elemental selves and Nichols succeeded in capturing this starkness in his almost brutal wash and charcoal compositions. The individuality of the men's features is submerged under the uniform strain shared by them as a crew. They feed the guns and perform their duties with an almost hypnotic impersonality. Nichols was not a prolific producer of war art, but what he did create remains a lasting record of the impact of battle upon those thrust into it.

☐ Two other young painters, Aba Bayefsky and Bruno Bobak, both commissioned at twenty-one, did some highly specialized and effective war paintings. Bayefsky was attached to the Air Transport Command and the reconnaissance activities of the Tactical Air Force in Northwest Europe, but his most compelling impressions are of the charnel house at Belsen Concentration Camp. His sketches of the prison pens and burial pits there are grim and not-to-be-forgotten reminders of a slaughter within a larger war, a slaughter where the victims had no strength, weapons or opportunity to do battle on their own behalf.

Bruno Bobak had a much more pedestrian world to record. He was attached to the 4th Canadian Armoured Division in England and Northwest Europe, but from often seemingly unpromising material he achieved some convincing portrayals. By his choice of unexpected points of view and dramatic lighting, he brought human overtones to the mechanical side of war.

Not all of the artists in uniform responded so intensely to the war as human drama; in some cases they were recording activities in areas far removed from the fields of battle. E.J. Hughes

BRUNO BOBAK *Sherman Tanks Taking up Position* 1945 28x48
The Public Archives of Canada

WILL OGILVIE *Horsa Gliders of the 6th Airborne Division* 1945 21x32
The Public Archives of Canada

portrayed Arctic manoeuvres at Kiska in the Aleutian Islands, off the coast of Alaska, in a series of brilliantly composed canvases. Other artists were employed at more specifically sedentary activities. Edwin Holgate, for example, primarily painted portraits. Goodridge Roberts recorded the effects of weather on aerodromes, and never ceased being the landscape painter he was in peacetime. George Pepper was one of the more active war artists, mixing portraiture with battle studies, and produced some of the most vigorous records of the European theatre, especially in Holland.

□ Of all the portrayals of what could be called the more passive side of the war, those by Molly Lamb Bobak were the most witty and engaging. The only woman Official War Artist, Molly Bobak was twenty-three when she shipped overseas, about the age of most of the members of the Canadian Women's

Army Corps whose lives abroad she was to paint. Her impressions of CWAC going through their paces are delightful as paintings, as well as valuable historical documents.

□ There were many other war artists who painted one phase or another of the conflict. Anthony Law, Miller Brittain, T.R. MacDonald, Moe Reinblatt, T.W. Wood, Campbell Tinning, Eric Aldwinkle, Albert Cloutier, Orville Fisher, Harold Beament, Robert Hyndman, Paul Goranson, Rowley Murphy, Donald MacKay and Donald Anderson were all Official War Artists. Jack Shadbolt, Jack Humphrey, Robert Pilot, Paraskeva Clark, Lilias Newton, A.J. Casson, Peter and Cogill Haworth, Sydney Watson and Pegi Nicol were others who are represented in Canada's national war records collection, most of them commissioned to record some activity on the home front.

WILL OGILVIE *Bombed Houses, Caen, Normandy* 1945 30x24
The Public Archives of Canada

CHARLES COMFORT *Canadian Armour Passing through Ortona* 1945 40x48
The Public Archives of Canada

8 / A Montreal school

The early 1930's saw the beginning of serious unrest in the Montreal art scene. The local artists felt isolated from notice and influence, both at home and in the larger national picture. Their work was unexhibited, unappreciated, and even unseen by local collectors and the public. The private commercial gallery activity, now so bustling, was then dormant in Canada's largest city, and only exhibitions of safe European art or older Canadian painting were featured.

Fortunately, the young, frustrated artists found a fellow sufferer in John Lyman. Lyman was one of the best trained, most informed painters Canada has known. He also was one of the best organizers and propagandists in the cause of creative painting. Like Lawren Harris, Lyman was possessed of private means and, also like Harris, he used his advantages to assist and fight for neglected talent. In Montreal he served as a catalyst on the cultural front. He founded a succession of art groups to stir up interest in, and support for, artists who otherwise might have had to go it alone.

During the early 1930's the big explosion of French-Canadian art was still many years away. Paul-Emile Borduas was only in his mid-twenties and the *automatiste* revolution was still more than a decade distant. Lyman and his younger associates were almost totally Anglo-Saxon, but their struggles helped lay the groundwork for the wider Quebec upsurge in painting that followed. (Lyman, in fact, was the most aggressive supporter of Borduas' talents during his most difficult years of the late 1930's.)

Lyman's first organized group, The Atelier, included himself, André Biéler, Goodridge Roberts, Edwin Holgate and Marc-Aurèle Fortin. The Atelier held two exhibitions (March-April

GOODRIDGE ROBERTS *Reclining Nude No. 2* 1961 40x48 Art Gallery of Hamilton

1932 and May 1933) at the Henry Morgan Galleries, but folded in little more than a year. The Atelier studio sessions did serve the purpose of bringing artists together for discussion, and paved the way for future efforts. Lyman continued to organize informal, one-shot group exhibitions with Goodridge Roberts, Prudence Heward, Jack Humphrey, Marian Scott, Beatrice Robertson, Alexander Bercovitch and Jori Smith.

In 1939, Lyman sponsored two vitally influential groups. The first, The Eastern Group of Painters—composed of Lyman, Roberts, Philip Surrey, Smith, Humphrey, Bercovitch and Eric Goldberg—was short-lived, but the second, The Contemporary Arts Society, flourished for six years, until 1945. It was the most consistent supporter of new and vital art in Montreal, and stimulated many tributary exhibitions and groupings, such as the Independents (Lyman, Borduas, Stanley Cosgrove, Muhlstock,

Alfred Pellan, Roberts and Surrey) which showed at the Galerie Municipal in Quebec City in 1941.

The Contemporary Arts Society included lay associate membership, and in the catalogue for its initial exhibit, at the Frank Stevens Gallery in December 1939, it stated its chief ambitions: "The object of the Contemporary Arts Society is to bring you the modern art of our time. Enterprise of this sort is one function of the CAS but it has another equally important— to awaken interest in our own tradition, which cannot thrive without moral and material support from the community."

In 1945, The Contemporary Arts Society expanded its activities to include Toronto, and held an historic exhibition at Eaton's College Street Art Galleries. It was the first exposure of a non-Quebec audience to that remarkable body of artists, and came as a shocking experience to a city where abstract—or even

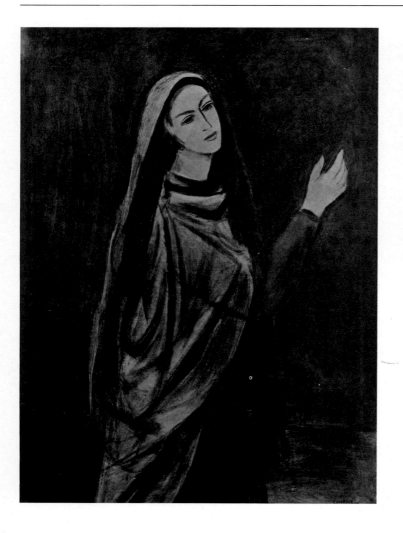

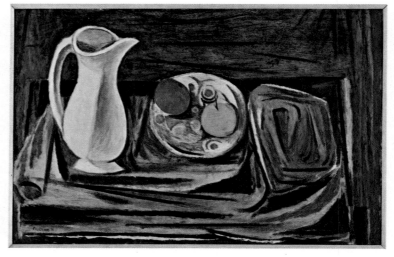

STANLEY COSGROVE *Saint Anne* 1952 46x35
Beaverbrook Art Gallery, Fredericton

STANLEY COSGROVE *Still Life* 1949 24x36 Art Gallery of Hamilton

semi-abstract—art was practised by only an isolated artist or two, and was roundly condemned both by painters and the public.

The heat of opposition in Toronto to experimental art at that time came home to me after my reviews of the 1945 CAS show appeared in *Saturday Night*. Letters arrived from artists and other readers accusing me of supporting "insane," "phony" and "Communist" painters. (The painters referred to included Paul-Emile Borduas, Fernand Leduc, Leon Bellefleur, Marian Scott, John Lyman, Jacques de Tonnancour, Pierre Gauvreau—all now recognized as artists of importance and, certainly in the case of Borduas, greatness.) Even the National Gallery waited until 1948 to acquire its first Borduas.

In my 1945 review I remarked: "A new, controversial spirit seems to be manifesting itself in the Canadian world of art. With the awakening interest in our native painting, increasingly keen and sometimes bitter differences of opinion are revealing themselves. Not for many years has one met with such surprisingly vigorous outbursts of indignation at modern art. These remarks are prompted by the realization that the paintings of such highly talented Quebec artists as Paul-Emile Borduas, Jacques de Tonnancour, Jean-Paul Mousseau, Pierre Gauvreau and Fernand Leduc have never been displayed in a commercial gallery outside of their province. This is especially worth noting when one remembers that Quebec is, on the whole, producing the most sensitive and scholarly painting being done in Canada at this time.

"Yet, in spite of the important role Quebec painters can play in our artistic life, their creations are hardly known to the rest of Canada. How many people in Ontario, for instance, are familiar with the works of Pellan or Borduas? Because French

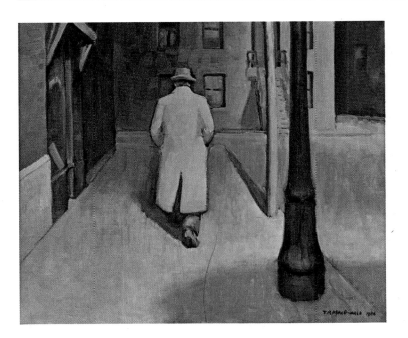

T.R. MACDONALD *1 a.m.* 1956 16x20 Art Gallery of Hamilton

H.W. JONES *Interior With Cats* 1957 30x40 Private Collection

Canada's painters underestimate the position of Ontario's Group of Seven in our art history—and possibly overrate Morrice's—is no fair reason to ignore them. Some arrangement, in fact, should be made to send Montreal's Contemporary Art Society's exhibition on tour across the country as is done with other society shows." That John Lyman persisted in his efforts to mount such exhibitions suggests the intensity of his conviction.

Lyman's determination to see his creative fellow artists receive their rewards was prompted partly by his own early treatment as a painter. His own first one-man show at the Montreal Art Association in 1913 was viciously attacked. One of the kindest remarks made about his paintings was: "They simply ruin the neutral tint of the Art Gallery's well-kept walls."

Lyman was exposed to the best of European art from the age of fourteen, when he made the first of his dozens of journeys back and forth between Montreal and France. He received his art training in France between 1907 and 1910, during one of the most experimental and exciting decades in the history of painting. He attended the Académie Julian and studied under the great Henri Matisse, at the latter's short-lived Academy. He came to know J.W. Morrice and the English painter, Matthew Smith. Lyman became close friends with Smith and painted with him over a period of several years. Matisse and Smith unquestionably had the deepest influence on Lyman's own work, influences he later passed on indirectly to such artists as Goodridge Roberts and Jacques de Tonnancour.

Lyman first showed with The Canadian Group of Painters in 1936, with his portrait of Nadia, followed later by Lassitude (1937) and The Serial (1939). His work is distinguished by its

GHITTA CAISERMAN *Girl in Window* 1957 36x48
Collection: Mr. and Mrs. Henri Kolin

FRITZ BRANDTNER *Burst into Life* c. 1956 21x26 Imperial Oil Collection

easy authority. Although his understanding of formal composition was complete, he rarely forced his forms into arbitrary designs for the sheer sake of aesthetic impact. He used his talent in a relaxed, stylish manner. His best portraits and landscapes possess an almost aristocratic reserve akin to that of the great French landscapist Albert Marquet.

The perceptive critic and painter Guy Viau, in a foreword to a Lyman exhibition catalogue (for Montreal's Dominion Gallery), wrote some phrases which apply equally to Lyman and his notable successor in figurative painting, Goodridge Roberts: "Lyman does not show off in his paintings. He reveals himself in them without effort. His art is one of contemplation."
□ Since he first exhibited with Lyman's Atelier group in 1933, Goodridge Roberts has consistently followed a figurative approach to painting, enriching its expression decade after decade. He has followed the classic tradition of painting landscapes, still lifes and figures with equal concern.

Born in 1904, Roberts first studied at the Ecole des Beaux-Arts in Montreal and then, like so many leading Canadian artists, attended New York's Art Students League. At the Art Students League he had the teaching of two of America's greatest painters, John Sloan and Max Weber. His first Canadian landscapes were a memorable series of watercolours of the Ottawa Valley, painted in the early 1930's. In order to do such paintings, Roberts earned his living then and for the next fifteen years by teaching, first at Queen's University and later at the Art Association of Montreal.

Roberts first started painting seriously in oils in 1938 and his best paintings of that year have a dry, stark power which still impresses. They are mainly dramatically-lit Gatineau views, and

PHILIP SURREY *The Red Tuque* 1968 18x14 Private Collection

Montreal street scenes in late afternoon, with long shadows. There was a strong emphasis on pattern in the paintings of this period that persisted for several years. The hard contours are particularly marked in the still lifes, nudes and such portraits as Marian Roberts, exhibited with The Canadian Group of Painters in 1939.

It was early in the 1940's, with his luminous green summer landscapes of Saint-Alphonse and Saint-Jovite, that Roberts emerged into the rich, heavily pigmented and loosely textured paintings which were to set the pattern for the rest of his career.

Socially, Roberts is a shy and tentative person, but his painted statements are direct and unabashed. His canvases are richly pigmented and vigorously rendered. In an era when most artists deny the essential material of their paint by brushing, spraying or rolling it as smoothly as possible, he takes delight in its

fatness, fluidity and adaptability. Roberts is also completely dedicated to natural forms for his subject matter. He paints all of his canvases directly and on-the-spot. Some of his paintings are finished within a few hours, while others take a few days, but all of them are done before the subject.

In an introduction to Roberts' first major show in Toronto in 1951 I commented: "Roberts rarely re-paints a canvas once it has dried. Once he has recorded the visual impact of the subject before him, the artist lays down his brush, for better or worse.... Whether painting a compote of pears, a rolling green Gatineau vista or a youthful nude, his best painting holds securely the spiritual moment of meeting between artist and object." Even his largest landscapes are done on location.

Roberts has been one of the most consistent exhibitors with The Canadian Group of Painters. From 1939 onward, he rarely

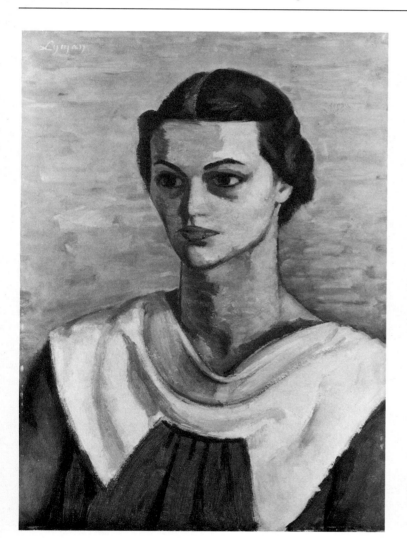

JOHN LYMAN *Woman with White Collar* c. 1942 24x17
National Gallery of Canada

JEAN-PAUL LEMIEUX *Amelie et le Temps* 1965 29x71
Collection: Mr. and Mrs. Jack Wildridge

missed sending paintings to its shows. From Still Life and Autumn Landscape in 1946, through Nude, Still Life and Laurentian Lake (1947-1948), Joan in the Rocking Chair and Georgian Bay (1955-1956) to Apple Trees in 1967, Roberts exhibited some two dozen works.

☐ In 1944, a small monograph about Goodridge Roberts was written by Jacques de Tonnancour. It was the warm tribute of a student to his former teacher. De Tonnancour had studied under Roberts during his mid-twenties, after what he describes as a four-year period of "sterile development" at Montreal's Ecole des Beaux-Arts. "Roberts," de Tonnancour said, "had a liberal outlook and a good understanding of creative problems. He helped me to find myself theoretically." Although he was a late starter, de Tonnancour's restless creative ambition brought him rapidly to public attention. For two years he was deeply influ-

enced by Roberts' landscape style, and even followed him in working directly from nature. Changes came quickly after that. From 1943 to 1945, de Tonnancour painted a series of elegant figure paintings under the shadow of Dufy and Matisse. As always, he was frankly aware of those influences in his work. They won him almost instant fame and success, as well as a scholarship to paint in Brazil.

The year in Brazil brought to de Tonnancour a creative crisis. When he arrived there in July 1945, he applied his easy command of technique to the lush South American landscape, and found his approach wanting. "There was so much natural beauty," he recalls, "that I felt it was hopeless to attempt competition with it." He felt strongly that he could not gain any continuing creative satisfaction from using nature as a model and, although he did considerable painting during his visit to

South America, he was constantly preoccupied with what future form his work might take. After a fallow period of many months, his painting took the form of a series of Picasso-oriented still-life and figure paintings.

Since his Picasso period of the late 1940's, de Tonnancour's restless intellect has taken him through several highly contrasting styles, ranging from descriptive landscape to pure abstraction. In the mid-1950's he returned to a series of straight landscapes of the Laurentians and Georgian Bay, followed by highly formalized, "black" studies of the same subjects painted with a rubber squeegee. In the 1960's, he went on to completely non-objective built-up relief panels in single-colour fields of Indian red, grey or ochre.

De Tonnancour exhibited a number of memorable canvases with The Canadian Group of Painters, including The Willows

(1952), Lonely Soul (1952), The Owl (1954), The Island (1956), and Laurentian Hilltop (1957).

☐ An artist who has been as consistent in his approach to painting as de Tonnancour has been experimental, is Philip Surrey. For more than thirty years, Surrey has recorded the human comedy in Montreal's streets, taverns, cafés and homes. No other Canadian artist has painted life in the city with such constancy and authority. He has shown it in all seasons, weather and moods, with candidness and a highly original outlook.

Surrey was born in Calgary in 1910, and began his art studies at the Winnipeg School of Art and at the Vancouver School of Art under Fred Varley during the late 1920's. Like so many leading Canadian figurative painters, he also attended New York's Art Students League. During the 1930's, Surrey settled in Montreal and in 1939 was a founding member of both The

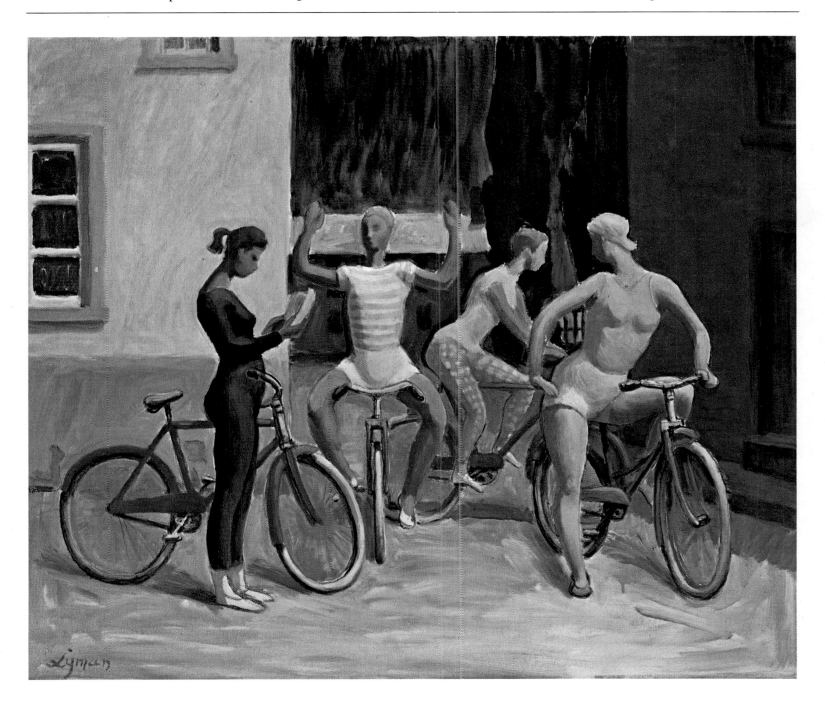

PHILIP SURREY *Girouard Avenue* 1968 31x23
Collection: Mr. and Mrs. R.N. Steiner

JOHN LYMAN *Cyclists* c. 1960 25x30
Dominion Gallery, Montreal

Eastern Group and The Contemporary Arts Society.

Philip Surrey's paintings are as much Montreal as Wyeth's are Pennsylvania or Vermont, and Colville's are New Brunswick. Since the thirties, he has drawn and painted hundreds of works dedicated to its people and places. Their titles tell the story, from Smoky Compartment (1941—Montreal Museum of Fine Arts) to Youville Tavern (1945), Pedestrians (1952), Dominion Square (1953), Tourist Rooms (1957), Café Plaza (1959—Winnipeg Art Gallery), Russell Hotel (1960), Bus Travellers (1962), Place Ville Marie (1964), Windsor Station (1965), Sherbrooke Street (1967), Orange Light (1968) and Victoria Square (1969). The basic theme, with variations, remains the same. Surrey has found more visual richness at home than many widely travelled artists have found in their searches. The style and technique with which he presents his material, however, has undergone subtle changes and enrichment through the decades. He has remained loyal to the classic materials of watercolours and oil paint, but his approach to composition, texture and especially colour, has become increasingly personal and evocative. During the 1960's he produced a series of works which captured the light-studded mystery of night in the metropolis as no one else has done. He has brought together the fluorescent world of traffic lights, neon-tubing, cast shadows, and passing forms reflected in shop windows, and integrated them into harmonious and crisply composed wholes.

A number of Surrey's earliest cityscapes appeared in Canadian Group shows: in 1937 Going to Work, in 1939 Sunday Afternoon, and in 1942 Montreal School Children and Listening to Music.

☐ During the 1930's a number of other Montreal artists were

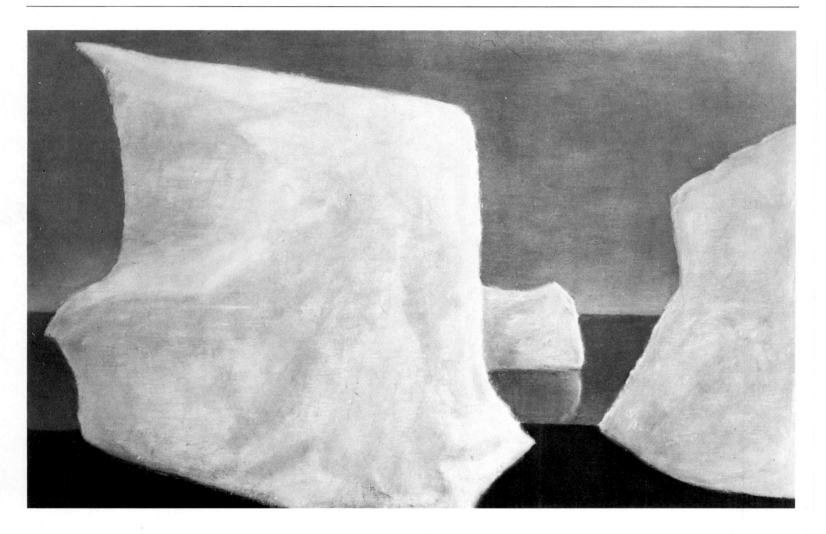

JEAN-PAUL LEMIEUX *Icebergs* 1962 27x43 Collection: Mr. and Mrs. A.N. Steiner

occupied with life in their city. These included Louis Muhlstock, Marian Scott, Fritz Brandtner and T.R. MacDonald. All of these artists, with the exception of Brandtner, were born in the first decade of the century and inherited basically the same figurative traditions.

Louis Muhlstock was born in Poland, but came to Montreal in 1911 as a child, and has spent most of his long career painting and drawing that city and its residents. He first exhibited with the Canadian Group in 1936, and since then has regularly shown in their exhibitions his briskly-painted canvases of Montreal views. These included such luminous streetscapes and interiors as Summer Landscape (1937), Street Corner in Montreal (1945), From My Window (1945), Spring on Mount Royal (1947), Groubert Lane (1954) and Two Doors (1956). Muhlstock divided his energies between such paintings and fluent crayon drawings of heads and nudes. He managed both media with equal effect. In a 1944 *Saturday Night* review I remarked that: "Muhlstock, besides being an excellent draughtsman, has a rich feeling for painting. Rather than possessing the dry, harsh contours which are too often the mark of the draughtsman-painter, his pictures are mostly rich, almost succulent, in paint quality and brush texture." In the 1960's his exhibits concentrated mainly upon nude studies. These works reveal Muhlstock as one of the few major figure draughtsmen to emerge in this country.

☐ Like Muhlstock, Montreal-born Marian Scott first made her reputation with city-oriented themes. Her Builders (1936), Cement (1942) and Tenants (1942), all exhibited with the Canadian Group, convey the grey mood of the Depression years. Her attention turned increasingly to symbolism and ab-

JEAN-PAUL LEMIEUX *Cardinal Léger* 1962 40x28
Collection: The Honourable Jules Léger

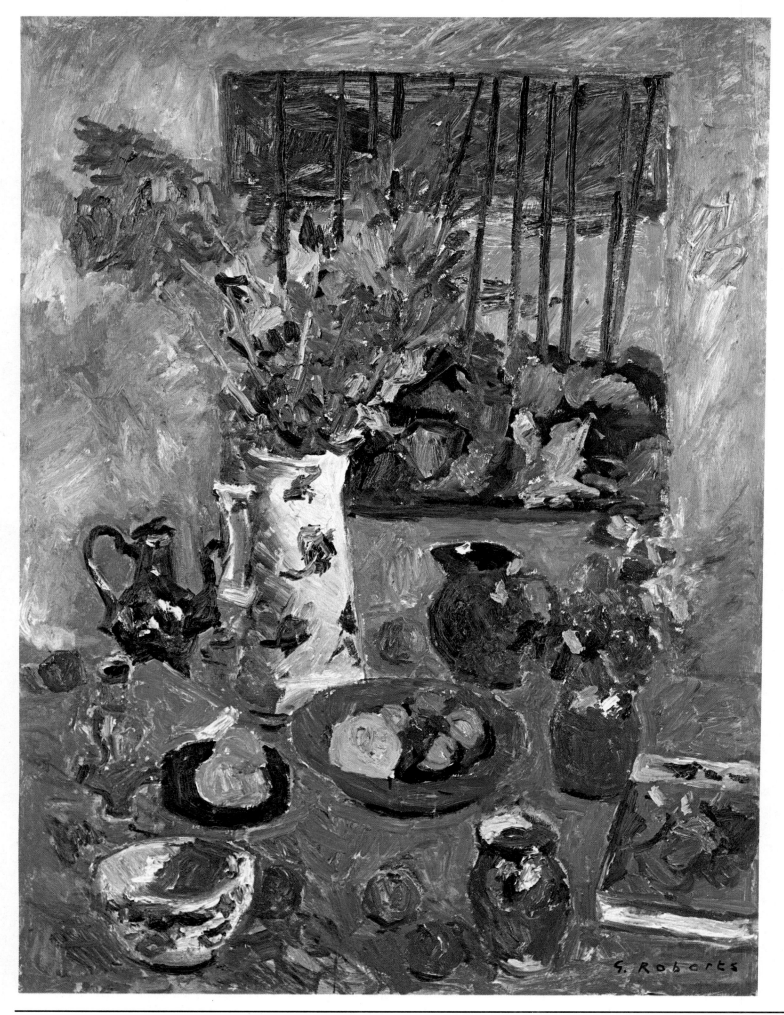

GOODRIDGE ROBERTS *Still Life with Detail from Velasquez Print* 1963 48x36 Art Gallery of Windsor

straction after she was commissioned to paint her mural (Endocrinology) for McGill University in 1940. The cell-like forms involved in that work directed her to a preoccupation with semi-abstract compositions based on scientific models. Cell and Crystal (1945), Fertilization (1945), Fossils (1945), and the crystal series of 1966, all shown in Group shows, led finally to the purely non-objective canvases of the 1950's.

☐ Fritz Brandtner was a product of German expressionist teaching, and remained true to it throughout a long career spent almost entirely in Canada. Brandtner was born in Danzig in 1896 and arrived in Canada, an already accomplished artist, in 1928. After some years in Winnipeg, he went to Montreal in the early 1930's and began his expressionist series based on city life. These are mostly executed in the pure black, red-yellows and blues of his German training, relentless in their pattern and vigour of execution. Their initial impact in Montreal exhibitions was such that one local critic referred to the "headaches of Fritz Brandtner."

Brandtner was an introverted artist, who preferred building his canvases up in his studio from notes to painting them on the spot. Most of his paintings are images and places remembered. For almost thirty years, he sent the best of these energetic canvases to the Canadian Group exhibitions, which he loyally supported until his death in 1969. Among these were Hockey (1939), The Blue Horse (1945), Billboard (1945), The Age of Anxiety (1947) and Winter Night in the City (1954).

☐ An artist who was very much a part of the Montreal scene during the 1930's, but later spent most of his career in Hamilton, is T.R. MacDonald. Born in Montreal in 1908, he studied at the Montreal Art Association and in Europe. Like Surrey,

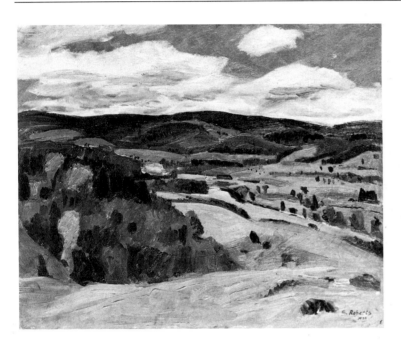

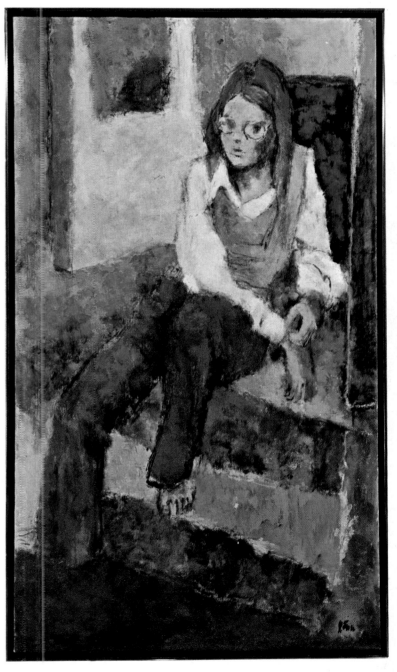

GOODRIDGE ROBERTS *Laurentian Landscape* 1939 20x24
Dominion Gallery, Montreal

JOHN FOX *Model 1* 1971 47x27
Marlborough Godard Gallery, Toronto

MacDonald captured the mood of the city in paintings done in both of his home bases. Although he has been the director of the Hamilton Art Gallery for a quarter of a century, MacDonald has continued to paint figures, interiors and streetscapes which are firmly based in the Montreal figurative tradition.

☐ Two nearly forgotten artists who contributed some fine work to the Montreal school were Alexandre Bercovitch and Ernst Neumann. Bercovitch was one of the Lyman group during the 1930's. Born in 1891, he painted many subtly composed and richly coloured portraits in the tradition of Cézanne. He exhibited Portrait of Ninel in the 1936 Canadian Group exhibition.

Ernst Neumann, a close friend of Goodridge Roberts and T.R. MacDonald, was one of Montreal's best figure painters and an accomplished printmaker. Born in 1907, his early death in 1955 went almost unnoticed, despite the fact that he had pro-duced some of the best studies of the figure then being created within the Montreal School.

☐ A student of Alexandre Bercovitch was Ghitta Caiserman, who continued Montreal's rich legacy of figurative painting into another generation. Born in 1923, she first gained prominence during the early 1950's with a series of novel compositions based on open windows. She explored the subject in numerous works throughout her career, each version having its own design and dramatic overtones, varying from rooms seen in deep shadow, with figures mysteriously hidden, to sun-shot views where the clarity of light draws the human subjects almost through the window frame. Ghitta Caiserman has remained a figurative artist when most painters of her generation have chosen abstrac-tion. She has focused on many themes, from domestic scenes of her own family to observations on contemporary chaos, in a

JACQUES DE TONNANCOUR *Figure Totemique* 1968 24x24 Imperial Oil Collection

compelling group of studies called Riots. She exhibited with the Canadian group from the early 1950's until its demise.

☐ Several prominent Canadian painters have studied painting in Mexico, among them Montreal's Stanley Cosgrove. Born in Montreal in 1911, Cosgrove studied at the Ecole des Beaux-Arts and at the Art Association of Montreal under Edwin Holgate. From 1939 until 1943, he worked in Mexico under a Quebec Government Scholarship. There he studied fresco painting with the great José Clemente Orozco, a fact which permanently influenced his style of painting. Cosgrove paints figures, landscapes and still lifes equally, but in all of them the thin dry technique of the fresco artist is evident. His technique is almost one of staining his washes of browns, burnt reds and ochres into a semi-absorbent ground. He was a member of The Canadian Group of Painters for several years.

☐ Perhaps the closest thing to purely French figurative painting in recent Montreal art are the nudes, portraits and landscapes by John Fox. Fox first studied under Goodridge Roberts at the Art Association of Montreal, and later in London and Florence. His technique is so tentative that his high-keyed colours seem at first to lose themselves in one another. Fox, however, is a draughtsman of skill, and beneath his gossamer hazes of pigment, a carefully composed structure binds the underlying forms together. His textures, point of view and colour all suggest the late work of Pierre Bonnard, but with an Anglo-Saxon accent which is all their own.

☐ The Montreal figurative tradition persists in the works of many younger artists who showed in the later years of the Canadian Group. Patrick Landsley, H. W. Jones, Tobie Steinhouse and Gentile Tondino have all contributed noteworthy

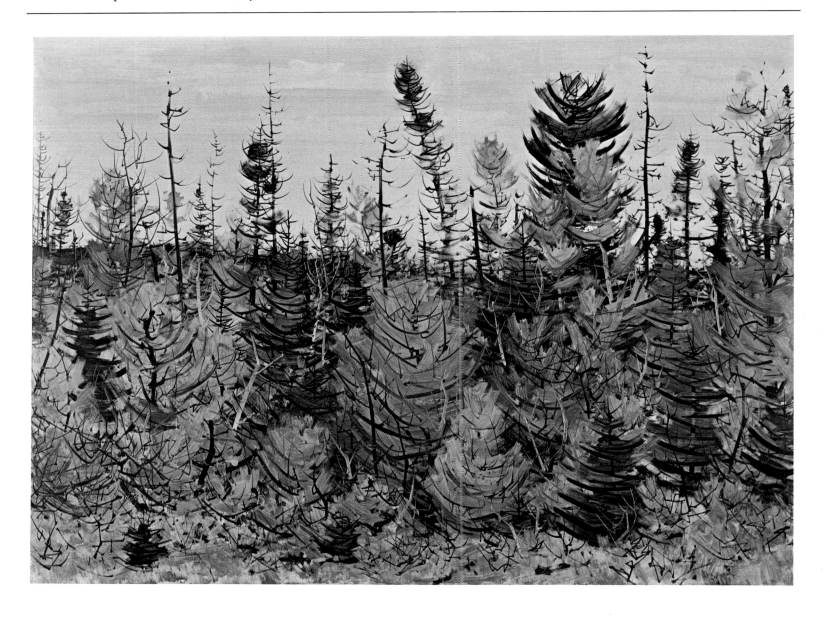

JACQUES DE TONNANCOUR *Edge of the Forest* c. 1957 32x44 Collection: Mr. and Mrs. J.A McCuaig

works to the Canadian Group and the Montreal figurative school.

Tobie Steinhouse worked in Paris from 1948 to 1957 and at New York's Art Students League. She has won international attention for her print-making, and her paintings reflect her special interest in experimental textural effects. She was a member of The Canadian Group of Painters and a regular exhibitor with its shows.

H.W. Jones studied at the Montreal Museum School of Fine Art under Arthur Lismer and Jacques de Tonnancour. Most of his paintings have been carefully patterned, semi-figurative compositions, with a strongly decorative bent. In recent years, sculpture has increasingly absorbed his attention and energies.

Moses Reinblatt is a Montreal-born artist who has contributed much to his native city through his painting and teaching. Born in 1917, he served as an Official War Artist with the RCAF overseas, and then commenced a teaching career—first under Arthur Lismer at the Montreal School of Fine Art and Design and later at the Saidye Bronfman Art Centre.

☐ A graduate of Montreal's Ecole des Beaux-Arts and later one of its finest teachers, is Jean-Paul Lemieux. Lemieux has been the quiet man of modern Quebec painting. Without fanfare, he has gone about producing his haunting and memorable images of French-Canadian life for more than three decades. If there is a lyric poet among Quebec painters, it must be Lemieux. He reaches the soul of the province through its people and landscapes, which he usually presents with a limited palette of greys, greens, ochres and browns, and a disarming simplicity of form.

Lemieux has come to his compelling simplicity through a long and searching evolution. Born in Quebec City in 1904, his

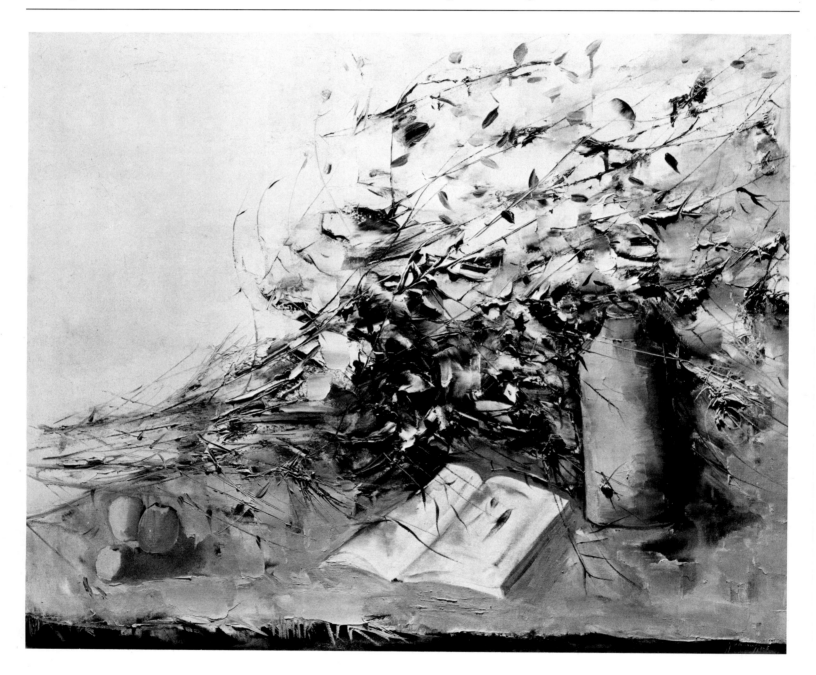

MOE REINBLATT *Still Life with Book* 1971 40x50 Waddington Galleries, Montreal

early paintings of the thirties were forthright green landscapes, not unlike those of Goodridge Roberts. (They were perhaps the result of his years at Montreal's Ecole des Beaux-Arts under Edwin Holgate and Charles Maillard.) By 1940, his lifelong concern for the customs and traditions of his fellow French-Canadians began to show itself in a remarkable series of detailed compositions, reminiscent at once of the early Italian primitive artist and of the English religious painter, Stanley Spencer. His Lazarus (Art Gallery of Ontario) is possibly the most telling religious painting done in Canada during this century.

During the 1950's Lemieux began reducing the detail in his paintings, deliberately setting aside his technical virtuosity to isolate a single figure or empty horizon, and to present them in the simple, tonal schemes that have become the special mark of his genius. In 1956, his first totally personal images appeared, and that year he produced such triumphantly original canvases as Le Visiteur du Soeur and Le Train de Midi, both of which were bought within a year of their creation by the National Gallery of Canada. Redolent of the open spaces of Quebec, their impact is often emphasized by Lemieux's choice of a long, narrow format for his compositions.

Lemieux's style has remained fairly constant since the late 1950's. He has merely enriched his output with new subject matter, such as the many portrait impressions which sometimes are unnamed symbols of Quebec character and at other times are specific portrayals, like the notable study of Cardinal Léger.

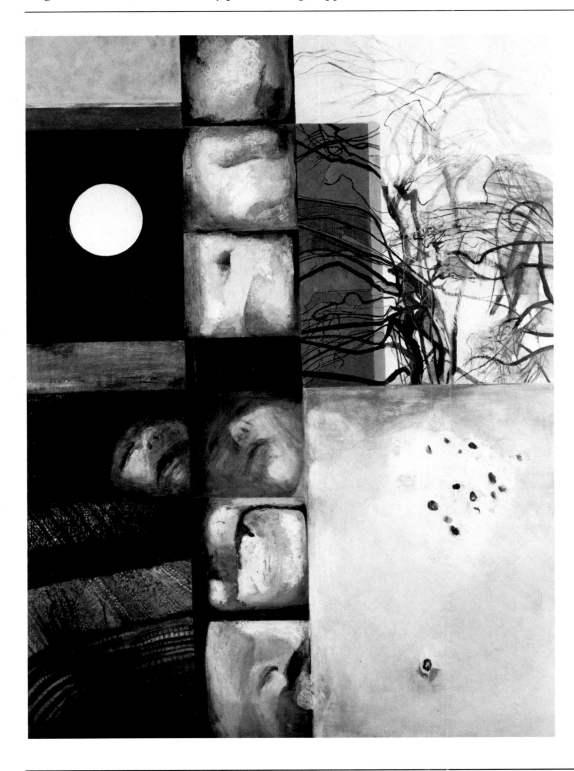

GHITTA CAISERMAN *Dream Puzzle* 1971 48x36 Waddington Galleries, Montreal

9/ Quebec explosion

Undoubtedly, the greatest single hero of recent Canadian art is Paul-Emile Borduas. He possessed all the right attributes—genius, supreme dedication, leadership and a compelling personality. He remade painting in French Canada for his own generation, and has become a legend for the one immediately following.

Paul-Emile Borduas' career was deeply rooted in the craft traditions of Quebec. His father was a carpenter, and a neighbour in St Hilaire was the brilliant painter and mural designer, Ozias Leduc. Like Borduas, Leduc was born in St Hilaire, was self-taught, and devoted himself utterly to his work as a painter and church decorator. Leduc's assistance and influence upon Borduas was undoubtedly the most important single factor in his evolution as an artist. Stylistically, no two artists could be further apart than those two, but in their monastic devotion to

their art they were alike. Leduc lived a completely solitary existence in St Hilaire, and Borduas buried himself in his studio for most of the fifty-five years of his life, only emerging to preach his particular aesthetic creed.

Borduas first learned his art on the job, in the tradition of the old masters. In his early teens he was apprenticed to Leduc, and for more than ten years he worked with him decorating Catholic churches in Quebec and the Maritimes. It may appear difficult to equate the young painter of traditional angels and madonnas with the revolutionary artist of later years, but the technical demands made upon Borduas in those early years revealed themselves later in his easy command of non-figurative forms.

Borduas was late in arriving at his knowledge of contemporary art movements. Though he had been to France in his twenties, he went to study church decoration under Maurice Denis at

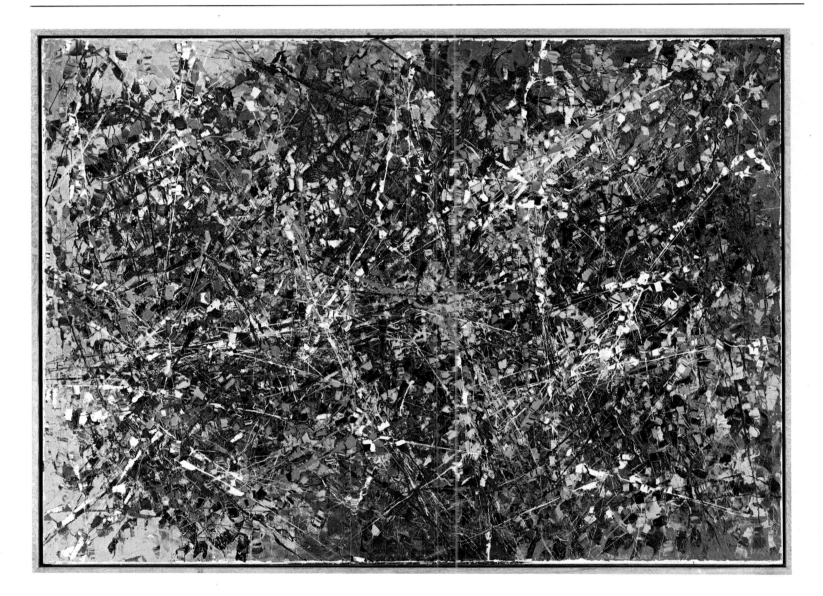

JEAN-PAUL RIOPELLE *Composition* 1952 72x108 Toronto-Dominion Bank Collection

the Ecole des Arts Sacrés, and there is no evidence that he responded at that time to the impact of surrealism and other experimental art of the period. His only symbolic revolt against traditional values and society was his rejected application to settle in the South Sea island of Tahiti.

It was almost certainly his meeting with John Lyman, in 1937, that first directed Borduas' restlessness into the fertile channels which would make him one of Canada's greatest painters. Lyman brought his attention to the European surrealist movement and, in particular, to the work of André Breton, the leader of the movement, an automatic painter and the chief surrealist spokesman. Moreover, Lyman gave Borduas active encouragement and a platform to exhibit on when he founded The Contemporary Arts Society in 1939. Borduas was Vice-President of that Society from 1939 to 1945, and in 1948

became its President.

It was Breton, however, who gave Borduas his creed and confidence, releasing his psychic needs and ending more than twenty years of creative frustration. Almost overnight, the Quebec painter's work changed from frustrated confusion to frenetic painting activity. His enthusiasm overflowed into propaganda among his fellow artists, which may indicate that his church art years left the mark of the missionary upon him.

Borduas accepted, almost whole, the ideas and writings of Breton. He seized upon his automatic or subconscious attitude to art, as expressed in the original Surrealist Manifesto of 1924 and restated in *This Quarter* in 1932: "Pure psychic automatism is intended to express in speech, in writing, or by other means, the true process of thought. Automatism is thought's dictation, sans all control exercised by reason and outside of all aesthetic

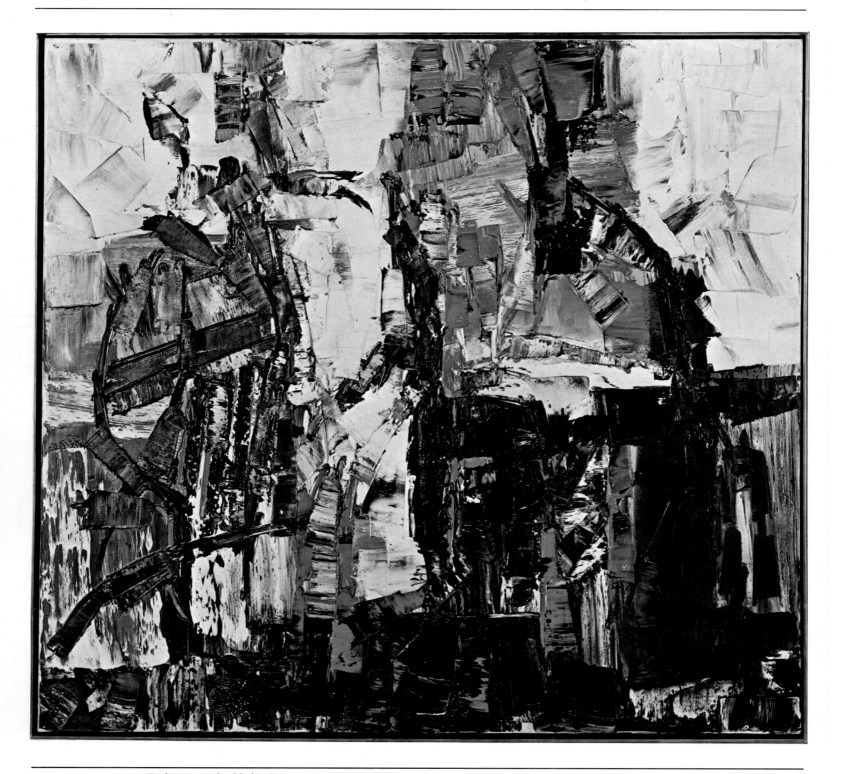

JEAN-PAUL RIOPELLE *Exploration* 1961 44x48 Gallery Moos, Toronto

and moral preoccupations." Uncritical spontaneity was the essence of Breton's surrealist dogma, and Borduas did not hesitate to adopt it when he issued his now famous manifesto, *Le Refus Global* of 1948.

The political activism which accompanied *Le Refus Global* perhaps reflects Borduas' genuine, if denied, religiosity, so deeply ingrained in his youthful St Hilaire days. Even the measured restraint of his last black-and-white paintings suggests a rooted, monastic temperament. Certainly, by the early 1940's Borduas was prepared to save Quebec art through his discovery of automatic surrealism, and he gathered about him a number of gifted and loyal disciples in the persons of Marcel Barbeau, Marcelle Ferron, Pierre Gauvreau, Fernand Leduc, Jean-Paul Mousseau, Jean-Paul Riopelle and Françoise Sullivan.

Le Refus Global was a combination of a social battle cry and a sincere bid for public attention. Despite later claims, the *automatistes* could not honestly say they had been completely ignored before the 1948 publication of *Le Refus* (although, it must be admitted, the public museums, including the National Gallery of Canada, refused to buy a Borduas until 1948 and after).

Years before *Refus Global*, as early as November 1945, I had written in *Saturday Night*: "In Borduas and Fernand Leduc, J.P. Mousseau, Pierre Gauvreau and Leon Bellefleur, all of whose work stems from the more creative half of surrealism represented by André Masson and Paul Klee, we encounter a group of artists whose works are very likely going to have to be seriously reckoned with in the not too distant future. No intelligent gallery-goer can deny that such paintings as Borduas' Composition, Leduc's Et leur ombre dit adieu au jour,

PAUL-EMILE BORDUAS *Le Chant de la Pierre* 1956 45x58 Toronto-Dominion Bank Collection

104

Gauvreau's Fonction and Mousseau's Aspect Franc form the basis of what is very likely to become an important trend in Canadian art of the next decades."

Borduas died just fifteen years after that was written, and in the intervening years his genius had exploded into masterpiece after masterpiece.

It is not necessary to demean the importance of *Le Refus Global* to note that it has served at times to divert attention from the works of art of Borduas themselves, which, after all, form the essence of the man's genius. Despite the vast notoriety it has received, much of *Le Refus Global* now seems a little obvious and banal, although its dramatic phrases no doubt were necessary in 1948 to arouse wide attention in Quebec. It is a *mélange* of ill-digested socialist, surrealist and anarchistic sentiments, with a touch of Quebec Libre. It is passionate but

naïve. Perhaps it broke new ground in Quebec, but its rhetoric is at times so commonplace that it would embarrass an undergraduate debating society. The most valuable part of it occurs in the early paragraphs which deal eloquently with the gradual emergence of French culture from its primitive agricultural beginnings.

Some of Borduas' protests in *Le Refus Global* suggest an interesting aside about his own personality. He had spent twenty-five years of his life for, and in close association with, the Catholic Church. His anti-clerical diatribes in his neo-Marxist manifesto suggest a child attempting to break away from the irrevocable heritage of his parents. "To hell with the incense-burners and holy-wine suppers!" he cries. "They extort a thousand times over anything they have ever conferred. Reaching over their heads we are able to touch the ardour of human

PAUL-EMILE BORDUAS *Figure Schematique* 1956 51x77 Gallery Moos, Toronto

PAUL-EMILE BORDUAS *Mouvement d'Avril* 1956 40x32 Dominion Gallery, Montreal

fraternity, to which Christianity has become a closed door." This from someone who had lived from the Church as an artist for more than a decade.

Le Refus Global builds up, in a kind of self-hypnotic megalomania, to the most banal evangelical cant: "In a foreseeable period of time we envisage mankind, freed from his useless chains, fulfilling in the unchartered, necessary order of spontaneity, in resplendent anarchy, the abundance of his individual gifts. Meanwhile, without rest or pause, in community of feeling with all who are thirsty for a better life, without fear of long delays, with encouragement or against opposition, we shall follow joyfully our violent fight for liberation." It is not surprising that some of Borduas' colleagues refused to sign such a windy, pretentious document, even if André Breton did praise it as "lucid and courageous." In 1955, older but not more

verbally cautious, Borduas—then living in New York—was to have serious differences with some of his co-signers of the *Refus Global* when he described their work as old-fashioned. Fernand Leduc, on behalf of his colleagues Jean McEwen, Pierre Gauvreau, Jean-Paul Mousseau, Rita Letendre, Marcelle Ferron and others, blasted Borduas for his disloyalty and unwelcome criticism.

Fortunately, Borduas' own painting at its best has been free of such empty flourishes. It is economical, even spartan, in its logic and classic simplicity of statement. Even at its most expressionistic, there is a classic order in the placing of the broad, painting-knife strokes. He built his paintings into a richly pigmented but firm architecture.

When the American abstract-expressionist Franz Kline described Borduas as the "New World Courbet," he caught the

PAUL-EMILE BORDUAS *Silence Magnétique* 1957 64x51 Collection: Mrs. Ayala Zacks

character of both the man and the artist. Gustave Courbet, too, was given to revolutionary pronouncements, but there is not much of disorder or the inflammatory in his soundly composed nudes, landscapes or still lifes. Borduas, like Courbet, preferred the palette knife to the brush. In his most mature canvases he used the painting-knife and trowel exclusively for his oil paintings. This enabled him to express his love of surface textures to the full, at times almost to a bas-relief degree. In the canvases of the late 1940's and early 1950's he revelled in pure earth colours and black to produce such lush expressions as Les Parachutes Végétaux (1947 – National Gallery of Canada) and La Prison des Crimes Joyeux (1948 – Art Gallery of Ontario). The greatest works of Borduas, however, and those for which he will be best remembered, are the white paintings he created from 1955 onward.

These, his most truly Canadian works, were all painted outside of Canada – in Provincetown and New York, from 1953 to 1955, and from then on in Paris, until his death in 1960. In the beginning the white is stained with colours in floral petal patterns, but in the end the white stands alone, confronted starkly by patches of pure dark blue, brown or black. They are proof that he never left the deep white snow of his native St Hilaire very far behind.

In December of 1955, Borduas in his homesickness wrote from France to his friend Madame Lortie: "At this point, I would give Paris and all the blessing of the earth for a small corner were it in Canada."

There can be no question now that Borduas possesses forever his small corner of Canada. The gravity, the intensity, the simplicity of his last black and white canvases make his stake

PAUL-EMILE BORDUAS *Masques et Doigt Leve* 1943 19x22 Art Gallery of Hamilton

secure. After his death, John Lyman, his early friend and counsellor, wrote perhaps the best brief epitaph for him: "He scorned the easy way; he sweated blood."

☐ Borduas' most famous student was Jean-Paul Riopelle, who studied with him at Montreal's Ecole du Meuble in 1943. Unlike Borduas, Riopelle's path to international fame was quick and easy. Born in Montreal, he emigrated to Paris permanently in 1947, when he was twenty-four, and is now most often regarded as a painter of the French school.

Riopelle's vivacious, extroverted style of painting readily caught the eye of noted French dealers who influence the trends of international patronage. His Paris agents arranged for allied dealers in London, New York and elsewhere to feature his art, and he became the first Canadian-born artist to be promoted on a truly international scale.

Riopelle has justified the faith of his supporters with decades of iridescent, technically remarkable abstractions, many of them contemporary masterpieces. He is a prolific worker and his works already run into the thousands. Most of his canvases are purely non-objective, but from time to time he has returned to themes derived from the landscapes of Canada, New York's Fire Island or France.

Riopelle has worked with palette knives almost from the beginning of his career, but he handles the knife with a delicacy and variety of touch that singles him out from other action painters. He builds his paintings up with mosaic-like strokes, which are alternatively blended and hard-edged. In the works of the early 1950's which first brought him to fame, the overall texture of his compositions is close-knit. In later years, his calligraphy has often changed to wide expressionist swirls as he

ALFRED PELLAN *La Mer Rose* 1964 40x48 Collection: Mr. and Mrs. Jack Wildridge

reaches for new variations of his basic technique.

Riopelle has ridden his multi-coloured magic carpet style to numerous international awards, including the prestigious UNESCO prize at the famed Venice Biennale exhibition of 1962. In that year, he filled the Canadian Pavilion in Venice with fifty-four paintings and sculptures. He had previously been Canada's representative there in 1954, at the age of thirty-one.

Riopelle has lived abroad now for more than half of his life, but a special allegiance to Canada has remained, and when he is asked to name the painters who have influenced him most deeply he always places near the top of the list the same Ozias Leduc of St Hilaire who taught and employed Paul-Emile Borduas.

□ A fellow-student of Jean-Paul Riopelle under Borduas was Marcel Barbeau, who now lives in the United States. Barbeau, born in Montreal in 1925, shared a studio with Riopelle for a time and signed the *Refus Global*. He showed in the 1940's with The Contemporary Arts Society and was represented in a number of *automatiste* exhibitions. In recent years, Barbeau has joined the retinal school of Op painting and has established a reputation for his vibrantly patterned compositions.

□ Another major hard-edge artist who graduated from the romantic attitude of the early *automatistes* to the highly-disciplined classical abstract school is Fernand Leduc. Born in Montreal in 1916, Leduc is unquestionably one of the most accomplished and informed of all contemporary abstract painters in Canada. He is perhaps the ablest spokesman among French-Canadian painters, and defended himself and his colleagues, McEwen, Mousseau and Letendre, against his old

ALFRED PELLAN *Evasion* 1949 60x36 Art Gallery of Hamilton

leader, Borduas, when the latter called Montreal abstract art "old-fashioned" in 1955.

☐ Three other graduates of the *Refus Global* days are Pierre Gauvreau, Jean-Paul Mousseau and Marcelle Ferron. Gauvreau's reputation rests solely upon his work during the *automatiste* days, but Mousseau and Ferron have continued to develop and change their painting into increasingly individual forms.

Mousseau, who early shared exhibitions with both Riopelle (1947) and Ferron (1949), later specialized in luminous sculptures composed of neon tubing.

Ferron, like so many Quebec artists, has divided her time between Montreal and Paris since 1953. She painted with Borduas in 1950 and adopted his method of working with a wide trowel. Her best works are expressionist colour-field compo-sitions in red, green, blue and black.

☐ Two women artists who are indirectly the legatees of Borduas' leadership are Lise Gervais and Rita Letendre. Lise Gervais paints with the same rich, trowelled patches of paint utilized by Borduas during his last period, but the impact of her pictorial message is very different. She sinks brilliant wine reds, ver-milions, blues and blacks in her white fields, composing canvases that are as feminine as they are compelling.

Rita Letendre has moved from the heavy impasto of Borduas to lean, optical designs which stress linear movement. Straight converging lines rush to a vanishing point in patterns that suggest spacial infinity and speed.

☐ The importance of Borduas in the history of modern Quebec painting is rivalled by the great fantasist, Alfred Pellan. Pellan and Borduas were born within a year of one another (1906 and

ALFRED PELLAN *L'Heure Inhumaine* c. 1943 51x64 Private Collection

1905), and both were members of The Contemporary Arts Society under Lyman. Pellan joined the Society in 1940, upon his return from more than ten years in Paris, bringing to the group a very different aesthetic philosophy and character from Borduas. Both artists had their own band of loyal disciples. Pellan, who began to teach at the Ecole des Beaux-Arts in 1943, strengthened his position in the Montreal art community. The Pellan and Borduas supporters divided into bitterly opposed factions. In 1948 the inevitable happened when the Borduas group won control of the Society at its elections and appointed Borduas its President. The Society split, and Pellan, with Jacques de Tonnancour, Mimi Parent and other sympathizers, resigned from it. Much to John Lyman's regret, The Contemporary Arts Society ended nine years after it began.

In a footnote to the Contemporary Arts Society conflict,

Borduas claimed in 1949: "Pellan completely rejected surrealism which for us has been the great discovery. Pellan only believed in cubism which, somewhat thanks to him, had already lost its mystery for us." In this, Borduas was both unfair and inaccurate. The statement only reflects the spillover from the surrealist movement in Europe, where dissent within was the norm, and most founding members found themselves ousted at one point or another during its existence. Although Pellan was not an "automatic" surrealist—any more than he was merely a "cubist"—much of his art is based on the free association of classic surrealism. That free association, however, is expressed in figurative or semi-figurative forms. The same is true of the work of such pioneer surrealists as Max Ernst and Giorgio de Chirico.

Pellan, by his very experimental nature, has never tied himself

ALFRED PELLAN *Persian Tree* 1960 18x18
Collection: Mr. and Mrs. Elliott Morrison

ALBERT DUMOUCHEL *Still Life* 1964 30x40
Carmen Lamanna Gallery, Toronto

to the structure of any single school. He has moved through straight representation, cubism, symbolism and surrealism with equal aplomb and good humour. He utilizes any source material required by his turn of fancy and remakes it into a brightly coloured world of his own. The closest thing to a label one could apply to him would be "fantasist," and one who relates unmistakably to his native Quebec, despite his international reputation. During his large one-man exhibition at the Paris Musée d'Art Moderne in 1955, French commentators at once noted the blending of Pellan's brilliant technique and sophisticated art knowledge with undeniable homespun accents of Quebec life. The Museum's noted director, Jean Cassou, also noted that Pellan's art was "animated with secret purposes, tumultuous with mysterious dreams and private myths"—all the pure stuff of surrealism.

In a dialogue between myself and Alfred Pellan that was published in *Here and Now* magazine in 1949, Pellan responded to a question concerning surrealism: "I embrace the surrealism of André Masson, Klee and Miro. But for Dali and Tanguy— those clever magicians—I have no respect...the subconscious is only a part of the painting problem. Surrealism has added to the richness of the artist's raw material. That material should still be filtered through the conscious mind. The painter should be like a fisherman who keeps some fish and throws the rest back. Then, of course, the fish should be carefully mounted."

Few Canadian painters have approached Pellan's prodigious technical skill. Borduas, for all of his genius, could not equal it. As John Lyman wrote: "Borduas was never able to construct a strong figurative image; the path he was to choose escaped that difficulty." Pellan drew figures and portraits as well as anyone

<LISE GERVAIS *A l'Angle des Terrasses* 1964 72x36
Toronto-Dominion Bank Collection

JEAN D'ALLAIRE *Still Life* 1953 34x36 Private Collection

in this country has done. He is one of our few great colourists, and he handles pattern in a way that is little short of magical.

Pellan has been one of the most productive of all our artists and the first Canadian modern to work regularly on a large scale. His paintings of the late 1940's often measure seven by five feet. Within them, kaleidoscopes of shape and colour compete for attention.

It was during the 1940-1950 period that Pellan realized many of his major compositions: Au Soleil Bleu (1950), Symphonie (1946), Surprise Académique (1944), Floraesin (1950), Femme d'une Pomme (1943) and Les Iles de la Nuit (1946). All of these works are painted in a fairly straightforward, classic manner, with a minimum of heavy impasto and emphasis upon black contour outlines. The figurative element, though distorted and freely associated, remains strong.

In the late 1950's, Pellan's work took a completely new direction in a series of exotic "Garden" paintings. These completely imaginative equivalents are virtually sculpted in heavy paint, engraved and stamped with cake cutters and other utensils, and sometimes embedded with glass and other materials. It would be difficult to imagine anything more appropriately declamatory in colour than these Garden canvases.

In the January 1949 issue of the *Royal Architectural Institute of Canada Journal*, Jacques de Tonnancour wrote of the 1940 return of his friend Pellan to Montreal: "What French-Canadian art needed in order to be resurrected...was a vigorous blow from the outside and Pellan provided just that blow." Speaking of the 1940 large Pellan exhibition in Quebec and Montreal, he commented: "Everyone passing through those rooms had to think of painting as something that could reach a tremendous power."

JEAN D'ALLAIRE *Chien Appocalyptique* c. 1950 21x28 Dominion Gallery, Montreal

By coincidence, I wrote the article on de Tonnancour in that same 1949 issue of the *Journal*, an echo of the days when Pellan and de Tonnancour formed the short-lived Prisme d'Yeux group in 1948 as an answer to Borduas' *automatistes*. Unlike the *automatiste Refus Global*, the manifesto of the Prisme d'Yeux did not attempt revolutionary social changes. It was, indeed, a mild declaration, which said, in part: "This movement does not make slaves of its adherents who must prove a given theory, row in a galley one behind the other, without vision, without hope of perceiving an individual position." Pellan refused to make of Prisme d'Yeux more than an exhibition society, and it lasted hardly more than a year. A few years later, Pellan made his first appearance with a national Canadian organization, when he showed his canvas Les Pensées in 1942 with The Canadian Group of Painters. In 1958 his Face au Polyèdre and Détente were exhibited with the Canadian Group.

The differences between Borduas and Pellan vanished quickly. Both remain as large figures on the stage of twentieth-century Canadian art. They both risked, and lost, important teaching posts in their defence of artistic freedom. They, and their followers, emerged as the vanguard of contemporary art in Canada, and were followed during the next few decades by groups of painters in Toronto, Vancouver and Saskatchewan. □ A Montreal artist who bridges the differences between Pellan and Borduas, and was associated with both, is Leon Bellefleur. For many years, Bellefleur laboured in the shadow of other Quebec abstractionists. For most of his life, he taught school and painted his richly-textured purple abstractions in his spare time. His sense of fantasy was developed by a close association with Pellan, and his almost graffiti-like style of drawing owed

LEON BELLEFLEUR *Transmutation* 1968 51x64 Roberts Gallery, Toronto

much to his acquaintance with the *automatistes*. Bellefleur was strong enough to issue from both as very much his own master. He now must be ranked among the foremost Canadian painters of his generation. Bellefleur exhibited with The Canadian Group of Painters for many years, and many of his finest canvases appeared in its shows.

□ One of the true fantasists of Quebec painting was Jean D'Allaire, who died at the age of forty-nine in 1965, leaving behind him an artistic legacy that combined humour, mystery and eccentricity in equal degrees, as well as a consistently fastidious technique. A painting by D'Allaire is immediately recognizable, yet each one is utterly different from the next. Neither his fruitful imagination nor his self-respect as a craftsman would permit him to repeat a theme for profit. As a result, he knew relatively small success and possessed a limited, though enthusiastic, following.

In his teens D'Allaire studied art under Peter Haworth and Charles Goldhamer at Toronto's Central Technical School, and later under Maurice Denis (who had taught Borduas) and André Lhote in Paris. He enjoyed designing tapestries, however, and was probably most deeply influenced by the great French tapestry artist, Jean Lurçat. Even his paintings have a tapestry texture. No Canadian artist ever possessed a more complete and delightful bag of pictorial surprises.

D'Allaire has been described as a "little master," and he is certainly an important one.

□ One of the most scholarly of the experimental Quebec painters was the late Albert Dumouchel. Born in Valleyfield, Quebec, in 1916, he studied print-making in Paris for many years and was possibly the finest engraver this country has known. The character of Dumouchel's heavily textured prints is echoed in his

LEON BELLEFLEUR *The Marsh* 1968 25x32 Roberts Gallery, Toronto

richly impastoed abstract paintings. His death, early in 1971, removed a major figure from the Quebec art scene.

The significance of the creative explosion in Quebec art during the forties and fifties can hardly be exaggerated. Its impact upon the cultural confidence of French-Canadian creative workers generally was far reaching. The self-confidence and courage demonstrated by Borduas, Pellan and many of their colleagues symbolized and encouraged the cultural search for self-identity within Quebec society. The recognition given to these artists by museums and critics abroad appeared as a further vote of confidence in an indigenous creative vitality.

The Quebec art revolt had an important impact upon painting outside of its native province. It was the forerunner of abstract-expressionist and other experimental art in other parts of Canada, particularly in Toronto and Vancouver. Although developments in those places took on a very different stylistic accent, there can be no question that the example of Quebec's *avant-garde* painters helped encourage other creative artists across the country.

JEAN-PAUL RIOPELLE *Rafale* 1957 28x36 Collection: Mr. and Mrs. Henri Kolin

10/ The Toronto scene

The 1948 Montreal art furor had little immediate impact in Toronto. The art scene there received abstract art in a less convulsive and more gradual way. The artists living in Ontario did not yet have the same direct line of communication with changing developments in Europe, nor was there the same arch-conservative hierarchy to revolt against. The examples of the Group of Seven and The Canadian Group of Painters had prevented the growth of a rigid academic caste, and abstraction arrived by the more leisurely routes of reproductions and exhibitions. When abstract art did appear in the local studios, in the 1950's, it came mainly via the New York school of abstract expressionism.

□ Typical of the artists involved in the early evolution of modernism in Toronto was L.A.C. Panton, whose career followed the familiar pattern of Toronto painters, from commercial art to teaching. J.E.H. MacDonald, Arthur Lismer, Franklin Carmichael, Jock Macdonald, F.H. Varley, Will Ogilvie, Charles Comfort and others had taken the same route, and many of these artists continued teaching until their deaths, (creating their paintings in their spare hours and during holidays).

Lawrence Panton was born in Egremont, England, in 1894, and arrived in Toronto in 1911. He began his art career as a designer at Rous and Mann Ltd., under the same Albert Robson who had employed most of the Group of Seven. A.J. Casson was a co-worker with Panton, and in 1949 Panton recalled how as young men they "worked together as commercial artists. At times it required an almost monastic fidelity to mere duty to forget our private dreams in order to illustrate the remarkable properties of a shaving cream. . . and art seemed very

WALTER YARWOOD *Clown* 1958 48x60 Robert McLaughlin Gallery, Oshawa

far away indeed. It was a period of what might be called happy anxiety, and for my part, I floundered about producing immature and incompetent works.... But whatever the quality of the work, it was something we lived and ate and breathed for twenty-four hours a day."

Those comments of Panton's refer not only to himself and Casson, but to many artists of his own and the following generation. York Wilson, Jack Bush, Tom Hodgson, Oscar Cahen, William Winter and Walter Yarwood all shared similar experiences. Advertising, for them, had provided the springboard to creative freedom.

In 1926, Panton left commercial art for teaching, to which he was to devote much of the rest of his life. When he died, in 1954, he was Principal of the Ontario College of Art. It is not surprising, therefore, that his approach to painting was that of a scholar — patient, searching and tentative. Full assurance and originality did not come to his work until the late 1930's, when he began that series of Maritime abstract landscapes which has earned him a prominent place among the painters of his generation. He had passed from what he described as his "immature and incompetent" period into a decade of respectable academic canvases before he discovered the rocky shores of the East Coast. "I am charmed," he wrote, "by the bleak stony barren lands in Nova Scotia."

The Nova Scotia scenery released in Panton a pent-up and deep-seated romanticism. He had always been more concerned with the mood and drama underlying a scene than with its external appearance. Along the North Atlantic, this characteristic found an ideal frame of reference. "I was struck," he recorded, "by the quality of sinister and moving life that seemed to underlie

L.A.C. PANTON *Mist Rising from the Rocks* 1948 28x32 Collection: Mr. and Mrs. Max Merkur

the whole landscape, much as one senses the life in a sleeping figure. There is something powerfully stirring and dramatic to me in that whole vast chaos of rocky valleys beside the sea."

In a 1955 memorial tribute to Panton, written for the catalogue of an exhibition at the Art Gallery of Toronto, I commented: "Like that of most romantics, Panton's art cannot be readily pinpointed as a product of a particular place or time. Unlike his contemporaries of the Group of Seven, he influenced no one directly and is unlikely to do so in the future. In his last works, he emerged as a most singular artist. He stands quite alone among his generation of Canadian painters. His world of poetic imagery is not easily entered and his audience may never be a large one, but through his vision it will gain a fresh and vivid insight."

Panton was a member of The Canadian Group of Painters and showed in its exhibitions such major works as Nova Scotia Landscape No. 1 (1947), Atlantic Fugue (1952) and Poem to Nova Scotia (1954).

☐ A close associate of Panton's during the 1940's was York Wilson. The two often sketched together and shared many of the same basic ideas about painting. Though neither propagandized their convictions, both were early supporters of experimental art.

Toronto-born, Wilson entered commercial art at the local Central Technical School. He first worked at Brigden's engraving house in 1926, where Charles Comfort and Will Ogilvie had a strong influence upon his first efforts at painting. After employment at several other art studios at home and in Detroit, he opened up his own studio in Toronto in the early forties in the New Wellington Building at 137 Wellington Street

YORK WILSON *Taormina and Mt. Etna* 1958 36x24
Canadian Breweries Collection

GUSTAV WEISMAN *White Water* 1960 32x48 Collection: Pitney Bowes

West. (That building is important in local art history, because during the years of 1942-1945 many of the people who were to change art in Toronto worked or owned studios there. Besides Wilson, there were Jack Bush, Oscar Cahen, Walter Yarwood, D. MacKay Houstoun and M.F. Feheley, all of whom, one way or another, made an impact on the local art scene for the next two decades.)

Wilson first gained notice as a painter with a number of studies of burlesque, one of which, Burlesque No. 2, was shown with The Canadian Group of Painters at the New York World's Fair of 1939. After that, he concentrated for some years on figure studies of ballet dancers and satiric comments on local society. His first full-scale show was with Jack Bush at the Women's Art Association in Toronto in 1944.

By 1950, Wilson was able to give up commercial art and de-

vote full time to painting. That year, he made his first trip to Mexico—a trip that marked his emergence as an original artist. The forms, colours and textures of the Mexican towns, people and landscape completely changed his creative outlook. A second visit to Mexico in 1953 brought him into contact with the great American painter, Rico Lebrun. Lebrun's genius and philosophy made Wilson question his own approach to painting, and also brought him into contact with many new techniques. Wilson's interest in mural painting was aroused in Mexico, where he was surrounded by the monumental wall paintings of Rivera, Orozco and Siqueiros. He has travelled and painted in many parts of the world, but it was Mexico that gave him an open-ended perspective in art and confirmed his future as a mural painter.

Wilson must be ranked as the most important of all Canadian

YORK WILSON *Atotonilco* 1969 52x66 Museo de Arte Moderno, Mexico

mural designers. Since 1954, he has completed ten major commissions including McGill University's Redpath Library, Montreal (1954), the Imperial Oil Building, Toronto (1957), the O'Keefe Centre, Toronto (1959), General Hospital, Port Arthur (1965) and Carleton University, Ottawa (1970). The giant Imperial Oil design, comprising two panels each twenty-one feet high and thirty-two feet long, is the most ambitious and impressive in the country. On July 14, 1959, Lawren Harris wrote to Wilson from Vancouver: "Although it is certainly not my customary habit to write so-called 'fan' letters to my colleagues, in this singular instance I feel moved to do so. The reason being that on my way here I made a point of stopping over in Toronto with the express purpose of seeing your Imperial Oil Building murals. I am happily convinced that this break in my journey was completely justified and rewarded, for said murals proved to be beyond my fondest expectations. You have succeeded in a gigantic undertaking, the very thought of which would undoubtedly terrify the great majority of your contemporaries in your own profession."

Within a few decades, Wilson has developed from a spirited and competent reporter to one of Canada's finest abstract painters. His works have been exhibited in the Carnegie International at Pittsburgh, the São Paulo Bienal, and in one-man shows at the Musée Galliera in Paris and the Palacio de Bellas Artes in Mexico City. He first exhibited with The Canadian Group of Painters in 1939 and continued to appear in its exhibitions until it disbanded. Among his contributions to its shows were Young Ladies (1947), Mexican Pattern (1950), Echo (1954), Red Abstraction (1959), and Ghioggia (1965). ❏ An artist even more closely associated with Mexico than

ISABEL MCLAUGHLIN *Prelude to Winter* 1964 32x36 Collection: The Artist

Wilson is Leonard Brooks. Born in London, England, in 1911, Brooks studied art briefly at Toronto's Central Technical School and the Ontario College of Art. During his restless early years, he travelled and painted throughout Europe before the Second World War. After service in the Navy and as an Official War Artist, he finally settled permanently in Mexico in 1947. He kept up his contact with Canada, however, through regular exhibitions of the abstract paintings and collages that have won him wide attention.

☐ Another Toronto painter with close links to Mexico is the watercolourist Gordon MacNamara, whose atmospheric works appeared in Canadian Group shows of the 1940's.

☐ One of the most constant Toronto exhibitors with the Canadian Group, and an unabashed representational painter, is Aba Bayefsky. Toronto-born, in 1923, Bayefsky attended Central

Technical School under Peter Haworth and Carl Schaefer. His first paintings were impressions of local slums and markets, and he has maintained his concern for painting humanity since then. Bayefsky has been an acutely socially-conscious artist and does not hesitate to give his paintings a message. Like the Mexican muralists he admires, he introduced the human drama into his wall paintings for the Canadian Pavilion at the Brussels World Fair in 1958; and into his large mosaic for Northview Heights Collegiate (1957) and murals for Beth-El Synagogue, both in Toronto.

☐ Like Bayefsky, two other Toronto members of The Canadian Group of Painters remained sturdily attached to the figurative style. Alexander Millar and Gustav Weisman have explored their own variants in the expressionist style. Both are relatively sombre artists, concerned with the more serious aspects of man

JACK BUSH *Coup de Main* 1957 40x50 Robert McLaughlin Gallery, Oshawa

JACK BUSH *Slow Curve* 1970 79x56 Collection: Dr. and Mrs. H.J. Hoffman ▷

JACK BUSH *Rose* 1964 88x57 Toronto-Dominion Bank Collection

and nature. Millar paints his pictorial messages large and uses such humanistic and biblical themes as that of Job. Weisman, who is also a distinguished stained-glass designer, paints landscapes with brooding and deeply subjective undertones.

□ Sydney Watson also studied art at the Central Technical School in Toronto which has one of the best design departments in Canada. Watson was to use his studies there to become the city's leading liturgical designer. His tapestries, murals and altar screens ornament many of Toronto's leading churches, and, in a more worldly vein, he has created wall designs for the head-office buildings of banks, schools, hospitals, universities and government buildings in Ontario and Quebec.

Watson's contribution to Canadian creative life has been quiet, but manifold. He is an authority on type and lettering, and has written several books on the subject. As an educator, he

was on the staff of the Ontario College of Art from 1946 until 1970, the last six of those years as Principal. As a painter, he exhibited regularly with The Canadian Group of Painters from the early 1950's.

Watson's serene, tonal canvases reflect his design-oriented talents. The best of these are still lifes and portraits of old Toronto buildings such as The Music Store (National Gallery of Canada). They are deceptively simple compositions but many of them are deeply satisfying.

□ A founding member of The Canadian Group of Painters was Toronto painter Will Ogilvie. Ogilvie's first exhibits with the Group were studies of his native South Africa: Xosa Women Washing (1933), Boatmen (1933) and No Sutu (1936). These and his other paintings of the thirties show the crisp delineation he shared with his close friend Charles Comfort. In those years,

WILLIAM WINTER *Ball Game* 1962 22x34 Collection: Mr. G.M. Moses

Ogilvie concentrated on figures with a landscape background, the figures formalized to such a point that they almost appeared a part of the landscape itself.

Ogilvie was a member of the small group of artists who gathered weekly during the early Canadian Group days to draw from the life at Comfort's downtown commercial studio. He also shared the latter's interest in mural painting, and designed wall decorations for the Hart House Chapel at the University of Toronto in 1936, and later for the home of Mr. and Mrs. John David Eaton in Toronto.

Ogilvie worked as a teacher with the Art Association of Montreal for a few years before the last war, and then served as an Official War Artist with the Canadian Army in Italy and Normandy. During his later peacetime years of exhibiting with The Canadian Group of Painters, Ogilvie divided his talents

between impressions of his native South Africa and landscapes of the Georgian Bay and Caledon areas of Southern Ontario. Perhaps his most characteristic works, and the ones for which he might well be most remembered, are the close-up studies of Georgian Bay, often featuring superbly drawn details of dragonflies, loons or other inhabitants of the Bay. As a watercolour artist, in particular, Will Ogilvie will occupy a significant place among those artists who wrote the history of mid-century Canadian art.

☐ Two Toronto-based artists, William Winter and Jack Bush, shared a commercial art studio for many years, but as painters they moved in very different directions. Winter, born in Winnipeg in 1909, is a painter of people, and is generally satisfied to make simple depictions of everyday life around him, whether in Toronto or abroad. His most telling canvases were done during

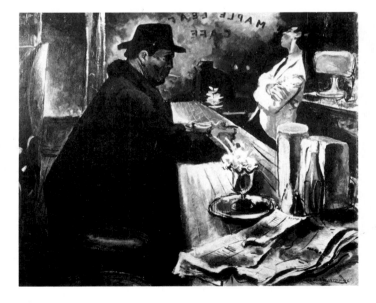

YVONNE HOUSSER *Shattered Glass* 1966 24x48
Collection: Mr. and Mrs. James McKague

WILLIAM WINTER *Midnight at Charlie's* 1946 20x24 Vancouver Art Gallery

the 1940's and early 1950's, when he painted penetrating studies of the inner city of Toronto. These capture the colour and conflict of downtown life, as in the nocturnal, Midnight At Charley's (Vancouver Art Gallery), exhibited with the Canadian Group in 1945. What Philip Surrey has done for the Montreal scene, Winter, at his best, has done for Toronto.

Jack Bush is a signal figure in contemporary art. His large, powerful, abstract canvases have won him more international attention than any other Canadian painter, with the exception of Riopelle. No artist currently at work anywhere has a more courageous or lyric feeling for colour. His compositions readily hold their own in the most distinguished company at major international art shows.

Jack Bush's road to creative triumph was a long and testing one. He came to abstract painting relatively late, in his mid-forties. Before that, under the mantle of Charles Comfort, he had made his way as a commercial artist, doing ads for marmalade and nickel companies and illustrations for magazine fiction. In his spare time, he painted vigorous, earth-coloured landscapes of rural Ontario and its people, which he began to exhibit with the Canadian Group in 1945. These included Ditch Diggers (1945), Lonely Land (1947), Summer Afternoon (1950) and Thirsty Man (1950). This last painting inaugurated a series of intense, symbolic figures which terminated in the awesome, Christ-like, semi-abstract Hanging Figure of 1959, a painting which reflected his entry into abstract expressionism at its most intense, and his increasing need for large-scale subjects. Hanging Figure was more than six feet high and more than eight feet wide.

Jack Bush, like so many of Canada's best artists, served for a

GORDON MACNAMARA *City at Night* c. 1947 15x22 Collection: The Artist

time as a director of The Canadian Group of Painters, and in 1954 designed its catalogue cover. His many contributions to Group shows trace, in major works, his complete path to totally abstract colour-field painting. From his 1952 canvas Summer, the progression included Festive Confusion (1954), Hymn to the Sun (1955), Coup-de-main with Red (1956), New York (1956), Painting With Red (1958), The Blue Cloud (1958), Dagger (1958), Hanging Figure (1959), R#3 (1961), Rising Red (1961) and Cranberry Green (1965).

Throughout the 1960's Bush's simplification of space and colour became increasingly his own. The terse, commanding works that terminate the decade stand alone in Canadian art. Much has been made of the impact of Matisse upon Bush's colour, and the influence of the American critic and adviser Clement Greenberg on the artist's painting since 1957. Both of these facts are relevant, but are of slight importance compared to his incredible determination to be his own man, which began back in the forties. No one plodded harder on his way to inspiration than Jack Bush. Creation never came easy to him, and the lasting eloquence of his best work owes much to that essential fact.

Painters Eleven

Coincidentally with Bush, a number of other Toronto-area artists were evolving toward abstract painting during the early 1950's. Most were inspired by the then pre-eminent New York abstract-expressionist school of Willem de Kooning, Jackson Pollock, Franz Kline, Mark Rothko, Clifford Still and others. Eleven of these Toronto artists joined together in 1953 to form an exhibition group of abstract painters. They called themselves

WILL OGILVIE *Loon Call* 1962 22x32 Art Gallery of Ontario

"Painters Eleven." Of the eleven, all but one – Hortense Gordon were active exhibitors with The Canadian Group of Painters that same year. The other ten were Jack Bush, Oscar Cahen, Tom Hodgson, Alexandra Luke, Jock Macdonald, Ray Mead, Kazuo Nakamura, William Ronald, Harold Town and Walter Yarwood.

Separated in age by more than a quarter of a century, the members of Painters Eleven together shared a buoyant energy of style and a contagious optimism of outlook. Their paintings were mainly dominated by a rich warmth of colour and vigorous calligraphic brushwork within the abstract idiom.

Painters Eleven did not claim any message or mission, although their exhibitions did more to awaken public interest and stimulate younger painters than anything that had happened in Toronto for more than a decade. Their impact, in fact, can fairly be compared to that of the *automatiste* movement in Montreal. The basic difference between the Eleven and the Quebec group was that the Eleven did not issue manifestoes. The closest they came to a declaration was their statement: "There is no manifesto here for the times. There is no jury but time" – a declaration which could not have been more modest or impersonal.

The first Painters Eleven exhibition was held at the Roberts Gallery in Toronto in February 1954. It turned out to be one of the most heavily attended private gallery shows ever held in the city. Despite this keen public interest, the exhibition was not a success as a commercial venture; there were virtually no sales.

That first show travelled to Ottawa in March – to the Robertson Galleries – the initial exposure of the Group outside of Toronto. The Roberts Gallery held a second Painters Eleven exhibition in February 1955. This was hardly more successful

D. MACKAY HOUSTOUN *Configuration* 1965 62x50 Collection: The Artist

than the first in a commercial way, but it proved profitable in terms of public attention. It resulted in a travelling exhibition which was shown that autumn along the Western Ontario circuit of public galleries, which included London, Hamilton, Windsor, St. Catharines and Oshawa.

It was in 1956 that the members of Painters Eleven finally won an audience that was to give them a close and critical inspection. International attention came to them through an invitation to exhibit as guests at the Twentieth Annual Exhibition of Abstract Artists at the Riverside Museum in New York City. Each of the Eleven was represented by two paintings, and the show lasted from April 8th to May 20th.

In my foreword for the catalogue of that New York exhibition I wrote: "Painters Eleven is not a rebel group with a mission. The artists who compose it are not devoted to any narrow aesthetic creed. Originally, in 1952, they joined as a convenience for exhibition purposes. Their congenial association prompted the establishment of a formal *entente*. Painters Eleven is a free association of kindred spirits. It has no jury. Each painter submits for exhibition whatever he chooses and it is hung. There is no election of officers. Despite these facts, the group has a remarkable unity. It is united by its isolation from the main currents of Canadian painting.

"Abstract art is still an island in the sea of Canadian art. A large part of the country's talent is sincerely devoted to realism. Painters Eleven represents an Ontario phase of abstract art in Canada. Its counterpart in Quebec, led by Borduas, Riopelle and Pellan, has already established an international respect for our abstractionists. The French Canadians looked to Paris for their aesthetic sustenance. It is only natural that the Ontario

SYDNEY WATSON *Still Life in a Window* 1952 36x26 Private Collection

SYDNEY WATSON *Mural* 1962 120x204
Canadian Imperial Bank of Commerce, Montreal

LEONARD BROOKS *Hidden Treasures* 1969 50x40 Toronto-Dominion Bank Collection

group, set geographically in the middle of the Continent, should look to the United States. In introducing the work of Painters Eleven to the United States, the American abstract artists reveal a phase of Canadian art not often seen outside our borders. Too often, Canadian painting is remembered as a desolation of rocks and pine trees caught in the web of the northern lights. Painters Eleven is a lusty denial of this. They introduce a compelling new accent to North American art."

Back in Toronto, there were later exhibitions of the Painters Eleven at the Park Gallery in November 1957 and May 1958. Early in 1958, there was also an exhibition of their work at the Ecole des Beaux-Arts in Montreal. The Park Gallery show of that year was to include, for the first time, invited contributions from Quebec artists. It was the one and only time that the *avant-garde* painters of the two provinces showed in tandem.

The Quebec contributors were Leon Bellefleur, Paul Borduas, Albert Dumouchel, Paterson Ewen, Jean McEwen, Jean-Paul Mousseau, Alfred Pellan, Claude Picher, Jean-Paul Riopelle and Jacques de Tonnancour. This venture certainly proved to be Painters Eleven's most stimulating exhibition and justified what I said in the catalogue foreword to their 1957 Park Gallery show: "Within the few years since its formation, Painters Eleven has performed a service for Canadian art far beyond its numbers." As one who was close to the movement, I regretted the group's decision to disband early in 1959, but, inasmuch as one of its members, William Ronald, had resigned and another, Oscar Cahen, had died, perhaps that was the only proper course.

The path of the Painters Eleven had not been completely strewn with critical roses. There was some praise but there was also satire and dissent. *The Toronto Daily Star* remarked: "The

PETER HAWORTH *Ice Break* 1969 25x20 Collection: The Artist

B. COGILL HAWORTH *Huron County* 1971 45x55 Collection: The Artist

pictures all bear titles but these, you may be certain, bear no clues as to the identities of the subjects. It's a quiz game from first to last." An editorial in *Saturday Night*, in March 1955, complained: "In all of the works of the Painters Eleven exhibition there was obvious artistic freedom, but to us there were few that had the power of communication. . . . It is possible that many of today's artists have spent so much time exploring the abstract qualities of personal creativeness that they have become completely introverted and have lost all identification with life." Writing about the 1958 show in Montreal, Robert Ayre of *The Montreal Star* described Jack Bush's paintings as "a blot here and a blot there, completely empty." In describing Walter Yarwood as an insensitive painter he added that "insensitive is the adjective that fits more than one or two of the group. They seem to be more interested in being striking than subtle." His

colleague, Dorothy Pfeiffer of *The Montreal Gazette*, described the Painters Eleven as "Canadian sensationalists," and singled out individuals for special rancour. "Tom Hodgson," she remarked, "evidently believes in intimidating the viewer by sheer size. His work evoked in my mind nothing more profound than a wry recollection of backstage frenzy at a fashion show."
□ During most of the group's existence, from 1953 to 1959, its dominant figures, both as artists and influences, were Oscar Cahen and Jock Macdonald. Oscar Cahen's arrival in Toronto in 1952 was a pivotal event in the city's art history. His formidable talents startled Toronto artists into a new look at their own painting. His impact upon his younger colleagues in Painters Eleven is difficult to exaggerate, and is frankly confessed by most of them.

Cahen was a complete artist when he arrived in Montreal,

JACK NICHOLS *Monologue* 1964 29x21 Imperial Oil Collection

YORK WILSON *Chioggia* 1958 51x77 Imperial Oil Collection

after the Second World War. He was accomplished, dedicated and original, with a training and background few Canadian artists could equal. Born in Copenhagen in 1916, he had received his training in Dresden, Paris, Stockholm and Prague. In England, in 1939, he was interned by the British and sent to an internment camp in Canada the next year. After his release at the end of the war, he became a Canadian citizen. With his consummate art knowledge and his rich background of human experience, Cahen made some of his new colleagues appear naïve, noisy and superficial.

Cahen, like the majority of Painters Eleven, depended upon commercial art for his livelihood. His magazine illustrations were the wittiest and most sophisticated to ever appear in Canadian magazines. On the other hand, his paintings were demanding and uncompromising statements, sometimes tragic,

and always stamped with his enormous vitality. He combined his superb draughtsmanship with astonishing colour. Cahen gloried in colour. With an almost unerring sense of harmony, he would merge pure reds, pinks, violets, blues and blacks into unique chromatic statements. His paintings were never easy or merely decorative. His experiences in Europe and later as an internee disqualified any flip attitudes.

Cahen's drawings, in particular, underscored his seriousness. A sketch of 1950 shows the frightened face of a little man, a direct result of Cahen's observations of Nazi Germany as a Jew. His later drawings continued the theme of terror into increasingly abstract, and even more dramatic, forms. Their effectiveness was increased by Cahen's control of techniques which allowed him to mix together inks, pastel, wax and watercolour in surprising and original ways.

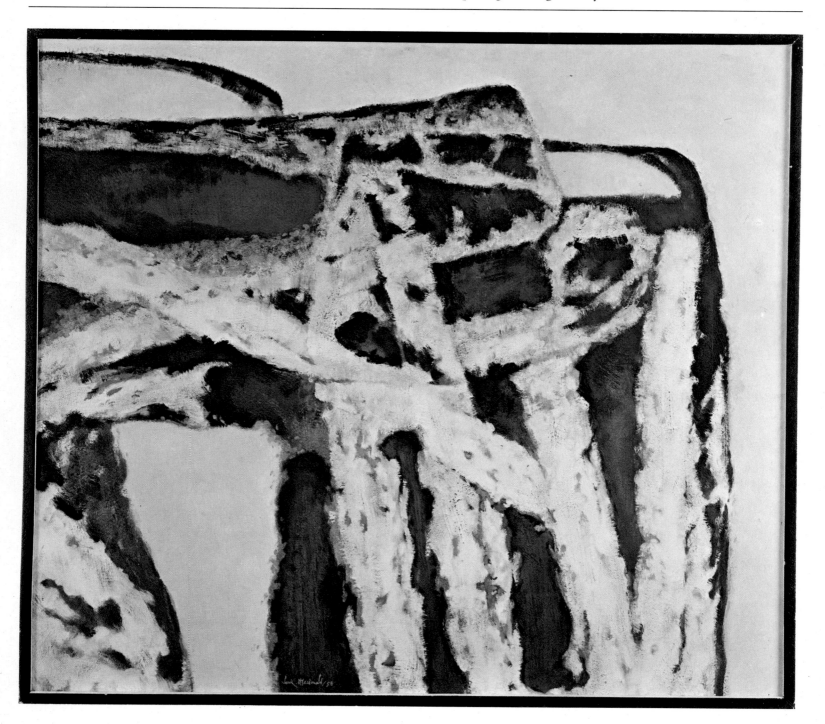

JOCK MACDONALD *Watcher of the Night* 1958 27x40 Roberts Gallery, Toronto

Cahen had a fondness for sports cars and some of his best compositions related to them, as witness his Austin-Healy 100 Engine. It was an irony of fate that his love of fast cars led to his death at the age of forty, when his Studebaker Golden Hawk collided with a gravel truck in the late fall of 1956. Cahen's early death may well have robbed Canada of its potentially greatest painter. No one in this country has ever shown a more complete command of the expressive resources of an artist.

Before the formation of Painters Eleven, Cahen was already showing with The Canadian Group of Painters. In 1952, he exhibited Ancient Throne (Hart House, University of Toronto). To the 1955-1956 exhibition he sent his Vivid Structure.
□ When Jock Macdonald arrived in Toronto from Vancouver in 1947, he was just beginning to emerge as an original abstract artist. A series of what he called his "automatic" watercolours

of the late 1940's led to the free-form oils which were to enrich the Painters Eleven and Canadian Group exhibitions through the 1950's. Even in his most abstract canvases, Macdonald usually relates his forms to nature. Often this inspiration is frankly acknowledged in the titles of his works: White Bark (1954), Twilight Forms (exhibited in a 1954 Canadian Group show), Sombre Dusk (1957), North Wind (1957), Primordial Fire (1957), Earth Awakening (1959) and Nature Evolving (1960).

At the Ontario College of Art, Jock Macdonald taught a number of the artists who were later to be associated with him in Painters Eleven. They acknowledged his influence upon them and the personal mode of his instruction. Macdonald was passionately involved with painting and he projected that concern, both within and without the classroom. Somehow, he found the

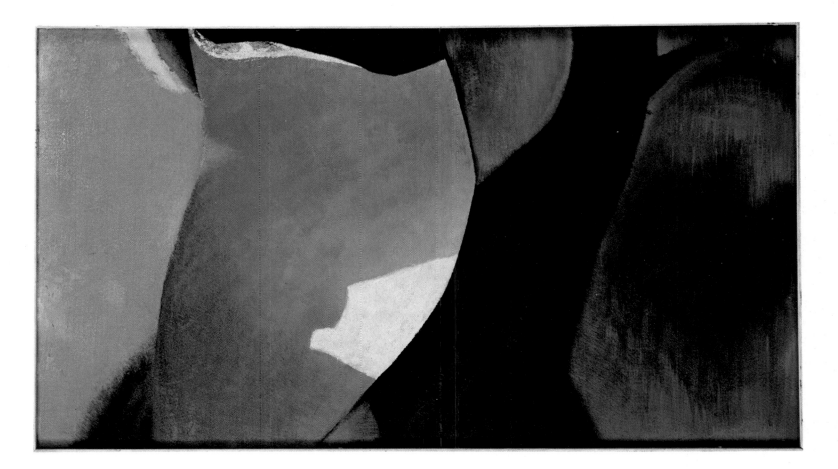

JOCK MACDONALD *Legend of the Orient* 1958 54x48 Roberts Gallery, Toronto

time, on weekends and holidays, to produce the large, ambitious compositions which earned him a place among Canada's most significant artists. His finest works were realized during a short period of three years, between 1957 and 1960.

Jock Macdonald was a founding member of The Canadian Group of Painters and continued to show with it until his death. The paintings he sent to its exhibitions traced his total evolution in a series of his masterpieces from Black Tusk in the 1933 Atlantic City Show to Heroic Mould (1959).

☐ An artist who came in for more than his share of abuse during the Painters Eleven shows, and whose work of that period is too little appreciated, is Tom Hodgson. He was an action painter, in the truest sense of the word, during the 1950's and early 1960's. His immense canvases of that time (he was one of the first of the Eleven to paint very large works) are restlessly articulated statements in the pink, orange and red palette he had inherited from Cahen but then made his own. No matter how closely these canvases were covered with strokes, smears and actual squeezings from the paint tube, Hodgson's strong sense of design held them together by a firm underlying structure.

Hodgson, at the time of Painters Eleven, was one of the best commercial designers in Canada, and that background served him well as a painter, as it did Cahen and Bush. Hodgson was also one of the country's best painters in watercolour, a medium in which his sense of structural design shows very clearly.

In the mid-1960's, Hodgson moved into figurative painting and portraits in what might be called a "Pop" style. In these, hard-edged realism is merged with rich, wet turpentine washes and occasional collage, but his colour maintains the same high pitch he has favoured since the beginning of his career. To that

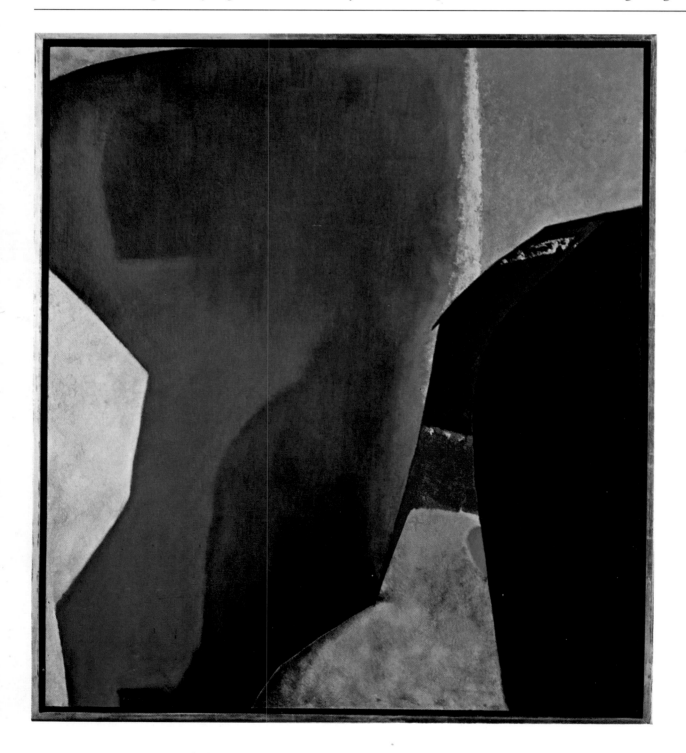

JOCK MACDONALD *Rust of Antiquity* 1958 42x48 Robert McLaughlin Art Gallery, Oshawa

and to the classic medium of oil paint he has remained faithful.

Born in Toronto in 1924, Hodgson graduated from Central Technical School and the Ontario College of Art. He first exhibited with The Canadian Group of Painters in 1955, and continued as a member until it disbanded. Among his paintings shown in its exhibitions were: Construction (1955), It Became Green (1956), Dark the Mostly Light (1956), Portrait of A Shirt (1958), March Pond (1958), January 58 (1959), M2, 59 (1960), M2, 60 (1961), Checker Cab (1963), Daughter of the Nawab of Rampur (1965), Darling Like My New Dress (1966) and Silver Haired Dancer (1967).

☐ Harold Town was one of the most naturally endowed of Painters Eleven. He could manipulate any medium or style to which he turned his attention — and he turned his attention to many. Prints, drawing, collages, paintings, sculptures issued easily and prolifically from his clever hands. His works contain a brilliant, if sometimes brittle, wit, and often a touch of the theatre. Town is a performing artist, who constantly appears to be challenging the earlier achievements of others — Picasso, Motherwell, Cahen, Klein, anyone at all.

Town is the most controversial figure to emerge from the Painters Eleven. He has brought forward highly contrasting opinions. At home he has an admiring following, who hail his every novelty as an aesthetic breakthrough. Abroad, he has been less fortunate. Noted *New York Times* critic Stuart Preston in 1964 observed that: "Harold Town is an unclassifiable abstractionist whose huge pieces occupy a puzzling vacuum with superb confidence." The attitude of many Canadians to Town's art has been equally mixed. Dennis Reid, of the National Gallery of Canada, wrote of Town in 1969: "He is, in the public eye,

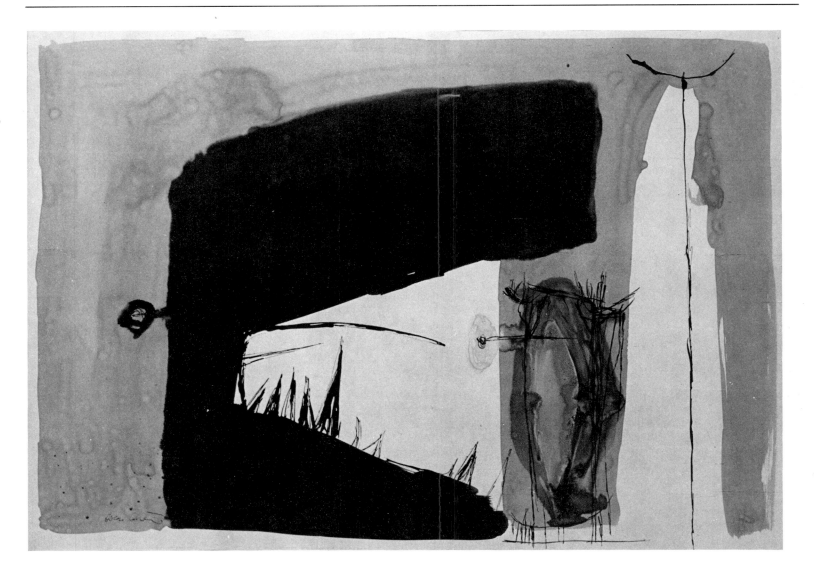

OSCAR CAHEN *Untitled* 1953 22x30 Private Collection

142

the very image of the Painter. In recent years he has had more presence in the art community through his personality than through his painting, and his international reputation seems of a limited sort."

That Town is one of the best print-makers of his generation is beyond question. And he has produced a number of superb collages, deeply felt and fastidiously executed. About his large paintings, some reservations may be justified; they are facile, colourful and ingenious, but have rarely achieved the success of his works on a less ambitious scale.

Town's work has been widely acclaimed, however. His canvases hang in many public collections within and outside of Canada, and he is the favourite Canadian painter of a large number of private collectors. But the true qualities of Town's work are so beclouded by publicity, personality conflicts and

showmanship that only the perspective of time will sort them out. He will either emerge as the establishment artist of his days or as a compellingly original painter.

Town showed regularly throughout the 1950's with The Canadian Group of Painters. His exhibits included: With Fruit (1952), Morning Alarm (1954), Night Sign in the Snow (1954), Before Adam (1955), Homage to Dylan Thomas No. 2 (1955), Dead Boat Pond No. 2 (1956), First Flight of the Poet (1957), Monument to C.T. Currelly (1958) and Garden for a Eurasian Princess (1959).
□ Kazuo Nakamura has been as silent on the Canadian art scene as Town has been noisy, but his subtle and esoteric art speaks eloquently for him. I first encountered Nakamura's painting while he was a student at Central Technical School. He had entered a painting in the Canadian Younger Artists

OSCAR CAHEN *Ascend* 1951 37x27 Robert McLaughlin Art Gallery, Oshawa

OSCAR CAHEN *Painting with Black Spot* c. 1954 36x36 Collection: Mrs. Eugene Hawk

OSCAR CAHEN *Animal Structure* 1953 40x36 London Public Library and Art Museum

Group competition. George Pepper and I were the judges and Nakamura won first prize with a misty watercolour of the Don Valley.

Born in Vancouver in 1926, Nakamura was a late starter in art, not entering the Technical School until he was twenty-two. Since that early period of watercolours, his art has undergone many changes, but always it has displayed a nicety of craftsmanship that reflects his Japanese heritage. In the 1950's he painted in oils—green landscapes executed, for the most part, with the edges of razor blades. He built up his foliage and earth patiently, in tiny domino-shapes. These delicate works are among the most evocative in Canadian art.

Nakamura has frequently carried on two parallel and very distant styles, and his monolithic tower series of the same period is as textureless and dramatic as his landscapes are lyric. He carried simplification even further in what he called "string" paintings, works in which a wet ground of white pigment is drawn with incised lines and is stained with grey-green or ochre glazes. These "string" paintings were the first minimal works to appear in Canadian painting, and depend entirely for their impact on the subtlety of their linear pattern. In later years, the Vancouver artist has combined fragments of landscape or still life with broad, simple bands of dark blue. He is completely careless of popular praise, and whatever direction he takes, his art always arises from a deep inner conviction.

Nakamura was a member of the Canadian Group and exhibited such major works as Night Fall in the Woods (1955), Hillside (1954), Fortress (1956), Rushing Wind (1957), Lakeside Reflection (1958) and Inner Core (1959).

☐ The Painters Eleven canvases by Ray Mead were as bold as

KAZUO NAKAMURA *Spring* 1957 29x37 Collection: Mr. and Mrs. Henri Kolin

Nakamura's were discreet. His large slabs of vermilion, black, grey and white sound forth like a clarion.

British-born Mead was a graduate of London's famed Slade School, and when he came to Canada in 1946, at the age of twenty-five, he used his capacity for design as an advertising art director. One of the most extroverted painters of Painters Eleven, he attacked a canvas directly and searched out his composition as he progressed. He was a deep admirer of Franz Kline and Nicolas de Stael, but his best paintings have a personal and vital impact of their own. He exhibited with The Canadian Group of Painters The Red Wind (1956), The Embattled (1954) and Untitled Painting (1952).

In 1957, Ray Mead shared a two-man show with Walter Yarwood. Yarwood was born in Toronto in 1917 and has earned his living mainly as an advertising artist. As a member of Painters Eleven, he showed a number of richly textured semifigurative canvases. For a time, during the 1940's and 1950's, he was occupied with painting a number of variations on nature themes: The Garden (1945), Spring Tree and Tree No. 6 (1956), In the Spring (1958), Pine (1957), November No. 3, No. 4, and No. 9 (1958). Most of these were exhibited with The Canadian Group of Painters, of which he was a member. Regrettably, Yarwood gave up painting shortly after the end of Painters Eleven, in favour of sculpture, cutting short a promising career.

□ William Ronald has had one of the most varied careers of any member of Painters Eleven. He has been a designer, painter, writer and broadcaster, and for a time, enjoyed more international attention than any of his colleagues. In 1957, he resigned from the group because of commitments in New York

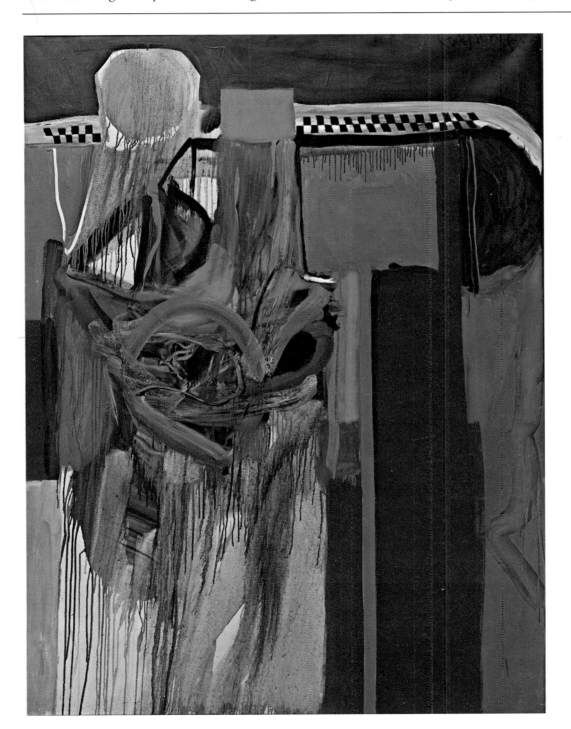

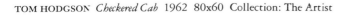

TOM HODGSON *Checkered Cab* 1962 80x60 Collection: The Artist

City, where he lived. Ronald was represented by an outstanding dealer and during his American sojourn he sold many works to leading U.S. museums.

At his best, Ronald is one of the most impressive painters in Canada. His compositions have a monumentality of design and a blazing richness of colour. These attributes have made his vast abstract mural for the National Arts Centre in Ottawa, Tribute to Robert Kennedy, one of the most dramatic and commanding wall decorations in the country. His exhibits with the Canadian Group included A Chase in the Sun (1952), Sunfalls (1954), Invasion (1955) and Excelsior (1956).

☐ Alexandra Luke, one of the two women in Painters Eleven, was older than most of the members. (She was born in Montreal in 1901.) She had no difficulty holding her own in their exhibitions, however. There was a vibrant directness in both her

painting technique and colour, and although much of her time was devoted to social duties and her family, she possessed a stubborn dedication to art.

Alexandra Luke studied under Jock Macdonald at Banff during the 1940's, and with the great teacher Hans Hofmann in New York, both of whom turned her interest toward abstract painting. With typical enthusiasm she organized a showing of Canadian abstract painting at the Oshawa YWCA, in the catalogue of which the exhibiting artists stated their creative credos. She herself wrote: "A painting should not stop with the already discovered beauty, but should continue searching. I think the artist should grow spiritually with his work so that each year the thought and struggle, his progress, should show an unfolding and not be a repetition of his former works." Her own search caused her to produce some of the most lyric abstract works

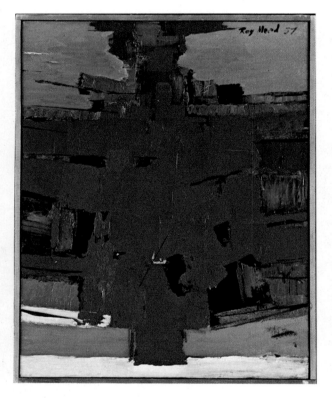

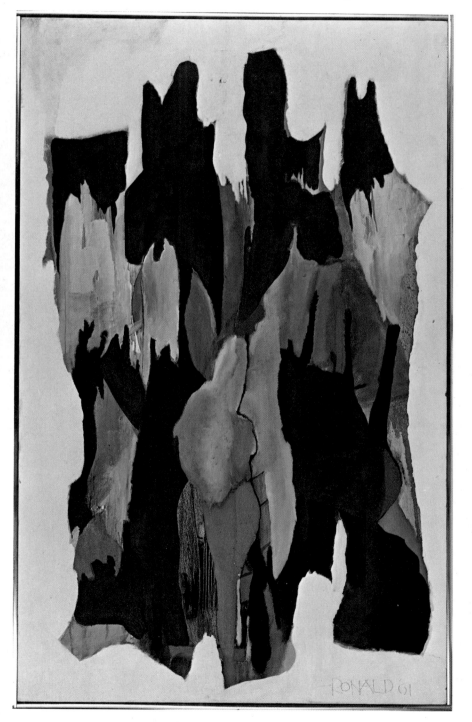

RAY MEAD *Crescendo* 1957 16x20 Robert McLaughlin Art Gallery, Oshawa

WILLIAM RONALD *The Muse* 1961 80x50 Robert McLaughlin Art Gallery, Oshawa

ever done in Canada. It is unfortunate that she is today generally neglected and underrated.

Alexandra Luke was a member of the Canadian Group and exhibited with it from 1950 until her death in 1967. Among the works she showed were: Still Life (1950), Transmutation (1952), Summer Song (1954), Quietude (1955), Blue Sphere (1956), Upthrust (1958), Crusade (1959), Greenbriar (1961), Confagration (1963), Surge of Summer (1965) and Season of Splendour (1966).

□ The oldest member of Painters Eleven was Hortense Gordon who was born in Hamilton, Ontario in 1887. Hortense Gordon saw and participated in all of the stylistic changes that led to current developments in Canadian art. She was successively a realist, impressionist, cubist and, finally, an abstract expressionist, after studying with Hans Hofmann in 1947. She was not a major creative painter, but she did much to encourage and influence artists and the art world around her.

□ Close on the heels of the Painters Eleven came a younger group of Toronto artists who shared no platform, but who benefited from the *bonhomie* which comes from close professional association. All of them – Graham Coughtry, Michael Snow, Dennis Burton, Gordon Rayner and John Meredith – dealt with the Isaacs Gallery, and all were about the same age.

Graham Coughtry was born in St Lambert, Quebec in 1931, but studied at the Ontario College of Art. His first one-man show was held in 1956, when he exhibited a series of interiors with sleeping figures. These were subtle works with misty lost-and-found forms, but their colour was hardly subdued. A born colourist, Coughtry used a Bonnard-like palette of purples, oranges, blues and pinks for these compositions, which were

JOYCE WIELAND *The Men in Her Life* 1963 9x6
The Isaacs Gallery, Toronto

GORDON RAYNER *Signal* 1971 48x48 The Isaacs Gallery, Toronto

characterized by such titles as Moonlight Inside and Shared Nights. The artist was twenty-five when he showed these nostalgic works and they contain all of the romanticism of youth.

A few years later, Coughtry moved into a sterner, more mystical group of emerging figures where the colour was richer and denser, the palette limited to deep purples, reds, browns and golds. In these works the spectator is no longer passively beholding a set scene; he is confronted directly by attenuated figures issuing from the canvas and only contained therein by a dramatic weaving of Rembrandt-like darks and lights. The increased technical vigour exhibited in these paintings was finally released in Coughtry's best-known series of paintings — the Two Figure compositions which have engaged him since the early 1960's. In these, abetted by his use of an oil-plastic paint mixture, Coughtry loads the pigment on in large strokes and lumps to build up textures which seem almost volcanic. The best of these Two Figure paintings have taken their place among the most committed and forceful figurative works ever done in this country.

Coughtry's major commissions include a mural for the Toronto International Airport (1962) and a wall relief in the Beth David Synagogue (1958). He was a member of The Canadian Group of Painters and exhibited with it such important works as Moonlight Inside (1958), Emerging Figure (1959) and Two Figure Series XVI (1965).

□ For most of his career, Gordon Rayner has been involved with interpreting nature and, in particular, the Ontario landscape. Born in Toronto in 1935, he has had a lifelong affection for the country north of his native city. He has paid his tribute to it in large, highly subjective landscapes with lush washes of

◁ ALEXANDRA LUKE *Surge into Summer* 1966 74x52
Collection: Mr. and Mrs. E. R. S. McLaughlin

JACK REPPEN *Edge of the City* 1961 48x48 Mazelow Gallery, Toronto

rich colour which alternatively float softly, blend into one another, or are contained by hard-edged contours. Rayner is a deeply committed painter and his creative intensity is reflected in the Turner-like mysticism of his most characteristic works. ☐ Dennis Burton is the *enfant terrible* of the Isaacs group. He is at once irreverent, bold and provocative, but his pictorial histrionics are usually saved by an admirable sense of design and first-rate draughtsmanship. Burton was born in Lethbridge, Alberta in 1933, and came to Toronto to enter the Ontario College of Art in 1952. There he won the Royal Canadian Academy scholarship and an award to study in California under Ben Shahn and the great Rico Lebrun who influenced so many prominent Canadian artists.

The first Burtons to gain prominence were a series of golden landscapes reminiscent of the artist's Alberta homeland. With one of these he won first prize at the prestigious Walker Art Centre Biennial, Minneapolis, in 1958. The works most associated with his name, however, are his Garterbeltamania series of modern women in various stages of undress. These comments range from humorous to rude and are expressed in the full stylistic range Burton commands, from realism to almost total abstraction. The response to these graphic comments on the "packaged" modern woman has ranged from applause to abhorrence.

Burton's brilliant sense of design has won him a number of mural commissions, including one for the Edmonton Airport and another for the home of Mr. and Mrs. John David Eaton in Toronto. With The Canadian Group of Painters, he exhibited Prodefunctus (1956), Lexicon 2 (1958) and Radiation Crop (1957).

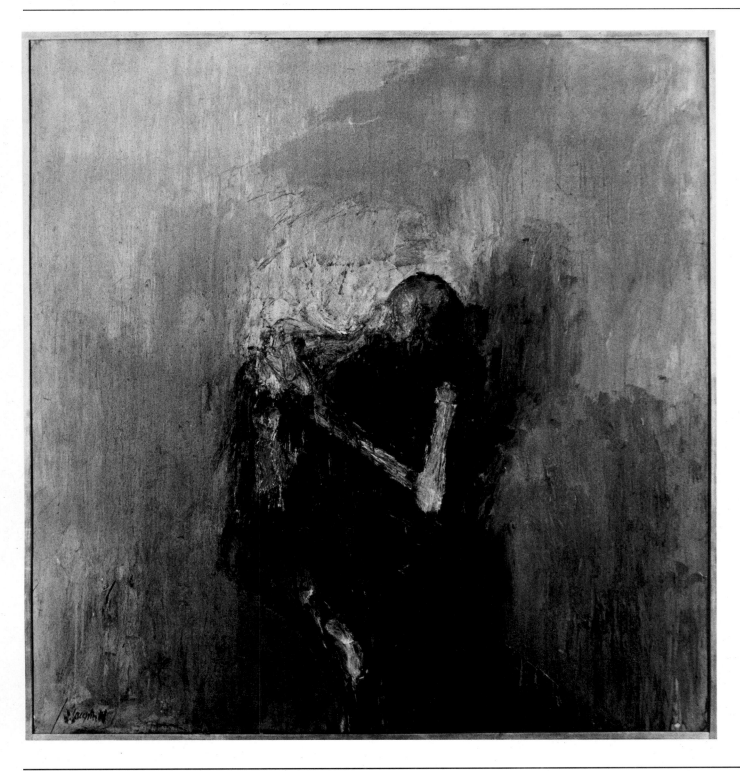

GRAHAM COUGHTRY *Rising Figure* 1961 53x51 Detroit Institute of Fine Arts

□ Michael Snow possesses perhaps the most multi-faceted talent of any current Canadian artist. He is a painter, sculptor, film-maker and musician, and in each field has shown the same authority and achieved similar success. As a painter, he is the most severely minimal of the Isaacs group.

For more than ten years, beginning in 1961, Snow has been engaged on his Walking Woman series, wherein he has made seemingly constant variations on a single female silhouette. Taking an almost commonplace pilot shape, he repeats it, reverses it as positive and negative shapes, varies its size, texture and juxtapositions—plays upon it with all the skills and wit at his command without once breaking the original pattern. To devote a large part of one's career to searching out the pictorial possibilities of such a set piece requires an almost puritanical dedication and a sort of intellectual bent, qualities which Snow reveals in all of his undertakings. Snow's wit is not of the *bon mot* sort, but the deeply considered, though novel, commentary of a committed classic artist. There is nothing sensuous about Snow's walking women but they compel because of the chess-board complexities of form their creator commands.

Born in Toronto in 1929, Snow has always remained a loner in the local and national art scene. He reflects the simple assurance of an artist who knows precisely where he wants to go, and has never engaged in the yahooing for publicity engaged in by more insecure performers.

□ In a very different style, John Meredith has shown much of the same persistence as Snow. He has cultivated a freely written calligraphic style for most of his career. On the bases of black cryptographs—which have been described as esoteric doodles—he composes his fields of gold, blue, pink and red spaces.

MICHAEL SNOW *Galaxy* 1965 59x27 The Isaacs Gallery, Toronto

JOHN MEREDITH *Courier* 1967 60x72 Collection: Dr. and Mrs. S. Wax

L.A.C. PANTON *Forest Collage* 1953 21x44 Collection: Mr. and Mrs. M.F. Feheley

Meredith's paintings range in scale from miniature watercolours to canvases more than twelve feet wide. All are marked by the same lyric, semi-barbaric colours and linear glyphs which place his works among the most truly personal being done in Canada. Meredith first exhibited with the Canadian Group at the age of twenty-three.

Like that of so many Toronto artists, the painting of MacKay Houstoun emerged from a commercial art background. A graduate of the same Western Technical School art classes attended by Walter Yarwood and Harold Town, Houstoun evolved from a figurative technique into an abstract style in the 1960's. He has developed a complex collage technique using rice papers, blotting papers and many hand-tinted materials from which he has created works of a translucent richness. Among Houstoun's exhibits with the Canadian Group were Evolution No. 2 (1963), Evolution No. 6 (1965), Landscape No. 1 and Landscape No. 2 (1966).

□ A figure who emerged from sports cartooning to play an important, if tragically brief, role in the Toronto art scene was Jack Reppen. Born in Toronto in 1933, Reppen died at the early age of thirty-one. He had his first one-man show at Toronto's Gallery Moos in 1959 and quickly rose to prominence with exhibitions in Toronto. Montreal and Ottawa in the years following.

The crucial creative point in Reppen's brief career was his visit to Mexico in 1961. From that trip and a second visit to Yucatan in 1963 sprang his passion for richly encrusted textures and luminous earth colours, blues and golds.

Reppen had already revealed his brilliance and potential greatness when he died in 1964 — a fact made clear by the Art Gallery of Ontario's memorial exhibition held that same year.

GRAHAM COUGHTRY *Two Figure Series No. 10* 1963 72x62 Hart House, University of Toronto

He was fascinated by Mexico's pre-Columbian cultures and their architecture and most of his works bear titles relating to them.

☐ Like Jack Reppen, Robert Hedrick received an important creative thrust from his studies in Mexico where he worked under Rico Lebrun and James Pinto in 1953 and 1954. Born in Windsor, Ontario, Hedrick is best known for a group of large abstract-expressionist canvases done during the late 1950's and early 1960's. These were composed of vigorously painted patch-work patterns of red, blue and white. At that time, he was simultaneously engaged in sculpture, an activity that has taken increasingly more of his time. In recent years, when away from sculpture, Hedrick has experimented with minimal overall pattern canvases and hard-edged stripe designs.

☐ James Gordaneer, who was born in Toronto in 1933, also studied and travelled in Mexico, though he later worked in Europe for three years. His abstracts are based on forms and impressions derived from the rural community of Mono Mills, Ontario, where he now resides. His paintings have continued to move closer to figurative content, but retain their large, colour-field masses.

☐ While the new artists of the 1950's and 1960's were breaking fresh ground, many of the senior artists who were considered radicals when they helped to form The Canadian Group of Painters back in 1933 continued to express their own creative vision. Without sacrificing the earlier traditions of craftsmanship they had apprenticed under, such artists as Yvonne Housser, Isabel McLaughlin, A.J. Casson, Peter and Cogill Haworth continued to add worthy achievements to the Canadian Group exhibitions of the later years when the spotlight inevitably was turned upon the experiments of younger artists.

DENNIS BURTON *Lady Bug* 1967 60x60 The Isaacs Gallery, Toronto

11 / B.C. emergence

Despite its great tradition of primitive Indian art, British Columbia was late entering the mainstream of Canadian painting. Until the 1940's, only Emily Carr had produced any significant art from the richly challenging natural wonders of the Pacific Coast. No other place can provide more abundant and varied forms to the perceptive eye. The hard edges of the mountain and the sea's horizon, the soft washes of mist, the rich tonal depths of the forests, and the constantly varying textures of the topography—these have existed for centuries. Yet until recently only one person had succeeded in evoking from this landscape any lasting works of art.

Part of the answer to this barrenness has lain, perhaps, in the great lack of public concern for art in British Columbia, a fact which tends to blunt the aspirations of all but the strongest and most self-centred artists. A second part of the problem is possi-bly the separation of the Pacific Coast from the rest of Canada.

Evidence of the difficulties caused by that geographical sepa-ration is found in the experiences and words of Jack Shadbolt, the most significant of recent British Columbia artists and a signal influence upon the creative emergence of West Coast art during the past twenty years.

By 1947, at the age of thirty-eight, Shadbolt had already es-tablished himself as one of the most gifted and original painters in Canada, with his compelling series of skeletal figures and scavenging dogs. These powerful comments on the aftermath of war should have brought him instant national recognition. Instead, his isolation in British Columbia helped to keep him from gaining proper notice in the East, where the dominant art markets were then centred. Like Jack Humphrey in New Brunswick, Shadbolt felt his isolation keenly.

GORDON SMITH *November* 1967 53x55 Toronto-Dominion Bank Collection

In response to a review of his work in the Canadian Group show of 1947 (in which he exhibited two remarkable works: Image in the Cedar Slash, and Red Knight), he wrote to me: 'One gets little intelligent appreciation of subtleties in Canadian criticism and I have been so used to being dismissed as having 'brilliant technique but for what' and such shallow inanities as the West produces that I was more than pleased to find someone actually understanding my point and perceiving that what had developed was from my own live experience in this country as much as from Picasso. . . . I have made an honest effort for a one-man show in the East and can find not one place. The situation is a trifle provoking. . . . My studio is bursting the seams with back work."

At the time that was written, Jack Shadbolt was the Director of the Drawing and Painting Department of the Vancouver School of Art, and had been teaching there for ten years. A man of such creative gifts and teaching stature should have been sought out by the galleries, rather than have had to seek them out and be rejected. The situation suggests the lack of rapport which existed between the Eastern Canadian art establishment and the Pacific Coast in the 1940's. This neglect certainly played a part in retarding the birth of a vital creative art movement in British Columbia. The only showcases in the East for talented Western artists were the exhibitions of The Canadian Group of Painters.

It was Shadbolt's patient faith in the future of B.C. painting that finally brought about the creative breakthrough of the 1950's. At that time a large number of gifted young artists suddenly emerged, most of them products of the teaching of Shadbolt, who had, himself, been a product of Fred Varley's

LIONEL THOMAS *Tree Forms* 1951 20x26 Art Gallery of Ontario

instruction at the Vancouver School of Art from 1934 to 1937.

By the early 1940's, Shadbolt was already showing an original bent in his watercolours of Vancouver street scenes, but it was his army experience between 1942 and 1945 that brought forth his first completely personal pictures. His haunting bleached-bone figures and symbols of carnage put his brilliant draughtsmanship to dramatic purpose. He himself has stated of those works: "During the years immediately following the war I was preoccupied with the 'state of man.' Anxious to convey potent social meaning through my painting, I began to explore an area of tense, symbolic subject matter." The post-war paintings that resulted seemed to have cleared his mind of the dark side of life, because within two years he had embarked upon a series of watercolours which were a total affirmation of life. Between 1949 and 1955 he composed a large suite of watercolours and

ink paintings celebrating growth, which have a very special place in Canadian art. In such graphic achievements as Winter Poppies (1955) and Emblems After Five (1950) he brought to a peak and joined triumphantly together his skill and sensibility as a draughtsman and his special world of fantasy. In these canvases he achieved an impact of chromatic richness, while restricting his palette mainly to earth colours and black.

Shadbolt the colourist was suddenly born in the south of France during his first Mediterranean trip of 1957. Reds, pinks and oranges vie with one another in richly conceived oil landscapes. Towers and fields are composed from lozenge-shaped forms which carpet the canvas from edge to edge.

Shadbolt's work since then has developed in similar sudden leaps. After wringing out the substance from one theme and approach, he seems to lie fallow until the arrival of a completely

B.C. BINNING *The White Ship* 1948 48x32 Art Gallery of Ontario HERBERT SIEBNER *Four Positions* 1969 30x24 Collection: Justin Harbord

different creative challenge. The luminous Mediterranean land-scapes lasted a few years, until eventually they were supplanted by the Emblem Series of the 1960's. In these, the artist's restless talent has integrated the awning stripes of Op art with the Canadian landscape.

Shadbolt's vigorous leadership of painting on the West Coast was fortified by two supporting circumstances: the arrival of Lawren Harris in Vancouver in 1940, and the presence of the Alberta-born painter, Bertram C. Binning. Until his death, Harris lent his prestige and assistance to the cause of younger artists on the West Coast, and B.C. Binning has been a major influence there, both as a painter and an educator.
□ Shadbolt and Binning have much in common. Born in the same year, they both studied for a time at the Art Students League in New York and began teaching at the Vancouver

School of Art within a year of one another. Like Shadbolt, Binning studied in London with Henry Moore. Binning's original ambition was to become an architect, and this predilection is reflected in the classic, deliberate design of most of his paintings and murals.

It was not until the late 1940's that Binning did his first paintings in oil; until then he had limited himself to elegant, thin-lined pen drawings of coastal landscapes. His natural sense of space and colour organization made it possible for him to create memorable canvases from the beginning. Such works as Ships in a Classic Calm, The White Ship, and Convoy at Rendezvous immediately established his reputation. Within a few years of their creation, such works were chosen to represent Canada alongside canvases by Riopelle and Borduas at the great Venice Biennale of 1954.

B.C. BINNING *Reflected Ship* 1950 48x20 Art Gallery of Ontario

E.J. HUGHES *West of Williams Lake* 1964 32x45 Dominion Gallery, Montreal

Bert Binning has made his presence felt in Vancouver both culturally and tangibly. From 1949, he was Head of the Department of Fine Art at the University of British Columbia, and organized many exhibitions that stimulated the interests and ambitions of potential painters. The tangible results of Binning's genius can be enjoyed on the walls of many Vancouver structures, from radio stations to bank buildings. His mosaics for the exterior of the B.C. Electric Building remain landmarks of Canadian architectural art.

□ Among the major artists who emerged in British Columbia during the historic 1950's was Gordon Smith who was born in England, but came to Canada at the age of fifteen.

Smith first studied under LeMoine FitzGerald at the Winnipeg School of Art, and derived his deep interest in nature and strong sense of design from him. His training as an artist and educator also included study at the Vancouver School of Art, the California School of Art in San Francisco, as well as at Harvard University, where he took a course in art history. He is extremely well informed and has a highly developed critical sense. Smith has painted some of the most original and arresting landscapes in this country. Glowing in colour and compelling in form, they are very personal equivalents of the West Coast scenery. His first exhibits with The Canadian Group of Painters show of 1954-1955 were the near-figurative composition, Pruned Trees (National Gallery of Canada), and Orchard. In these the forms are fragmented in a stained-glass sort of pattern and already reveal the artist's fondness for using black to heighten and contain his colour shapes.

By the Group show of 1958, Smith had reached the height of his landscape impressions in such near-abstracts as Wreck

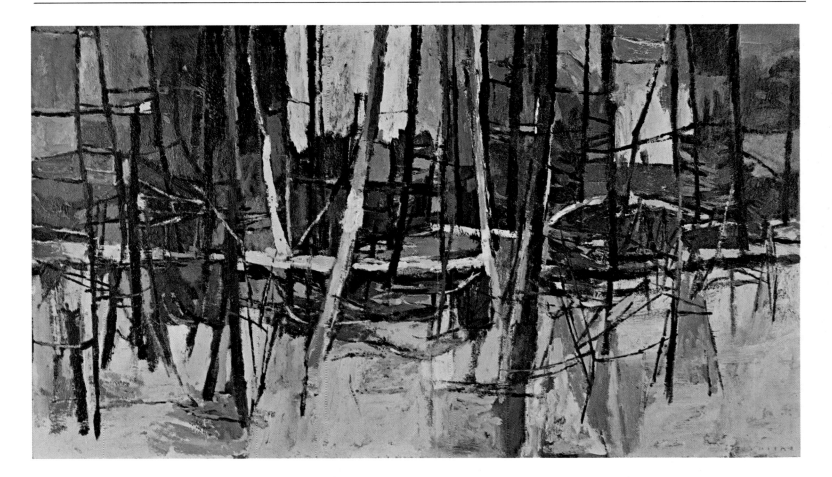

GORDON SMITH *Winter Woods* 1957 23x40 Collection: Mr. and Mrs. Henri Kolin

Beach and Yellow Painting, which were followed in successive exhibitions by such canvases as Nancledra (1961), Follower Picue (1962), Painting (1963), Towards the Sea (1965), Red Painting (1966), and, finally, by such abstracts as Through the Window (1967). Even in his most abstract paintings, Smith finds his inspiration from remembered impressions of natural forms. He has said of his abstract compositions: "I do not think of my paintings as devoid of subject matter. My feelings and themes are largely derived from nature; the sea, rocks, trees; the things I live with. I feel a painting should be much more than an anecdote or a decoration. Painting should be a re-creation of an experience rather than an illustration of an experience."

☐ John Korner is a Vancouver painter who shares Gordon Smith's artistic erudition. Born in Czechoslovakia in 1913, he first studied law at home and in Switzerland before beginning to paint. His art training included classes with Othon Friesz and Victor Tischler in Paris, while he attended courses at the Sorbonne.

Korner came to Canada in 1939, and since then has contributed much as a painter, teacher and organizer. Like Smith, he served a number of years as a senior officer with The Canadian Group of Painters and contributed important works to it. From 1956, he showed regularly, with such canvases as Destroyed City (1956), Glacier City (1957), Battles (1958), Landscape With Trail and Cross (1963), Still Life With Rose (1965), and The Present (1967). Such paintings trace his evolution in lyric imagery from near-representational landscape reports to his symbolic fantasy collages of the late 1960's.

As with almost all West Coast painters, nature, and particularly the sea, is at the heart of Korner's work. He underlined this in a statement he made in 1959: "During my childhood I

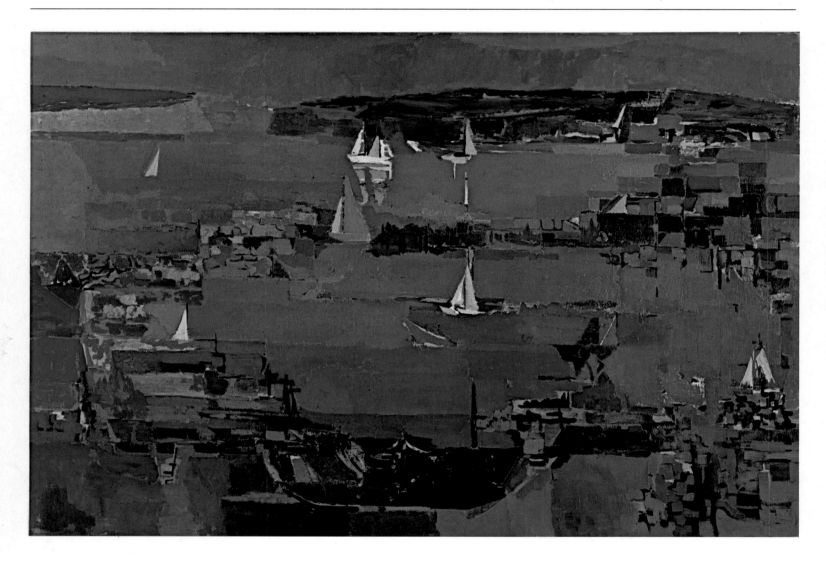

JOHN KORNER *Island Passage* 1956 31x48 Art Gallery of Ontario

lived in a landlocked community and always dreamed of being in close proximity of a harbour and the expanse of the changing sea. My life on the West Coast, for the past twenty years, has provided both. . . . The experience of this vital environment has given my theme, yielding it gradually, like a gift of many parts." □ Although Shadbolt, Smith and Korner lived in British Columbia from childhood or relative youth, all were born abroad. A native-born son who shares their passion for the Pacific landscape is Edward John Hughes. Hughes was not only born in North Vancouver, but has refused to leave his native province for more than the briefest trips, except for war years spent in England and Alaska. In fact, he rarely leaves his small village of Shawnigan Lake on Vancouver Island. From there, he moves along the coast to find the material for his painstaking, detailed landscapes. Ladysmith Harbor, Qualicum Beach, Savary Island,

Alert Bay, Rivers Inlet—the places in his pictures sound like an epiphany to the spirit of the West Coast.

E J. Hughes has been called a primitive, but his is not the result of an untutored passion. He studied for five years at the Vancouver School of Art under Fred Varley and Jock Macdonald. The technical beauty of his drawings was already arousing admiration during his school days. After his student days, he knew the sharp discipline of commercial art and, after 1939, the even more severe discipline of war service, first as an artillery gunner and later as an Official War Artist. All of these experiences supported his natural bent for concise, intense, detailed renderings of the British Columbia scene. His slow, painstaking technique (he originally produced only four or five canvases a year) and his natural inclination for solitude made the immediate post-war years very difficult ones for him. It was

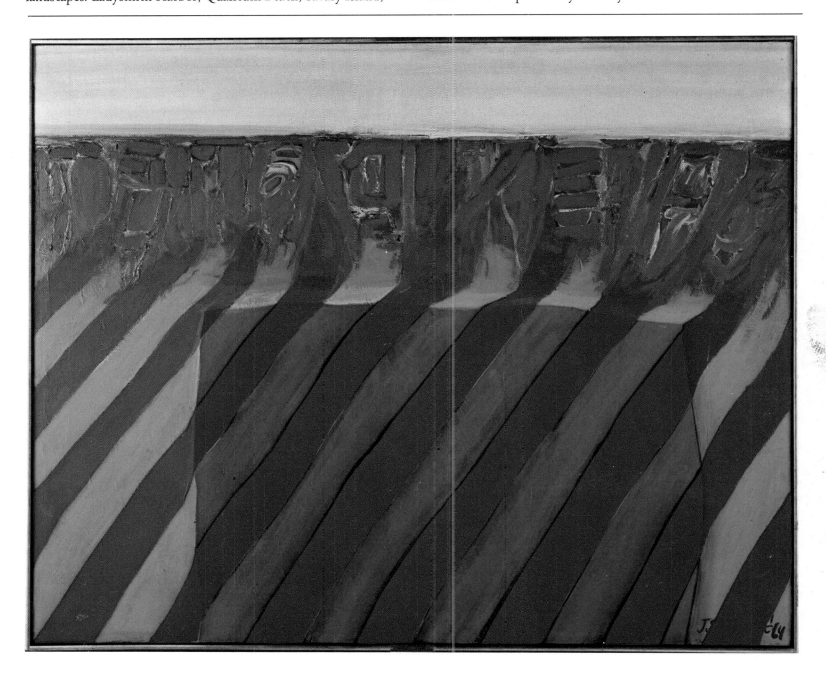

JACK SHADBOLT *Northern Elegy No. 2* 1964 39x49 Hart House, University of Toronto

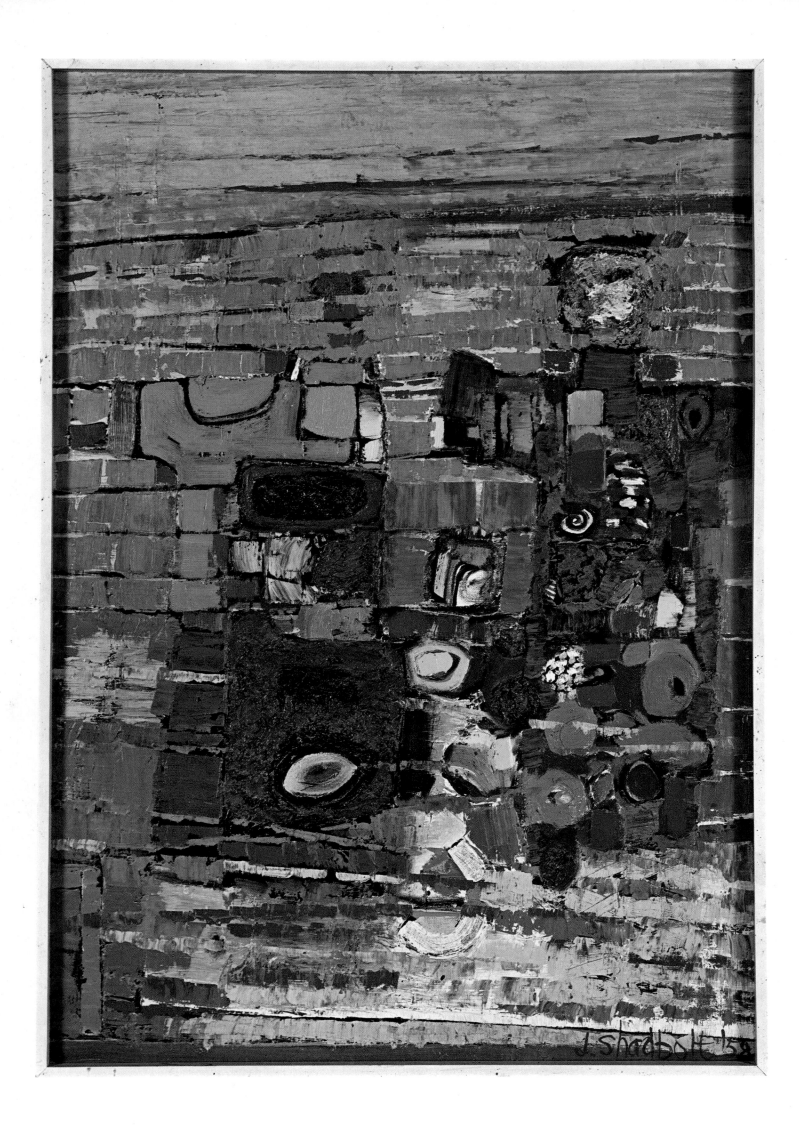

only a contract with a Montreal private gallery that finally gave him financial security and an opportunity to concentrate solely on his art.

Texture played a great part in the work of Hughes during the 1940's. His ferry boats, tug boats, automobiles and buildings, as well as the sea, sky and earth around them, are painted with a stirring richness of pigment, and every wave, pebble and board has its unique existence within the larger pattern of each composition. These paintings, which were done under great financial pressure, are perhaps the most evocative Hughes has ever achieved.
□ Lionel Thomas has proven himself a man of parts on the Vancouver scene. During the 1950 thrust of the British Columbia school, he was active teaching, painting and carrying out architectural commissions for murals and sculpture. He agitated for more government support for the arts in the form of com-

missions, and generally enlivened the West Coast scene on behalf of its artists.

Much of Thomas' own painting reflects his American studies under Hans Hofmann and Mark Rothko. Large blocks of colour are patterned with broad bands of black. The results are decorative, rather than profound, but it was that very flair for decoration that made Thomas so successful as a pioneer of mural painting in British Columbia.
□ One of the most extroverted West Coast painters is Herbert Siebner of Victoria, who has adapted a German-trained style to the British Columbia scene. Born in Stettin, he studied at the Berlin Academy before coming to Canada in 1954. A member of The Canadian Group of Painters, he has turned readily from painting to sculpture and print-making. His prints have appeared in important shows in Switzerland, Yugoslavia and Italy.

◁ JACK SHADBOLT *Mediterranean Forms* 1959 41x29
Collection: Mr. and Mrs. Pierre Berton

JACK SHADBOLT *Dream of Africa* 1959 60x42 Art Gallery of Hamilton

A Canadian master of collage is Toni Onley, who made his way to the West Coast via England and Eastern Canada. Born on the Isle of Man in 1928, he came to Canada in 1948 and first studied art under Carl Schaefer at the Doon Summer School in Ontario. He taught for a period in Brantford, Ontario, before heading out to British Columbia.

Onley's collages are made from cut-out canvas shapes pasted, white on white, to another canvas, to which colour accents in paint are added. With this seemingly limited technique, he has created many subtle and evocative works.

Two itinerant artists who could be placed in a number of Canadian and foreign locations, but will here be situated in British Columbia, are Molly and Bruno Bobak.

Molly Lamb was born in Vancouver and spent many of her creative years there. She was a student of Jack Shadbolt's at the Vancouver School of Art and revealed a special infectious feminine wit in her painting almost from the beginning. Her strength as an artist lies in her ability to express her joy in the life around her. Whether her themes are of Vancouver, Norway, England or Fredericton, she finds in them pictorial surprises in a personal vision of design and colour. In this country, where so much of our art has been serious, her buoyant, dappled works—of crowded beaches, pubs, playgrounds—ring a welcome change.

Molly and Bruno Bobak were married in 1945 while both were Official War Artists. Of the two, he is more inclined to experiment, and has worked using a number of styles in water-colour, wood engraving and oil. Perhaps his most memorable oils are a series, painted in the 1960's, representing European bridges and harbours.

The B.C. art awards known as Emily Carr Scholarships have

TONI ONLEY *Polar 12* 1962 47x52 Art Gallery of Hamilton BRUNO BOBAK *Eclipse* 22x14 The Montreal Museum of Fine Arts

played an important role in the development of West Coast painters. Such important artists as Joe Plaskett, Donald Jarvis, Peter Aspell and Takao Tanabe have all been recipients of them. (Incidentally, all but Tanabe studied with Hans Hofmann in New York City.)

Plaskett has been basically a European-oriented artist, and his career has been based in France since the late 1950's. In his Paris studio he has painted canvases redolent of tradition, with his self-portraits and figures placed against a candelabra-and-velvet decor.

Donald Jarvis emerged in the 1950's with a group of what might be called "spirit" landscapes and figure compositions. His forest scenes possess a flickering, ghost-like luminosity, and his people have an almost faceless, totemic form which suggests a mediaeval anonymity. Even in the abstractions of his later years,

Jarvis' work maintains this highly personal, mystical feeling.

Peter Aspell has been an Orient-inclined figure in B.C. painting. His hot pinks, reds, mauves and deep blues suggest Asiatic tapestries. He readily confesses his fondness for the exotic. "I love the East Indian painters," he has said, "and Bonnard, Gauguin, Gorky, Rouault. The figure has been, and always will be for me, a fascinating subject, and in time the figure will be absorbed in a world of colour light."

Takao Tanabe was born in New Westminster, but his cryptic landscapes reflect his Japanese heritage, with their black, orange and yellow calligraphy.

The complex of stylistic directions, thematic concerns and influences found in the works of such artists as Tanabe, Jarvis, Aspell and Plaskett compose the rich fabric from which future British Columbia painting will emerge.

MOLLY BOBAK *Stormy Day at the Beach* c. 1965 56x46 Imperial Oil Collection

12 / The spread of abstraction

Emma Lake, Saskatchewan, hardly sounds like a cultural Parnassus, yet it symbolizes the yeastiness of new directions in Canadian painting during the past two decades. It was the take-off point of an event in this country's art life as productive in creative flights as Montreal, Toronto or Vancouver.

Emma Lake is a small camp north of Saskatoon, the locale of a summer art school founded in the 1930's. In the early 1950's the site came under the direction of a small group of imaginative and talented Regina-based painters who turned it from a pedestrian art camp into a revival meeting-place for modern painting. The chief evangelist was Kenneth Lochead, then Director of Art at Regina College. He was assisted by painters Arthur McKay and Roy Kiyooka.

A workshop was established—a two-week session for senior students and artists that brought them into close contact with a number of pivotal figures in contemporary American painting. Annually, for a number of years, such artists as Frank Stella, Will Barnet, Jules Olitski, Kenneth Noland and Barnett Newman were invited to lead the workshops at Emma Lake. They came not to paint but to discuss mutual problems with Saskatchewan artists, to answer questions and to provide them with a vital and very personal contact with a mainline of contemporary painting. According to eye-witnesses, it was Newman's visit in 1959 that galvanized the ablest local painters into new creative action.

An equally important event was an exhibition by five Regina artists, which was organized by Ronald Bloore, then Director of Art at the University of Saskatchewan's Norman Mackenzie Art Gallery. The show, put on during a meeting of the National Museums Association, was seen by Richard Simmins of the

CLAUDE TOUSIGNANT *Accelerator Chromatique* 1968 72" in diameter Gallery Moos, Toronto

National Gallery. As a result, the National Gallery mounted a cross-country exhibition in 1961. The significant work of Ronald Bloore, Arthur McKay, Kenneth Lochead, Ted Godwin and Douglas Morton thus reached audiences a thousand miles away from Regina or Emma Lake.

The "Regina Five" (a label some object to) have since dispersed, most of them to other parts of the country, but the impact of that nervy adventure in Saskatchewan has been felt wherever the five artists travel and wherever their paintings are shown.

Ronald Bloore returned to Toronto to become Director of Arts at York University and to continue his distinguished career as a painter of subtly defined white-on-white compositions.

Arthur McKay remained in Regina, to teach at the University and to paint pictures for exhibitions in major art centres. His

lean, monochrome abstracts of single free forms floating in the centre of a canvas are among the most challenging in Canadian painting.

Ted Godwin continued to explore his extraordinary inner world on canvas in Regina, but the peripatetic Roy Kiyooka, early associated with members of the Five, moved restlessly from Regina to Vancouver, to Montreal, to Halifax. The serene, justly-organized abstracts he created on the way will hold their own any place. They are consummate in colour, design and ordered space.

Kenneth Lochead left for Winnipeg to teach at the University of Manitoba and to continue to give rein to an exploratory nature that had taken him, within a fairly few years, from portrayals of symbolic, chessmen figures through a number of abstract styles. Lochead's most recent canvases are lyrical and

RONALD BLOORE *Painting No. 1* 1959 48x48 Norman MacKenzie Art Gallery, Regina

high-keyed works executed with a rich air-brush technique.

Douglas Morton, possibly the most classically inclined of the Regina Five, joined the staff of York University. In recent years, Morton's scholarship, wrought from studies with a number of Europe's top artist-theorists, such as André Lhote, has shown itself in canvases that are monumental (and eminently personal) in character.

□ Still working in Saskatoon are the husband and wife team of William Perehudoff and Dorothy Knowles. Both of these artists were born in Saskatchewan and attended the Emma Lake workshop, but their work could not be more dramatically different. Perehudoff paints large, crisply delineated colour-field abstracts, while Dorothy Knowles creates landscapes in oils that are as delicate as watercolours in rendering. Miss Knowles' strong understanding of form and her unerring technique rank her as

one of the few original—and certainly one of the finest—landscape painters in Canada today.

□ Also situated in Saskatoon are the singular landscapist Otto Rogers and the realist Ernest Lindner. Otto Rogers was born in Saskatchewan but has a study background at the University of Wisconsin and New York City. Rogers' remarkable landscape canvases at first resemble giant doodles in their simplicity and seeming carelessness of form, although actually they are carefully considered and subtly felt productions. His paintings defy pigeonholing into any school and perhaps are as close to the mysticism of such earlier painters as Turner as they are to the modern American, Kenneth Noland, who clearly has affected Rogers' painting.

□ Veteran artist Ernest Lindner was born in Vienna in 1897 and emigrated to Saskatchewan in 1926. He has divided most of his

DOUGLAS MORTON *Totem* 1971 91x48 Collection: The Artist

A.F. MCKAY *Dense Form* 1961 48x48 Art Gallery of Ontario

life between teaching at the Saskatoon Technical Collegiate and painting. Since his retirement in 1962, he has been able to devote his full time to the finely rendered egg-tempera compositions he produces. Although he has had major one-man exhibitions in New York, Lindner is still too little known in Canada. His imaginative, metamorphic close-up portraits of logs and lichen bring an original note to high realism.

Restless new directions in Canadian art touch every part of the country and involve all of the major contemporary movements—from minimal abstraction, to Op, Pop, and magic, or high, realism. The spread of abstraction continually brings forward new talents to be considered and fresh developments by established artists to be assessed. In this environment, the viewer can no longer anticipate the future forms a given artist's work may take. In an experimental era, with new

materials continually being evolved, sudden tacks in style are no longer a cause of dismay or even surprise.

On the negative side, this changing, fluid situation widens the possibility of mere novelty or technological tricks being confused with a lasting creative statement. Even the validity of permanence or profundity of statement is being questioned in a cultural scene where it is sometimes insisted that the momentary "happening" is the essential thing, and disposable objects are sold as works of art.

Montreal continues to be the base for some of the most compelling abstract painting. There such significant figures as Jean McEwen, Yves Gaucher, Guy Montpetit and Fernand Leduc perpetuate the tradition begun by Borduas and Pellan. Jean McEwen, born in Montreal in 1933, has pursued a personal colour-field style for more than a decade. In his Flag and

KENNETH LOCHHEAD *Roll Along Colour* 1971 46x58
Marlborough Godard Gallery, Toronto

FRANÇOIS THEPOT *Emerging White* 1970 35x35 Private Collection
ROY KIYOOKA *Barometer* 1964 72x48 Art Gallery of Ontario ▷

Column series he has divided the picture plane into simple square or rectangular spaces and then proceeded to fill them with opaque paint and rich glazes built up into an encrusted, opaline surface. You look into, rather than just at, McEwen's canvases, since most of them rely in great part for their effect upon the richness of textures and colour that shine through one another in translucent layers.

The colour of Yves Gaucher's abstracts are as muted as McEwen's are iridescent. In fact, colour and texture are so minimal in most of his canvases that they virtually cease to exist. At one point, Gaucher used flat fields of brilliant colour, which he would break with carefully placed bars of white, black or a second blue. Now, his divisions of space are even simpler than McEwen's, and their lack of physical presence removes them almost into a special domain of monastic non-art. Like the art

of Ronald Bloore, Gaucher's compositions are so rarefied they have a sanctuary-like remoteness. The work of these artists almost suggests a noble disengagement, as though two very subtle men were reacting against, even repelling, the relentless pounding at the door of art by Op and Pop designers.

☐ Brian Fisher in Vancouver and François Thepot share some of the same disciplined reserve as Gaucher in their abstractions. Fisher was born in England in 1939, but came to Canada as an infant. He is one of the most gifted products of the Regina Five influence at the University of Saskatchewan, where he studied under Bloore, Lochead, McKay and Kiyooka. His finely-webbed linear abstracts reflect the disciplined approach of Bloore and Kiyooka, yet are completely unlike anything else done in Canada. They are both elegant and eloquent in the very best sense of those misused words.

GUIDO MOLINARI *Opposition Triangulaire* 1970 48x48 Carmen Lamanna Gallery, Toronto

175

François Thepot, who emigrated to Canada from Paris in the early 1960's, achieves with tonal relations some of the subtle impact realized by Fisher with linear patterns. Thepot limits his abstracts almost completely to monochromatic arrangements of greys, but his art is neither moribund nor drab. Within his restricted means, he arranges flat angular planes into restrained but satisfying harmonies.

☐ Three other hard-edged abstractionists who have achieved personal statements are Takao Tanabe of Vancouver, Guy Montpetit of Montreal and Sheldon Cohen of Toronto. Tanabe came to a geometrical approach via some of the freest calligraphic landscapes seen in Canada. These earlier works were rich yellow, orange and white lyrical impressions, strongly suggestive of the artist's Japanese heritage. Guy Montpetit, Montreal-born, turns his bright, chromatic abstract patterns into witty and happy visual excursions. His works prove that geometry in the right Gallic hands can be full of wit, and intensely human. Sheldon Cohen's compositions are based on simple colour masses which make him one of the most severe of all current Canadian abstract artists.

☐ Free, lyric, non-figurative painting is well represented in Toronto by Gershon Iskowitz and Paul Fournier. Iskowitz bases his soft-edged, floating shapes upon nature. As a landscape painter, he has moved gradually from an almost impressionist approach to his present canvases in which the presence of the land is echoed only in the luminous, sun-shot colours that softly contain his suspended forms.

Polish-born Iskowitz came to Canada from Europe in 1949, after spending several years in German concentration camps. His first works shown in Canada, at the Moos Gallery in

RALPH ALLEN *Colour and Space* 1965 48x48 Roberts Gallery, Toronto

Toronto, were bitter studies of prison life under Nazi domination. But his discovery of the lake country north of Toronto released a completely fresh creative vein within him, and his art changed from tragic reportage to works that reflect delight in the simple facts of sunshine, green trees and blue water.

☐ Like that of Iskowitz, the art of Paul Fournier, who was born in Simcoe, Ontario in 1939, is firmly anchored in nature. Fournier is self-taught, and his work has passed from brash, youthful abstracts, through a period of closely observed figurative drawings and prints, to wet-edged lyric landscapes. An ardent devotee of Turner, Fournier has a similar bent for using colour as an emotionally-charged creative weapon. With the discipline of highly realistic print-making behind him, he is able to manipulate his enthusiasm for colour with an increasingly easy and evocative authority.

Op-Pop High Realism

The centre for Optical—or "Op"—painting in Canada is Montreal, since its three leading practitioners, Guido Molinari, Claude Tousignant and Marcel Barbeau all reside there. Molinari was the first Canadian to apply himself to mastering the close, competitive colour relations that characterize Op paintings. He has explored it for more than a decade, in a variety of stripe, triangular and rectangular arrangements. Born in Montreal, in 1933, Molinari began experimenting with abstraction almost upon graduation. His early experiments included a brilliant series of watercolour abstracts in which the colours were flooded, wet-in-wet, into partly accidental patterns. Since he assumed his position as master of the Canadian Op movement, accident has been completely banished from

JACQUES HURTUBISE *Marielle* 1970 36x36
Carmen Lamanna Gallery, Toronto

JEAN MCEWEN *Column Supported by Red* 1962 72x50 ▷
Toronto-Dominion Bank Collection

Molinari's creative repertoire. No manual gesture is allowed to show; all is totally smooth, hard-edged and rigorously plotted before execution. From statements he has made concerning his colour theories and working methods, it is obvious that nothing in his studio is unplanned. In his best work, Molinari has graphically revealed the rich chromatic potential of the Op doctrine and, at the same time, clearly shows its limitations as a creative form of expression.

Claude Tousignant has moved from square, hard-edged canvases of extreme non-Op simplicity, painted during the 1950's, to his now famous circular Gong canvases which dazzle the eye with centrifugal patterns of yellow, red and blue. These extraordinary colour exercises appear to contract inwards like a whirlpool. Tousignant is clearly infatuated with their creation, after designing variation after variation for many years.

Whether they will wear as well for audiences of the future, or will appear as mere chromatic gymnastics, is another question. The answer to that should establish whether a painter can remove himself so far from any human reference in terms of design and any personal evidence in terms of technique, and still evoke an active response.

Marcel Barbeau almost blinds the retina with his weaving black-and-white patterns. He graphically proves that colour is not required to successfully hypnotize and shock the human vision. A creative intellectual, Barbeau is a veteran of Paul-Emile Borduas' fertile *automatiste* movement.

Few Canadian artists have come to prominence as rapidly as Jacques Hurtubise. Born in Montreal in 1939, he was given a one-man show by the Montreal Museum of Fine Arts at the age of twenty-two, and represented Canada at the prestigious

RAY CATTELL *Turn to Capdepera* 1972 30x40 Gallery Moos, Toronto

São Paulo, Brazil Bienal in 1965, when he was twenty-six. Hurtubise has turned Op colour principles to his own happy fancy. His jig-saw puzzle shapes and his choice of pigments are both witty and gay, suggesting flower gardens more than statements of colour theories. Appropriately, in his humanization of Op, Hurtubise uses girls' names as titles for his canvases.

An occasional visitor into the Op field has been Ralph Allen of Kingston, Ontario. Allen was born in England and studied at the renowned Slade School in London. He was a mature artist when he arrived in Canada at the age of thirty-one. A Professor of Art at Queen's University, he has experimented as a painter in many directions. His best Optical canvases have a jewel-like crystallization in both plan and colour.

□ There has been little Pop (a word shortened from popular) art in Canada. Pop, in its most essential form, is derived from comic books and the commonplaces of life—soup cans, overalls, sewer covers, hydrants, lawnmowers. Its creative role is to present these things in such a surprising way that we are provoked into seeing them anew. Thus, objects are much enlarged or reduced in scale. Comic-strip details are blown up to mural dimensions, hamburgers are created in giant dimensions, realistic plastic figures are reduced to puppet-size. In a sense, Pop art is the establishment of the ordinary.

The art of Greg Curnoe touches upon the Pop territory. One of a gifted group of painters based in London, Ontario, Curnoe has reduced many of his pictures to typographical designs composed of fragmented texts. In some of his major works, he has combined lettering with richly coloured semi-figurative compositions. Curnoe's pictorial comments are vitally contemporary; he paints the life of his own era and existence immediately

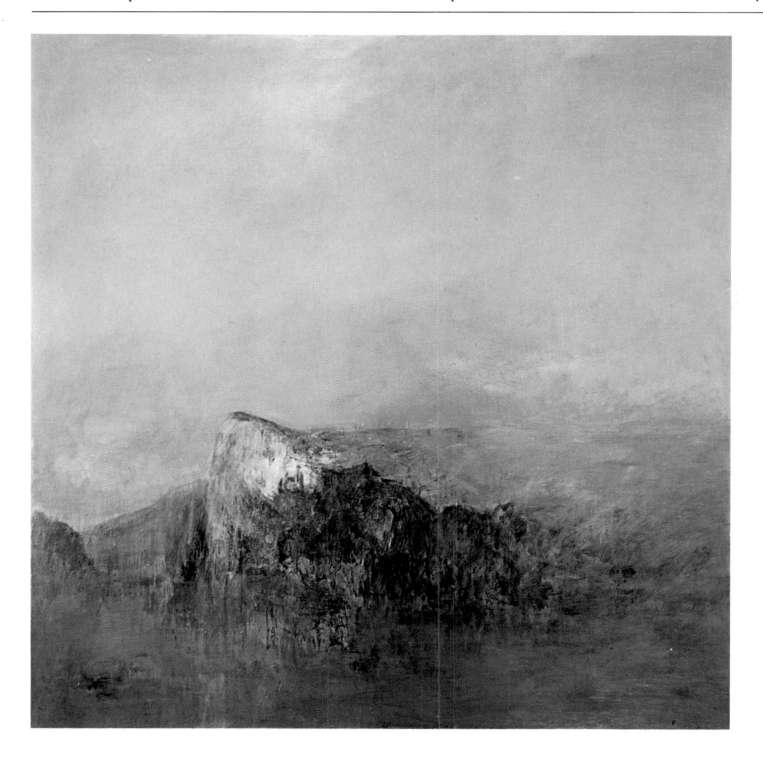

PAUL FOURNIER *Devon Set No. 3* 50x50 Art Gallery of Hamilton

about him in carefully, even classically designed canvases. His souvenirs of his own domestic life and neighbourhood are among the most telling figurative paintings done in Canada during recent years, conceived with humour and a virtuoso command of colour.

Joyce Wieland is feminine to the fingertips that sew and embroider her best-known cloth paintings. She has a unique place in Canadian art, transcribing her delicate and sure draughtsmanship to cushions and hangings that have sometimes been referred to as Op expressions, but actually belong in a singular Wieland-created world. As an artist, she is a loner who has created works that are at once irreverent, sensuous and happy.

☐ Four Canadian figurative painters who have cultivated dramatically personal worlds in paint are Claude Breeze of Vancouver, Ivan Eyre of Winnipeg, Maxwell Bates of Victoria, and Louis de Niverville of Toronto. Breeze is a protest artist who pours his vitriol upon society's flaws via slashing, satiric canvases. Breeze's expressionist technique and colour usually are as violent as his apparent anger. His paint is laid on with a molten directness, describing distortions similar to those of England's Francis Bacon. But, unlike Bacon, Breeze's pictorial message is more specific and political in its satiric intent.

Ivan Eyre, born in 1935, is less direct, and even reserved, in his comments about modern mankind. He often masks his figures in Assyrian severity and relates his concepts with a deliberate, smoothly executed style. Even his colour is usually muted to autumnal greys, greens, browns and earth reds.

Maxwell Bates, born in Calgary in 1906, is a veteran figurative painter who has also made excursions into the Op abstract school. In 1949, he studied with the great German artist, Max

GREG CURNOE *Feeding Percy* 1965 75x73 London Public Library and Art Museum

Beckman. Beckman confirmed in Bates his lifelong concern with the human comedy and added a note of monumentality to the design of his oils.

The imaginary world of Louis de Niverville is populated by pink pneumatic figures in a lush world of gardens and figured chintzes. His is almost literally a world seen through rose-coloured glasses. Pink flesh, pea green trees and eternally blue skies make most of his scenes resemble a fantastic lotus land, with once in a while a threatening touch of the macabre to spice his pictorial Eden. Born in Andover, England, in 1933, de Niverville has lived in his personal world of pictorial fancy since he first began to paint. His mural on the history of flight at Toronto's International Airport is one of the most entertaining wall decorations in the country.

☐ While abstract art spread across the country, realism re-mained vitally alive, even developing in new directions. The bulk of realism in Canada, as in the United States, is involved with the rural scene. Artists like William Roberts live in small rural communities where they can work undisturbed.

Roberts, who now has his studio in the village of Milton, Ontario, was born in British Columbia in 1921. After painting for a number of years in England, he returned to Canada to discover, as he phrases it, "the beauty of simple things," and his carefully crafted paintings are composed from the symbols of country and village life. In recent years, Roberts' canvases have been designed, in the manner of a collage, with multiple images which together evoke the aura of countryside nostalgia.

☐ William Kurelek paints a very different rural life of the past, that of the spreading Alberta farmland. In virtually hundreds of drawings and paintings, Kurelek has put together an indelible

WILLIAM ROBERTS *The Long Pier, No. 2* 1960 23x9 Hart House, University of Toronto

portrait of Ukrainian settlement life on the Prairies. Born in Whitford, Alberta, in 1927, his unashamedly sentimental record of his boyhood through pictures is sure to find a permanent place in Canadian art. Kurelek also proves that story-telling can still play an effective role in creative expression. He does not hesitate to inject humour, tragedy or religious feeling into his compositions, and he does so with a frank and accurate vision.

□ Two stylistically related and important Canadian figurative painters are John Chambers and Esther Warkov. Both paint with an almost photographic realism but free-associate their subject matter in an almost surrealist way. Dimensions are adjusted so that the scale of any given object has no relation to size in everyday life. Both artists also usually relate the tones in their paintings very closely, with few sudden contrasts, so that there is a suggestion of a twilight or dream world.

Esther Warkov is one of the youngest Canadian poetic realist painters. She was born in Winnipeg in 1941 and attended the University of Manitoba. Her technical skill, like that of Chambers, is impressive, and her concepts original and challenging.

John Chambers was born in 1931 in London, Ontario. For five years he studied at the Royal Academy of Fine Arts in Madrid, where he achieved the skills necessary for the realist manner he has adopted to his own creative purposes. Chambers was fully possessed of his personal style when he returned to Canada in 1962. In the past few years, he has moved into a more direct and descriptive kind of realism, seen in sharper focus and with intensified colour. His prime source material is photographic, and he readily exhibits the camera shots from which he fastidiously realizes the details of his pictures.

□ High—or magic—realism has become well established in

FRED ROSS *Young Boy* 1971 24x17 Galerie Dresdnere, Toronto

TOM FORRESTALL *The West Nova Scotians* 48x29 Roberts Gallery, Toronto

Canadian art through two main influences, that of Alex Colville and Andrew Wyeth. Through his teaching at Mount Allison University, in Sackville, New Brunswick, noted realist Colville has produced what might be called the Mount Allison School of Realism. His students include a number of high realists who have gone on to win their own creative laurels—D.P. Brown, Christopher Pratt, Tom Forrestall and Hugh Mackenzie.

High realist artists usually are regional artists in the most precise sense of the word. D.P. Brown, born in 1939, returned to his home province of Ontario after graduating from Mount Allison, and since then has painted the people closest to him and the countryside around his Collingwood, Ontario home. He works very slowly, producing very few paintings, in a painstaking style with the traditional egg-tempera technique. No painter working in that medium today uses it with a more classic precision and grace. Brown's work has been shown regularly in New York, and a number of his finest canvases are in American collections.

Christopher Pratt is unusual among today's close-focus realists in that he has chosen oil paint as his medium. With it, he has created a grave, poetic world of unpeopled interiors. With a window, a staircase and a patch of wall, Pratt composes paintings that are as deliberately designed as a Mondrian abstract, yet suggest overtones of human drama. Almost monochrome in colour, his canvases are flooded with a controlled and spectral light. Born in St. John's, Newfoundland, Pratt now lives in that province's town of St. Anne's.

Tom Forrestall has added a new dimension to high realism in his New Brunswick landscapes by using odd-shaped canvases in the form of ovals, circles and diamonds. Sometimes he will combine two of these together to vary the mood or focus within

D.P. BROWN *Cat at Window* 1968 16x18 Collection: Dr. Helen Dow

a single painting. Nova Scotia-born, in 1936, Forrestall now divides his time between Fredericton and Upper Clements.

One more Maritime name on the list of Canadian realists is Frederick Ross. Born in 1927 in Saint John, New Brunswick, Ross has devoted many years to portraying adolescence in crisply rendered mood studies.

Hugh Mackenzie was born in Toronto in 1928 and studied at the Ontario College of Art before attending Mount Allison. He now lives in Toronto, where he paints small watercolours and temperas with a closely-woven cross-hatch technique. Among Mackenzie's finest works have been a series of nudes, a subject infrequently painted by other Canadian high realists.

Ken Danby has probably gained more international attention than any Canadian high realist except Alex Colville. In 1963, his first egg-tempera, of a black cat, won the prestigious Jessie

Dow Award at the Montreal Museum. Since then, his works have been shown and acquired in Germany, Switzerland, France and the United States. Danby works on a larger scale than other Canadian high realists, his large panels sometimes measuring more than four feet across.

Born in Sault Ste Marie, Ontario in 1940, Danby now lives on a twelve-acre mill site near Guelph, and derives his subject matter mainly from that area. Like many of Canada's finest painters, he studied under Jock Macdonald, an outstanding abstract artist, but chose to move from abstraction to realism because of a personal need and conviction. It is this inner compulsion to find a personal vision—this dedication on the part of hundreds of artists— that has created the rich variety of individual styles which, together, make the total of Canadian painting one of the most satisfying to be found in the world today.

◁ CHRISTOPHER PRATT *Night Window* 1971 46x30 York University

KEN DANBY *Pulling Out* 1968 32x44 Collection: Mr. A. Latner

Index of reproductions

Index

This book was
set in 10 pt. filmset Garamond and
designed by Hugh Michaelson.
Colour separations are by Graphic Litho-Plate Limited.
Printed by Sampson Matthews Ltd. on
200M Royalcoat Enamel and bound by
T. H. Best Printing Company Limited.